THE
TRIBALS
OF INDIA

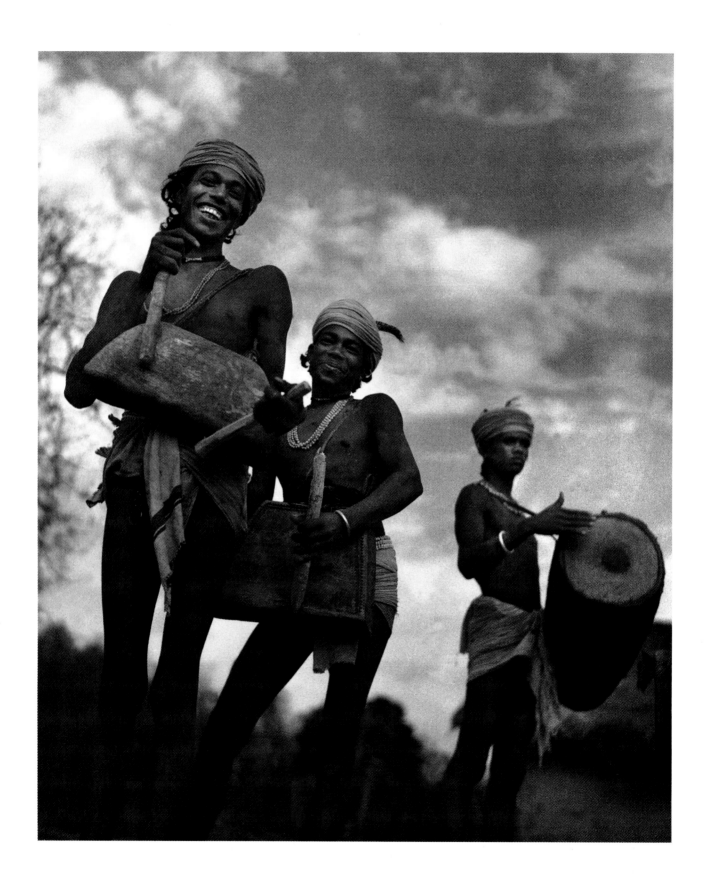

THE
TRIBALS
OF INDIA

through the lens of SUNIL JANAH

New Edition

OXFORD

UNIVERSITY PRESS

OXFORD

UNIVERSITY PRESS

YMCA Library Building, Jai Singh Road, New Delhi 110 001

Oxford University Press is a department of the University of Oxford. It furthers the
University's objective of excellence in research, scholarship, and education
by publishing worldwide in

Oxford New York
Auckland Bangkok Buenos Aires Cape Town Chennai
Dar es Salaam Delhi Hong Kong Istanbul Karachi Kolkata
Kuala Lumpur Madrid Melbourne Mexico City Mumbai Nairobi
São Paulo Shanghai Taipei Tokyo Toronto

Oxford is a registered trademark of Oxford University Press
in the UK and in certain other countries

Published in India by
Oxford University Press, New Delhi

ISBN 0 19 566127 3

Typeset in Goudy Old Style 11/13pts
Layout and design by Kamal P. Jammual
Printed at Thomson Press, New Delhi 110 020
Published by Manzar Khan, Oxford University Press
YMCA Library Building, Jai Singh Road, New Delhi 110 001

Acknowledgements

My greatest debt is to P. C. Joshi and to Verrier Elwin. Joshi sent me across the length and breadth of our country to photograph the people, and their political struggles for the journal of the Communist Party of India, and remained a good friend even after I had left the party. Verrier Elwin nourished my interest in our tribals, and recruited me as his colleague in his Tribal Welfare and Research Unit.

My wife Sobha had not merely accompanied me on some of the trips but helped me in compiling and editing my various fragments of writing and also in selecting the prints for this book.

My thanks to Nikhil Moitra, who had compiled from my diaries a series of articles and published them in Bengali in *Desh* magazine in the 1960s. These articles were of great help when I rewrote the text.

I acknowledge the *Sunday Statesman* who published the article, 'The People of the Green Rivers', on the Gadabas.

I am grateful to my daughter Monua Janah and to my niece Ilona Biswas for reading through the manuscript I had written twenty years ago, and suggesting many essential changes.

Samar Sen took pains to edit my lengthy introduction to its present size and Lady Vina Lindsay has kindly corrected all the errors in the final typescript.

The book may never have found publication without the persistent efforts of my friends Kiron Raha and Nirmalya Acharya and finally Rudrangsu Mukherjee. I am thankful to them and to the Oxford University Press for agreeing to publish it.

See page 2:
Muria Cheliks beating their
pitorka drums inviting the village
to a dance, Bastar, Chhattisgarh.

Facing page:
Garo couple fishing from a canoe
in a mountain stream.

PREFACE TO THE NEW EDITION

This book was first published in 1993 but the photographs were taken during the years 1943–72 and the text, based on my travel notes, was written shortly afterwards. I had nurtured hopes of going to and photographing other tribal areas that I hadn't been able to visit at all, so the book had, in my mind, remained unfinished. This, combined with my lack of enterprise and the lack of any interested response from the publishers in India I had approached at that time, had left the book unpublished for twenty years.

Many changes had taken place in the country in all these years and more have continued to occur in the ten years after which this edition is being published. This new edition needed a preface to bring my old introduction up do date, as the life of the tribals has also been affected by these changes. I would also like to use this opportunity to express my views on the criticisms the book had provoked from some of the reviewers when it was first published.

The tribes are no longer left isolated. The modern world with its industries and highways, markets and traders, has inexorably moved closer to the tribes and they too, have come closer to it, discarding their tribal dresses for more

conforming wear and covering their semi-nudity wherever it prevailed. Metal and plastic pots and pans have now arrived in their households, replacing the gourd-shells and the hand-crafted earthenware. The ways of life recorded in this book may soon become extinct.

A new era of rapacious international commerce, aided by the latest communication technologies, is now being ushered in by multinational corporations, more powerful than the government of any country. It is steering societies and economies towards a globalization in which no country or people can expect to survive unassailed, the tribal aborigines least of all. They have a precarious existence anyway, and they suffer depredations everywhere. Forests and indigenous people living in the forests have continued to disappear from all continents and in spite of the strongest protests from conservationists, environmentalists and human rights activists worldwide, governments allow timber barons and agencies prospecting for minerals to log, dig up and devastate these forest habitations. Dams are often built without considering the consequences on people living in the submergence area, and if this is tribal forest land, protests do not seem to help. The educated and politically aware spokesmen and women of the tribals, some of whom are now a part of our articulate urban population, have found a new voice, perhaps, too strident for our established power oligarchies. They have taken on the rebel *dalit* identity of the subjugated lower castes with whom they share common demands of equal status and opportunities.

Our country has been unique for the cultural diversities it had contained peacefully for centuries. People of all races and religions had come and settled, intermingling within these hospitable shores to make the people of this subcontinent. The tribal *adivasis*, being the earliest natives of this country, can certainly make the minimum claim of being no less Indian than the rest of us. I could not put away the thought that if the tribal territories were not redefined as their separate home states within the Indian Union, they would be piqued into claiming yet another disastrous partition. This is being remedied now and several tribal areas, including the semi-tribal Himalayan region of Uttar Pradesh, are now separate states.

When the book was first released, even some of the favourable reviews had complained that I had set out to glamourize and misrepresent the tribals. I was reprimanded for trying to reinforce the stereotyped image of primitives derived from Rousseau and Gauguin. Not

including photographs of the many distresses of tribal life or of shrivelled old women while filling the pages with pictures of pretty young girls, some of them with naked breasts, were reasons for one reviewer to dismiss the book as 'erotica' and 'exotica'.

I had photographed a surfeit of distress and naked misery during the famines, the murderous riots and migration of refugees which had scarred the years preceding and following our independence from British rule. When I quit doing photo-reportage of political events and the plague of sufferings around me and discovered our tribals, it was a great relief for me to photograph the joy, liveliness and laughter I found among them in spite of the poverty and the bare subsistence level at which most of them have existed unchanged from prehistoric times. My photographs had set out to celebrate this discovery and the emphasis on the charm and good cheer of the people and the sensual appeal of their women had been deliberate. One of the reviewers, despite being appreciative and doing the book the favour of devoting a full page of the pictures in his review, nevertheless judged my photography to have been 'exploitative'.

If that meant that I found a great deal of gratification from taking the photographs, I do not need to refute that but it could imply that my objective had been to make money from these photographs, using these people for my benefit. It isn't very uplifting for me to have to point out that the pittance paid for the publication of photographs and articles hardly ever covered the cost of the film and prints. Documentary photography in India, in our time, was not a commercial activity but a labour of love. My trips to our tribal countries were not sponsored, nor were they commissioned. They had often been quite expensive, since I had to hire my own transport to the interiors from the railway terminal and had porters carry my baggage for the rest of the way.

The first sentence in the introductory chapter had stated quite clearly that the book was not a sociological thesis and no claims were made that it was a comprehensive documentation of our tribals. I had only tried to take good photographs of these people who had fascinated me. When I found the astonishingly beautiful tribal girls in the full glory of their very transient youth, I photographed them, perhaps with the same reverence with which Gauguin had painted his South-Sea islanders, and if my photographs had put any statuesque

monumentality to some of them it was never done with Rousseau's concept of the 'noble savage' in my mind. My Rolleiflex camera, with its waist-level viewfinder and lens, had perhaps more to do with it than the implied intentions.

A young woman's body is beautiful and the appeal is largely sensual—that is how nature meant it to be. And if by using the skills acquired over the years, I have taken attractive photographs of the tribal girls, it is but a job well done. I do not know whether I should feel flattered or denigrated if the photographs I had taken of these simple primitive women without any make-up or lighting aids are considered 'seductive and titillating' by one reviewer.

The new revised edition of the book has several more photographs added to some of the sections and the text has a few additions and alterations.

February 2003 Sunil Janah

CONTENTS

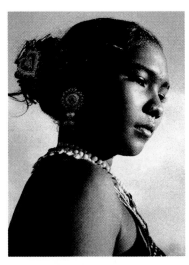

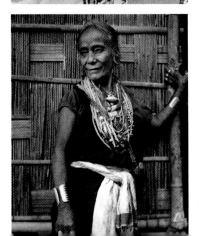

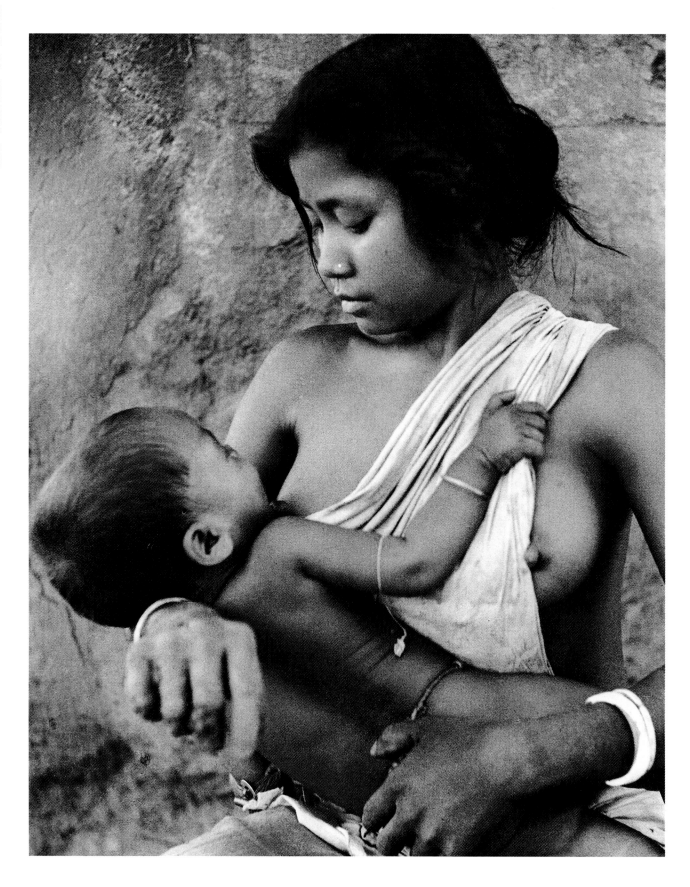

INTRODUCTION

This is a book of photographs and the brief text rarely aspires to be an ethnological discourse. I have described the tribes as I found them and have narrated my experience among them. My visits to them beginning in the early 1940s have been, however, spread over a period of more than thirty years and I have seen many changes in their way of life, not all of them happy. Inevitably, the economic potential of tribal regions, their mineral resources, forest wealth and the land itself, could not be ignored in a 'developing country'. Industries have marched in, and improved communications have been introduced. The tribals are not so utterly isolated any more.

Wherever railways and roads have cut across the previously inaccessible wilderness of the tribal territories, vast areas have been deforested. The huge, disconcerting structures of modern factories spouting smoke, pit-heads of mines, dams, hydroelectric plants and giant glittering pylons now tower over quiet paddy-fields and forests. Many of the young tribals have found new, unfamiliar jobs in these projects, mostly as unskilled labourers; their way of life has changed almost entirely. The impact of these changes on the economy, social life, morals, manners and customs is not hard to predict, and has been much more devastating among the tribes than among the equally poor Indian villagers

Facing page:
A Santal mother and her child.

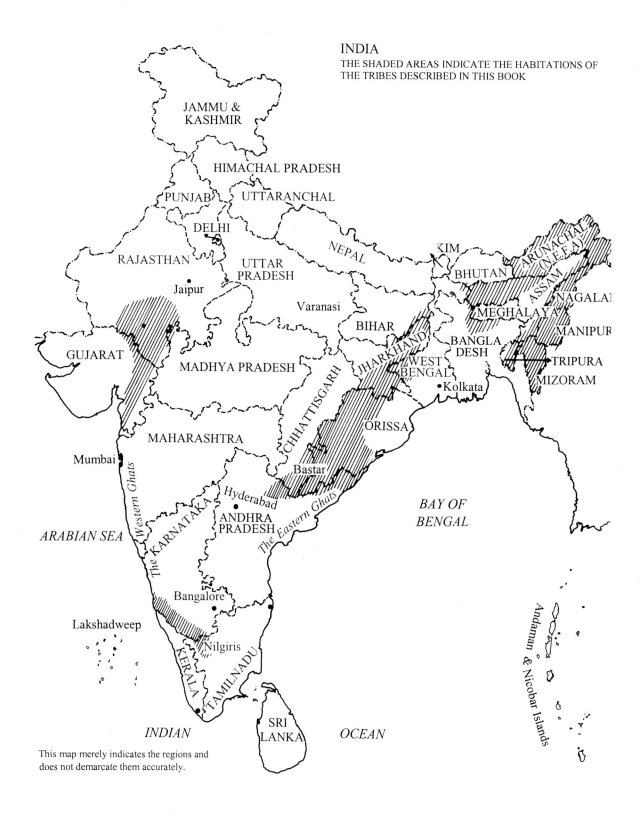

INDIA
THE SHADED AREAS INDICATE THE HABITATIONS OF
THE TRIBES DESCRIBED IN THIS BOOK

JAMMU &
KASHMIR

HIMACHAL PRADESH

PUNJAB UTTARANCHAL

DELHI

RAJASTHAN UTTAR
 PRADESH

NEPAL

SIKKIM

Jaipur Varanasi

BHUTAN

ARUNACHAL
(N.E.F.A)

ASSAM

NAGALAND

BIHAR

MEGHALAYA

MANIPUR

GUJARAT MADHYA PRADESH

JHARKHAND

BANGLA
DESH

WEST
BENGAL

TRIPURA

MIZORAM

CHHATTISGARH

Kolkata

MAHARASHTRA

ORISSA

Mumbai

Western Ghats

Bastar

ARABIAN SEA

KARNATAKA

Hyderabad

ANDHRA
PRADESH

The Eastern Ghats

BAY OF
BENGAL

Bangalore

Lakshadweep

KERALA

Nilgiris

TAMILNADU

Andaman & Nicobar Islands

INDIAN SRI
LANKA OCEAN

This map merely indicates the regions and
does not demarcate them accurately.

who have lived close to the industrial townships for generations. They have adjusted to gradual development and have not had it thrust upon them so suddenly. Moreover, it is not only the comparatively small invasions of modern technology with its undeniable advantages that have affected the tribal people. Religious and social reformers of all creeds, moral zealots among ministers, bureaucrats and block development officers and even schoolteachers have tried to make the tribals feel ashamed of their way of life. Puritans among Hindus, Muslims and Christians regard the freedoms of tribal life as abominations. They disapprove of dancing, drinking, free mixing of the sexes and 'improper' scanty clothing. They are shocked by many tribal customs as they come from backgrounds which condemn them as immoral.

My work as a photojournalist took me many times across the length and breadth of the Indian subcontinent. Going into one of our tribal villages and living with the tribals for a few weeks has always been far more rewarding to me than heading for the nearest beach or hill resort or even taking a frenzied whirlwind trip abroad. I went to the tribal villages because I came to love these people, and felt happy and relaxed among them. I adored the simplicity of 'primitive' societies. I loved the exciting visual stimulus of the costumes and the natural beauty of the people which was such a joy to photograph. I lived among them as an untrained observer, having none of the technical qualifications of an anthropologist. I have not collected statistics or folklore or samples of their crafts. Nor have I recorded their music or measured their skulls. It is painful to find them swallowed up and assimilated by a narrow, rather repellent and over-zealous form of Indian nationalism, unable to fulfil Nehru's ideal of 'unity in diversity'.

It may not be possible to take such photographs as these in many areas any more, and even less so in the future. These photographs may therefore be of some documentary value, apart from whatever artistic merit they may have. Perhaps they also convey some of the joy I felt in living among the tribes.

The economic organization of tribal communities varies, but there are no great differences in wealth, and no exploitation of the many by a few. Most of them are agriculturists; some are settled while others are nomadic, but hunting, fishing and gathering forest produce have remained an important part of their life. There are no capitalists or landlords. Although the chiefs have great power, most important decisions are taken collectively by the Village Council he presides over. Primitive communism prevails among many of them; the crops are still stored in communal granaries.

I have grouped the photographs under six geographical sections, although one often finds ethnic and cultural similarities between several tribes living far apart. Although the tribal belts represented contain the entire tribal population of India, I can hardly claim to have photographed all the tribes in any one area. These predominantly tribal areas, roughly indicated on the map, are as follows:

1. The hills and forests of Santal Parganas, Koraput, and some of the neighbouring districts of Bihar, Jharkhand and Orissa: These territories cover the border regions of West Bengal, Bihar, Orissa and Andhra Pradesh. This entire hilly terrain is the country of the Santals, Oraons, Hos, Mundas, Bhumias, Saoras, Konds, Gadabas, Bondos and the Juangs—and now constitutes the new state of Jharkhand.

2. The highlands of Bastar (now in Chhattisgarh) and the adjoining districts in central India: This territory is inhabited by the Gonds and their branches, the Murias, the Hill Marias, the Bison-horn Marias, the Koyas, the Baigas, and many other similar tribes. Bastar, a lovely green plateau, is at a high altitude, much above the scorched plains of central India.

3. On the western coast, the sandy desert of Rajasthan stretching through Gujarat and the sparse rocky forests of the Western Ghats, and in the deep south, the Nilgiris: The Bhils populate most of this desert country. The Banjaras and the Lohars (ironsmiths) also originate here, but they are nomadic gypsies and they can be found camping anywhere in India. The Warlis live further south, in the hills of the Western Ghats in Maharashtra.

 The Nilgiris in the deep south are inhabited by the Todas, and the Kotahs. They do not belong to one classifiable group. Only the Todas have been written about because of some of the unusual features of their habitat and their lives.

4. Tripura and the border regions of Bangladesh and Meghalaya: Among the many tribes of Tripura, I photographed only the Chakmas.

 Before the partition of India, the eastern-most states, Assam and Bengal, formed a continuous stretch of land. After the birth of East Pakistan (now Bangladesh), some of the Hindu tribes in north-east Bengal, such as the Hajangs who had been oppressed by the government of Pakistan, crossed the bordering Garo hills to make their new homes in Indian territory in Assam. For the purposes of this book, however, I have to regard these tribes as Bengali-Assamese as they are considered at present.

5. The hilly regions of Assam which now cover several separate states: This region is populated by numerous tribes which are ethnically quite different from the Dravidian tribes of central and western India. In the wettest part of the world, Meghalaya—'the abode of the clouds'—there are the Khasis, the Garos, the Jayantias and some of the Boros (Kacharis). The Mikir hills, outlying the valley of the Brahmaputra in Assam, are named after the tribe inhabiting them. In the Assam valley itself, and in some of the islands in the Brahmaputra, there are settled populations of the Miris from the North-East Frontier, and the Kacharis, Lalungs and several other indigenous tribes.

6. The densely forested foothills of the eastern Himalayas, bordering Tibet and the North-East Frontier Agency, namely Arunachal Pradesh, extending to Nagaland, and the mountainous regions of Manipur on the Burma border: This has been the homeland of the largest group of our Mongolian tribes, who have close affinities with the people of Tibet and Burma. Most of the Nagas and all the Mizos live in the states of Nagaland and Mizoram, but some Naga tribes and the Kukis live in Manipur while many other smaller tribes are distributed all over this region. Much of this territory is still marked in official maps as inhabited by 'unknown tribes'. I have been able to photograph only some of the more accessible tribes like the Miris, the Mishmis, the Abors and the Daflas.

As apparent from the above description of the tribal territories, except on the North-East Frontier, where the so-called Aryans in ancient times had not penetrated, the tribes which are now euphemistically called adivasis ('the original inhabitants') have been driven into inhospitable hills and forests and even deserts, while conquerors of different origins settled in the rich and fertile plains and river valleys. All our tribals are either highlanders or forest-dwellers, and a few like the Bhils live in the deserts, as do the sorry remnants of the 'Indians' and the aborigines in their 'reservations' in America, Australia and New Zealand. In India, however, the tribal inhabitants were not exterminated by ruthless genocide; instead they were allowed to languish away in poverty and isolation. Paradoxically, however, the tribals in the remotest areas have survived the best, retaining a simple and indigenous way of life. One has to go far into the interiors to find unchanged villages. It takes time and expense and a great deal of organized effort to reach them.

However, the trouble and the hardships are often more than amply compensated for. With a few exceptions, you find unending hospitality once you have introduced yourself to the headman and

have explained the purpose of your visit. I have always taken an interpreter, preferably of the same tribe, from the nearest township—a high school student or teacher, a small trader, a Forest Department official or some other minor government official.

Once you are accepted in the village, all doors are open to you. You acquire the status of a brother or an uncle and even on later visits, you will always be welcome. Tribal life is collective and not individualistic; it is a shared community life. There is little competitiveness based on acquisitive greed. The affection they have for each other is readily extended to a friendly stranger. You are always given shelter no matter where they may let you stay since you are treated as a guest of the village.

Nothing is expected of you. They are touched if you buy them a pig and a few pots of their local brew to feast on. You are sure to be rewarded with the music of drums and flutes and singing and dancing till the small hours of the morning.

Perhaps one of the reasons for the spontaneous joy of life in the tribals as compared to the rather morose Indian villagers, is that they never have to feel smaller than others in their own communities; they do not judge people in terms of 'success' or caste. They have no sense of sin about sex, and little or no shame about their bodies in contrast to the Indian villagers' inhibitions. They have preserved the physical expression of joy in their lively dances. Tribal children learn to dance as soon as they learn to walk. The boys and girls grow up together free from any sense of guilt about sex. Sexual offences are rare in these tribal societies, although bawdy humour abounds in their conversations, songs and pantomime.

Sex was never considered sinful by the ancient Hindus; on the contrary, it was treated as sacred and sculpted on temple walls as can be seen in the great temples of Konarak and Khajuraho for example. But successive invasions over the centuries influenced the Hindu mind, destroying its liberalism and preserving only its puritanical, ascetic aspects, the superstitions and the fears. Rites for propitiating the gods and rules governing the conduct of men became the prime concern of popular Hinduism.

The tribals, except for a few converted to Christianity by European missionaries, have remained largely unaffected by these encounters. They have their own gods, their rituals and their taboos. Very often, the tribal chiefs will not allow their young to go to a forbidden mountain or to wash in prohibited waters. Nor will he do any of these things himself. Fear of

landslides or of lurking crocodiles might have been the original reason for making these laws in some far-off time. But these laws are easy to observe and do not lead to confusion and despair.

The tribals have a 'culture' worth preserving. They are not literate but they have a rich oral culture—their poetry and their songs, myths, legends and dances. They have a storehouse of traditional skills and excellent handicrafts.

As a result of the cultural invasions taking place now, the tribals feel that they should think and behave like their equally exploited but conforming neighbours. The tribals are considered *junglies,* wild creatures, to be broken in, tamed and dressed up to look like everyone else. I remember an incident during the rehearsals of folk dances staged annually on Republic Day in New Delhi. There was a troupe from the Jayantia hills of Meghalaya. All the girls were wearing cheap, gaudy and ill-fitting, mill-made blouses and the young men were in equally odious shirts. All of them were looking extremely self-conscious and uncomfortable.

'Do you wear these horrid things when you dance in your villages in the hills?' I asked them. The response was immediate. 'Let's have our dress', shouted the leader with joy. And within seconds, as the men stripped to their waist, the girls discarded their blouses and draped themselves gracefully in their simple striped saris. Tribal clothing is often considered indecent for these occasions and the organizers dare not present the participants in their authentic costumes.

The dances always have the accompaniment of songs, and the music of flutes, drums and primitive string-instruments, which differ in design, but almost always have a sun-dried gourd shell as a base. The strings go across the hollow or (in the more sophisticated versions) over a wedge of wood fixed on the stretched skin covering the halved shell. Some of their simpler drums, such as the Muria *pitorka,* are only thin blocks of hollowed-out wood. They make good music echoing the sounds of nature. Tribal songs too have the melody of the wind and the rain, the rippling brooks, the cries of wild animals and of the vast silence. They sing about their joys and sorrows and even of rebellions—always with a slow, gentle and sensual rhythm and often with melancholy humour. But they do not work themselves up to the wild frenzy of African music or of Western 'pop' music. 'Oh re la la, la le la, Oh la la, la re la la', it goes on plaintively and endlessly with the same placid rhythm and lullaby cadences.

Primitive societies look after both the young and the old. Even the very old are lovingly taken care of and are never left to themselves separated from their families, to wilt away in old people's

homes. They become honoured headmen, or members of the Village Council, and impart to the young their wisdom and experience which are no less valuable than the physical work they can no longer do. As grandfathers and grandmothers living in the same house, they also look after the children and teach them the skills they will need when they grow up, while their parents are away working in the fields and forests.

All this does not, however, mean that if one wanders off to a tribal village in India one would find a Shangri-La. The tribals are certainly not free from human vices. They live in misery and poverty. One notices the marks of this poverty first—the cesspools of filth, diseases, malnutrition, ill-nourished children and the adults who are shrivelled and old at forty. Lack of sanitation and proper medical care lead to epidemics. Belief in witchcraft permits the medicine man to brand a sick child with a hot iron to drive away the evil spirits supposedly possessing him.

Although most of them are peaceful, there are some who take pride in their machismo and murderous inter-tribal blood-feuds. They too have drunkards and social misfits who are often victims of the autocratic domination of their tribal chiefs against whom there can be no appeal.

Unfortunately, the tribals are ruthlessly exploited by everyone from the outside world who come into contact with them—timber contractors, merchants and licensed distillers of the liquor they drink. Some petty officials even make a regular habit of collecting chicken, eggs, rice and forest produce from them without making any payment. The tribals are too poor to offer bribes and to avoid harassment, most of them run away from outsiders. This fear has other unfortunate consequences. They are unreasonably afraid of visiting government Health Department workers and vaccinators. My camera bag often scared them away because they thought I was another such person carrying injection needles and vials of strange liquid to pollute their blood.

The tribals are bound by crushing burdens of debt to the money-lender whose visits are dreaded; he may take away a whole year's crop in a lean year. The fascinating part of it is that they take it all in their stride and remain resilient and kind. They never brood on their misfortune and are usually cheerful.

The tribals have fought against economic exploitation again and again. Many tribal rebellions, fought with bows and arrows against guns, have been ruthlessly subdued and remain unsung sagas. The tales of their suffering and bravery remain buried in official files.

These people do not need industrial goods or moral education, but they should be provided with hospitals, medical care and a basic education aimed at removing harmful superstitions and

creating an awareness of their rights. We have a lot to learn from them about living together in peace and joy. We need not divest them of their dignity and simplicity in order to grant them a meagre share of our technological knowledge; nor need we make them give away their freedom for our dismal wage-slavery.

The depletion of the earth's forests, forest-dwellers and wildlife has been far greater in this century than during the millennia before the industrial age. It is only in the last decade that civilized man has begun to be seriously concerned about the ecological catastrophe caused by industrial progress. The tribal forest-dwellers are its immediate and most conspicuous victims. They are sustained by and are the natural custodians of the forests; they never harm nature nor do they needlessly slaughter its creatures. In the more technologically advanced world of tomorrow there may be no primitive men left to preserve the dawn of mankind.

I have been a close friend and an associate of the late Dr Verrier Elwin, a compassionate friend and chronicler of India's tribals who says in one of his *Twaru* (Tribal Welfare and Research Unit) newsletters:

> The tribesmen cannot be isolated any longer; they cannot be left alone. The great problem is how they can pass from their present life of primitive simplicity into the modern world, not only without being destroyed in the process but also so that they may make their unique artistic and human contribution to the modern world. A free India has no need to be ashamed of her primitive population; rather she should treasure and use it, accepting with gratitude the priceless gifts of strength, honesty and beauty that it can bring.

I have shared with Elwin the despair he had always felt about the inevitability of the tribals being totally assimilated into our prevailing hybrid and very confused culture, or worse, being wiped out by the relentless march of technology and modern commerce.

This book of photographs of India's tribals can only hope to remind us of a small and neglected tributary to 'the human stream', about which Pierre de Chardin writes in his extraordinary book, *The Phenomenon of Man:*

> Man is a phenomenon in which all civilizations, all races, all customs pour out their streams as tributaries to the main stream. They cannot afford to ignore, not only the loud proclamations but also the unheard whispers of truth from the great civilizations in advanced races or even the tribal world, irrespective of their geographical locations, who have something unique to contribute to the human spirit.

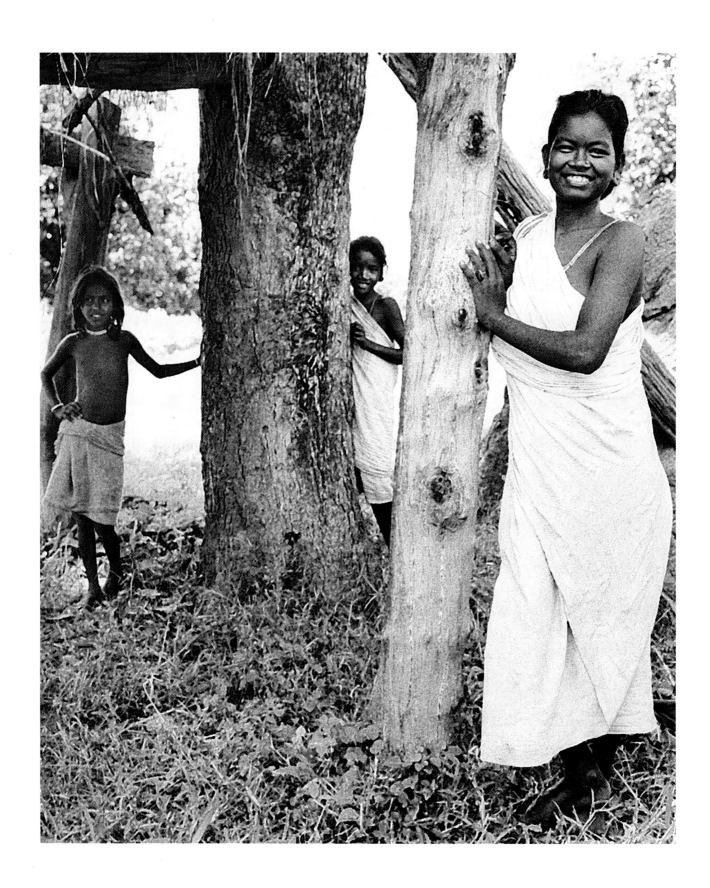

JHARKHAND AND THE BORDER REGIONS OF BIHAR, ORISSA AND WEST BENGAL

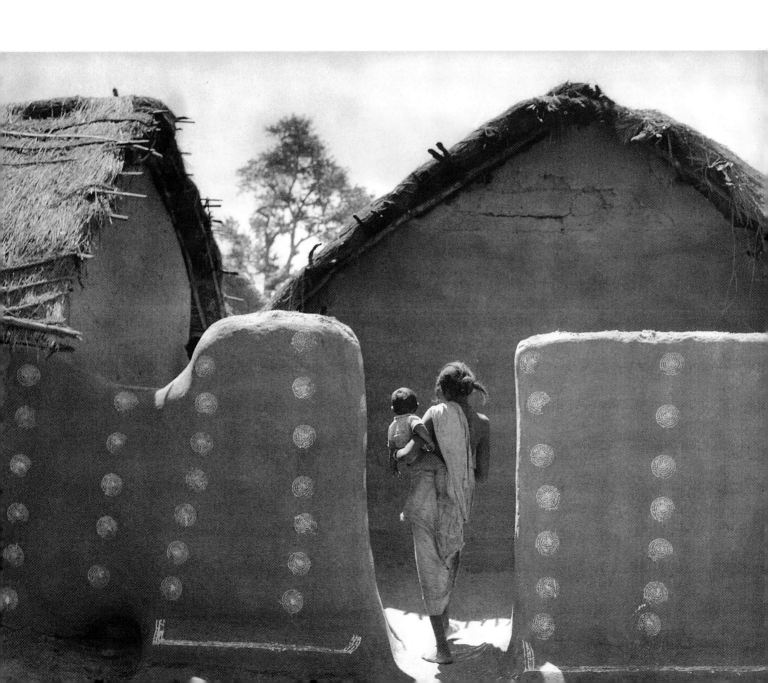

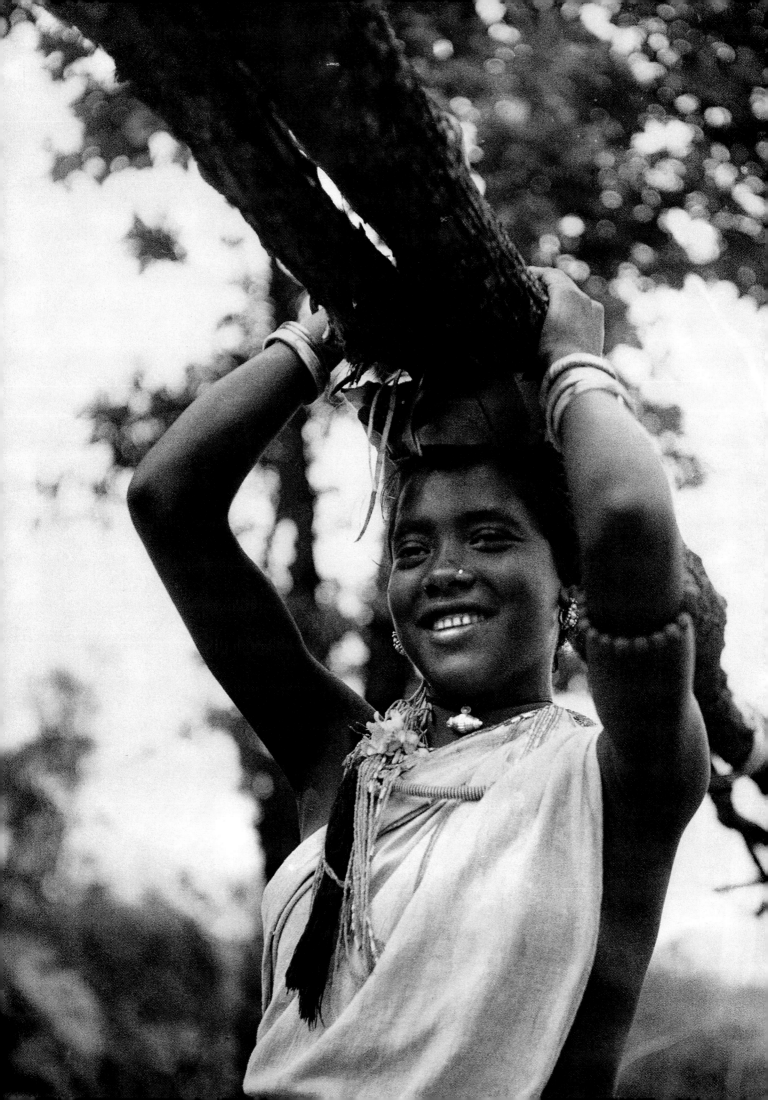

SANTALS, ORAONS, BHUMIAS AND HOS

The delta land of Bengal with its alluvial soil and evergreen plains is separated from the rest of north India by a rugged terrain of red earth, small hills and *sal* and *mohua* forests, which stretches all along the border of Bengal from north Bihar to Orissa. This stretch is the tribal country of the Santals, the Oraons, the Hos, the Mundas and the Bhumias. Many popular Bengali lyrics have romanticized the joy of taking the 'red earth' trail away from the plains to the enchanting hills and the mohua forests. They so captivated the sentimental Bengali imagination that many civil servants and professionals, as well as writers and artists, built themselves holiday and retirement homes in the small towns of the Santal and Oraon country which were easily accessible by train. These Bengali settlements still thrive and Kolkatans still go to these places for vacations. The tribal people had a grievance and used to clamour for a separate state, but were tolerant and friendly towards the Bengalis. The Bengalis have reciprocated their affection and have taken great delight in visiting all their fairs and festivals. The tribals' grievance too has at long last been met.

My acquaintance with the Santals has been since my childhood. I still have some photos of them taken with my Box-Brownie camera during my school-days. But my trip to Santal country as a photographer did not take place until 1946 when I was asked by my friend Victor Sassoon, who had set up a picture agency in Kolkata called 'Tropix', to do a photo feature on the Santals. Soon I was ready for the journey. I dismissed the idea of taking along an interpreter,

See page. 22:
Oraon children.

See page 23:
Decorated hut in a Santal village,
West Bengal.

Facing page:
'The most beautiful girl of
the village.'

knowing that all Santals understood Bengali perfectly and spoke with ease a charmingly faulty version of it. They dispensed with the more formal usage of the second person—*apni* and *tumi*—and used only the *tui,* which Bengalis would use, to address children, intimate friends and sometimes persons of much inferior social rank. This use of the familiar pronoun, far from offending the Bengalis, in fact endeared these people of the forests to them.

But with all their charm, the Santals could be rebellious when roused. Exploitation by landlords reduced most of them to landless agricultural labourers, which led to the Santal rebellion of the 1850s, when they defied the rifles of the British with bows and arrows. The rebellion was ruthlessly put down. In 1967, they rose in armed rebellion once again, this time in Naxalbari, in north Bengal. The guns were provided by the Naxalites, the extremist communist group.

My photographs of the Santals were, however, taken in peaceful times. My introduction to them was through a British scholar and ex-civil servant, William Archer, who had written about them with an affection born of living amongst them for a long time. I had first met him at the Victoria and Albert

Santal women during a dance.

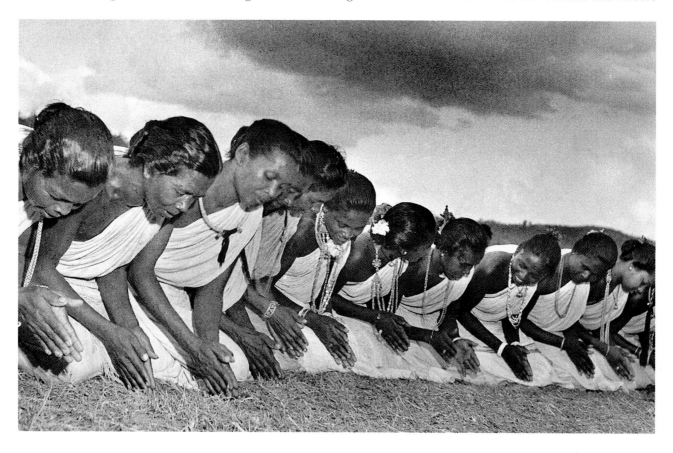

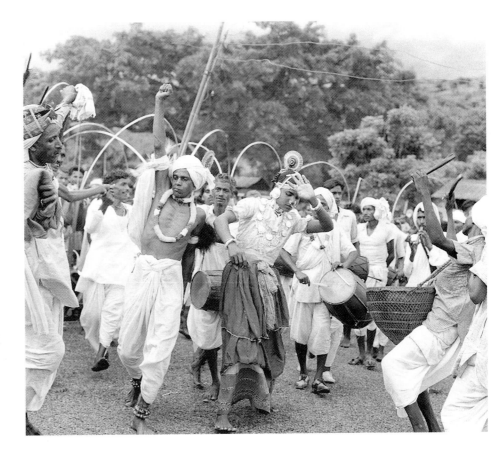

Right:
Santals and Oraons, indentured tea-plantation labourers in the Oroars, north Bengal, dancing during their Chet festival.

Below:
Oraons dancing.

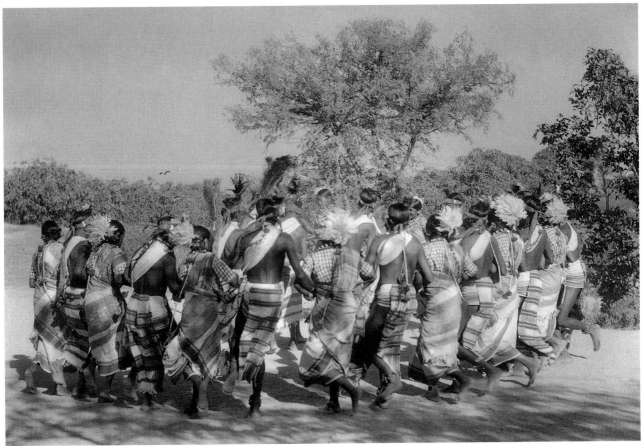

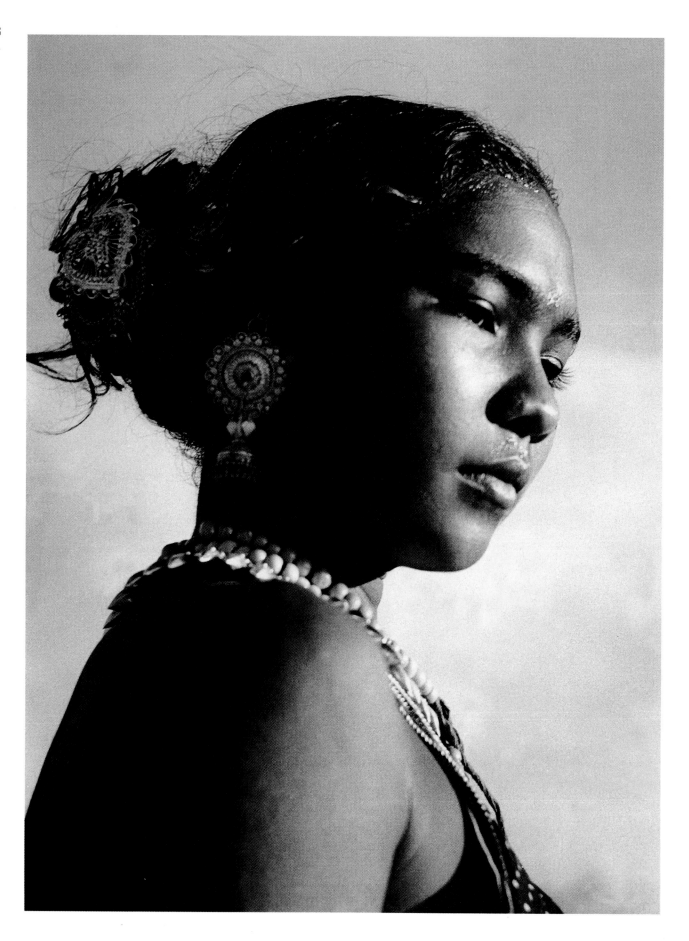

Museum in London. I saw his face light up when I talked to him about the Santals.

I took a train from Kolkata to Dumka to reach the village he had asked me to go to. When I reached Amtala village by bus from Dumka and met Chotaramu Murmu, the village headman, I was welcomed as a friend of their beloved 'Bill Sahib'. For all purposes, I was assured, the old man's house and the village were mine. I could stay as long as I liked, take my prying camera to any household, at any time, and he, Chotaramu Murmu, would personally escort me everywhere, even to other villages around.

Food was brought long before the evening set in: pig's trotters in very hot and salty gravy, potatoes and turnips, coarse red rice and an enamel mug full of red mohua wine. Happy with this simple meal served with much love, I slept blissfully on the *charpoy* laid out in the fenced front yard of Murmu's dwelling. Neither the concerted howls of jackals and the screech of peacocks nor the snores of Chotaramu sleeping next to me could wake me up.

I was up early. There was, of course, no tea, and refreshing ourselves with a bowl of *muri* (puffed rice), and some purple berries which had a sweet and sour taste, we set out to explore the village. The first person we met was Chotaramu's son who had gone out to the forest before daybreak to collect the evening meal for his guest. He had a muzzle loading country-made gun in one hand and a peacock slung over his shoulder. It was a pity that so beautiful a bird, resplendent in its gorgeous plumage, had to die merely to provide meat. The village awakened around us and I soon forgot about the kill, remembering with gluttonous depravity how good its meat tasted, even better than a turkey's.

We began our round of the village. No house was barred to me because Chotaramu escorted me. It was fascinating to watch what happened in the morning when all the able men and women prepared to leave for the whole day to work together in the fields and forests.

In non-tribal Indian villages, only the men leave and the women are left behind to do the household chores and look after the children. In the tribal world, not only women, but even growing children work with the men. Only infants, cared for by the grandparents, and the old and the sick stay back. The morning meal and the food carried in clay pots and neatly laid out within a

Facing page:
A Bhumia tribal girl, Orissa.

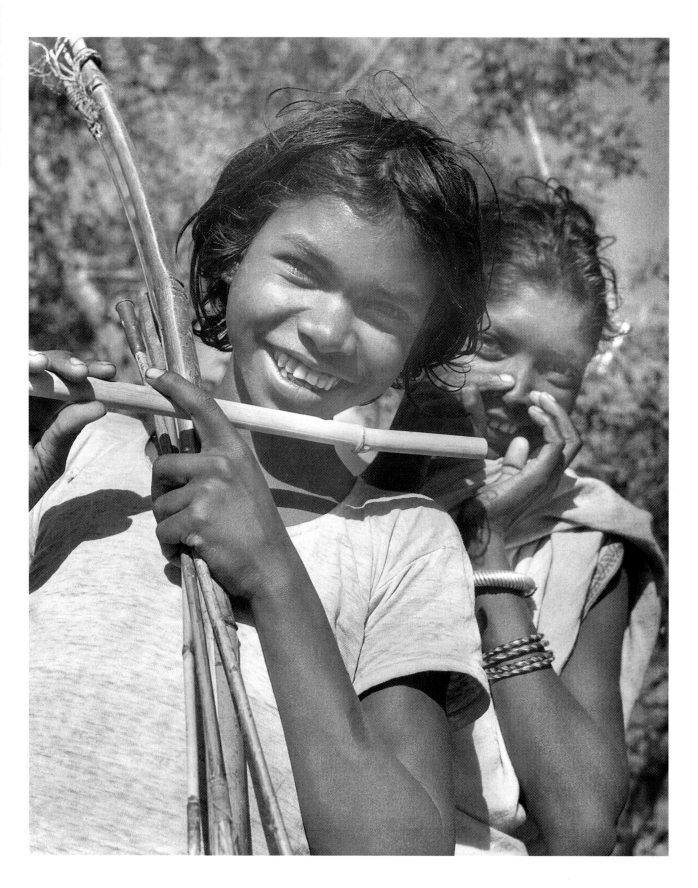

Facing page:
Santals from West Bengal.

Right:
Ho girls from Rourkela, Orissa.

Below:
Santals watching performers at
a year-end Charak fair near
Santiniketan, West Bengal.

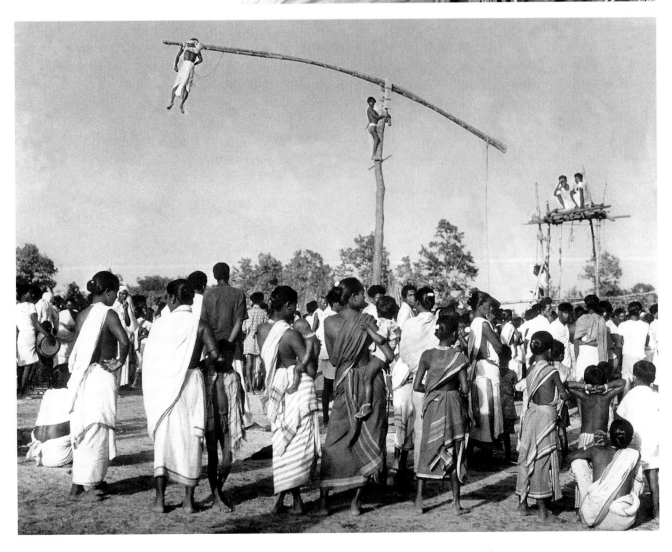

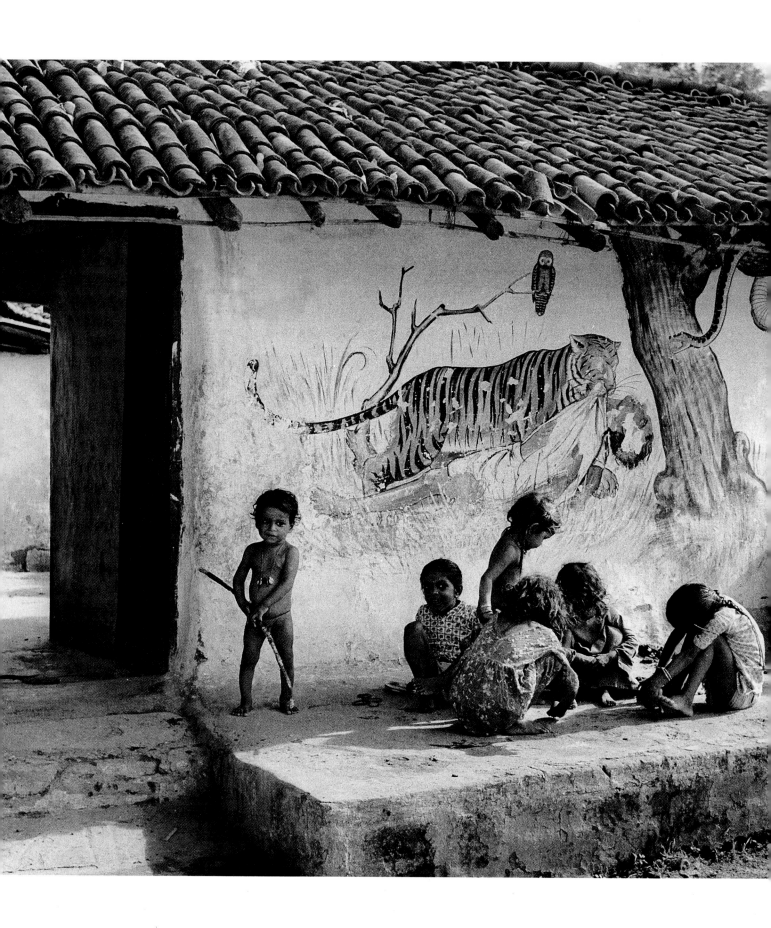

cane basket, are cooked at dawn. Gourd shells filled with rice-beer are suspended from the ends of the spliced bamboo stick they use for carrying all loads on their shoulders. The bustle ends; the smoke from the wood fires rises no more, and only goats, pigs and little children are seen romping in the lanes and courtyard of the deserted village. I have seen this pattern again and again in all tribal villages, and I know that except on festive days, I can never expect to get any photographs of the people unless I am in the village early in the morning, before the exodus begins. Occasionally, one may be lucky and find a few stragglers, but more often than not, one has to go all the way to where they are, scattered over many fields and forest patches, up on a hill cutting wood or down by the river bank, fishing. But by the time one gets there, the sun is high and the light too harsh, so one has to wait till the afternoon for the sun to mellow.

The Santals are settled cultivators and what one finds in their villages is not very different from others in the region. There are the same hay stacks, the winnowing and threshing of paddy, the tap-taps of husking with a *dhenki*, a wooden seesaw-like contraption with a stout wooden peg at one end which digs into a pit packed with paddy. A woman walks up and down the other end to work it. She clutches a rope hanging from the rafters for balance. Another woman sitting near the pit deftly removes the rice from the pit and puts more paddy in as the peg is lifted. Then there are the mango groves, cool and inviting with a fragrance pervading the air in the flowering season. The boys mind the grazing cattle, playing their bamboo flutes all day long. Except for the sound of the flutes and sometimes the carefree beating of drums by an aspiring youth or an old hand practising to wile away the monotony of a long afternoon, there is a hushed quietness in the Santal village.

There is an extraordinary cleanliness and a sense of beauty expressed in the decor of Santal houses. They adorn their impoverished homes lovingly. Every yard, every back lane, is swept clean, every fence kept in good repair, every kitchen garden with its poor array of *okra*, chillies, aubergines and radishes is well tended and every gourd creeper climbing to the thatched roof is well trimmed. The walls of their huts are never allowed to crumble but are kept in good condition by the women with mud and cow-dung plaster and there is never a day when one does not find some lone woman, spared from her work in the

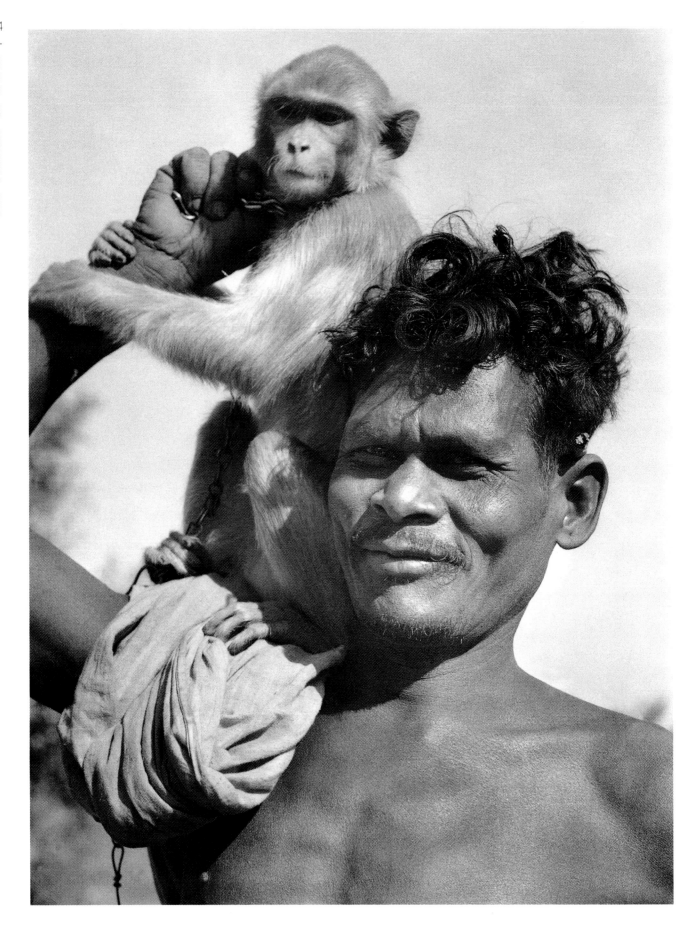

fields, doing this. When her task is done, she may lend the space to a painter among them to do a mural. He may not be a professional, but the village gives him a few days off from his communal task to let him use his talent and imagination. He is rewarded, not necessarily with money, but always with food and drink while he works surrounded by admiring onlookers. And as long as the wall lasts, everyone will appreciate the work of art and reminisce, 'Our Munshi Tudu did that!' What greater reward is there for an artist!

The Santals, along with their sister tribes, have the largest repertoire of poetry, songs and dances among all our tribals. The ultimate expression of their joy is in their dance. There can be no one living close to the land of the Santals, who has ceased to be thrilled by the beat of their drums rising above the silence of an evening, broken only by the cicadas and the wind whispering amongst the sal leaves. It is an invitation to the dance, an invitation to sharing the pleasures and gaiety of a communal life. I have often responded to the distant sound of drums in our tribal forests, and have marched long distances, as though under a spell, just to be present at a dance.

Chotaramu, who was well above sixty, walked tirelessly from house to house, from one village to the next, while I, then only in my early twenties, was soon footsore and ravenously hungry. In any household we entered, the first question he would ask was, 'Have you any of the red?' The 'red' was the undistilled, home-brewed mohua wine for which he had a special fondness. If there was none, he would be provided with the white—the distilled mohua spirit which was not home-made but procured from licensed distillers.

It is a pity that the government allows these licensees to get rich while penalizing the poor tribals for their addiction. For them, moderate drinking, indulged in to some excess only during festivities, is a part of their way of life. It promotes sociability, provides much needed nutrition to a poor people surviving on extremely inadequate food, and relieves the burden of the distress created by their exploitation by outsiders who do not even try to understand them. These licensed vendors often sell them adulterated and poisonous hooch. Of course, they have the good sense to distil it themselves illegally whenever they can, but it means bribing the police regularly, and all told, it does not come cheap.

See pages 32–33:
A mural outside a Ho hut painted by a tribal.

Facing page:
Oraon young man with his pet monkey.

Mohua trees grow abundantly in the tribal country from Bihar to central India. Its fruits and flowers ferment by themselves and the forests smell of mohua wine. During the mohua season, bears eat the ripe fruits and get blissfully drunk. I have found an entire family of bears, including baby bears, sound asleep under a tree. 'Poor chaps! They are drunk', the Santals say and they never shoot or hurt them then.

I hadn't drunk the fruity mohua wine earlier, but after partaking a great deal of the libations offered to the headman and myself, I walked merrily arm in arm with him to the paddy-fields at the edge of the village to photograph the harvesting activities. Noticing my youthful preference for photographing girls, Chotaramu said, 'If you want to photograph our prettiest girl, don't waste too

Santals practising archery.

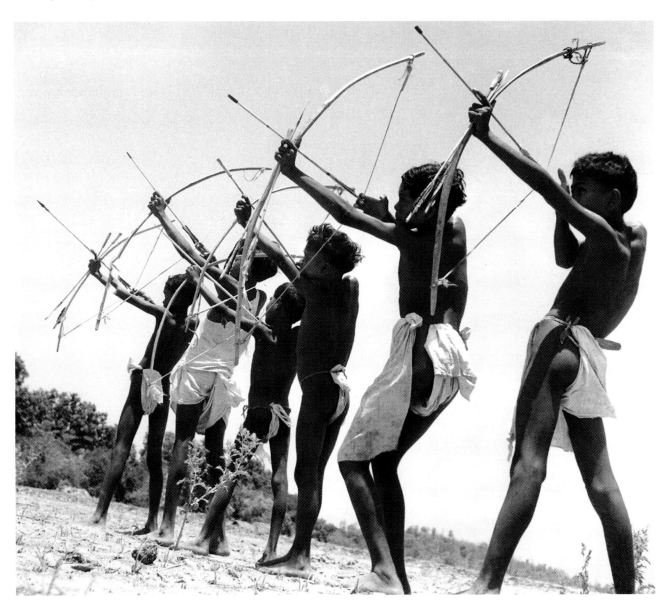

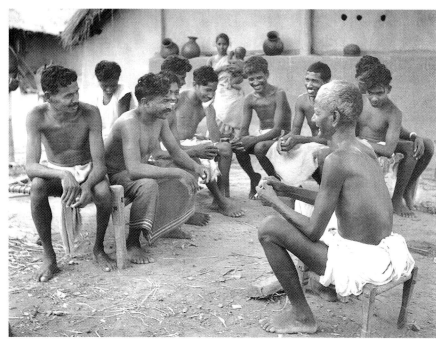

Chotaramu Murmu, talking to young men in his village.

Courtyard of a Santal household.

much of your time here. She is in the forest cutting wood. You will make me a sad man if you go away without taking a photograph of her.' None of the girls I was busy photographing, resented the old man's words. 'Yes, she is beautiful. Go with him, and find her before the sun goes down', they chorused. So we did find her after a three-mile walk. I photographed this belle of the village with a load of firewood on her head, lit by the glow of a setting sun. The following morning, I found that Chotaramu had detained her and her equally lovely sister, a child in her early teens, to be photographed again, lest their beauty which he took such a grandfatherly pride in, went unrevealed to the world.

The Oraons, the Hos, the Mundas and the Bhumias are sister tribes of the Santals and are of the same sturdy build, in contrast to the small-boned Gond tribes of central India, although they belong to the same ethnic group. They inhabit the forest country around Ranchi, Jamshedpur, Chaibasa, Jharsuguda, Sambalpur, Keonjhar and Baripada, and the townships of Hirakud and Rourkela in the border regions of Bihar (now Jharkhand) and Orissa. This area is rich in mineral wealth—coal, iron ore, mica, manganese and bauxite—and within it lies India's only copper mine.

The collieries were the first mines to come up in this area and the tribals began to be recruited as mine labourers. Their love of freedom and the 'claustrophobia' they consequently suffered did not however, make them good underground miners. The Bihari labourers found greater favour with the employers. But the surface workers, engaged in carrying basket-loads of coal from the pitheads to the railway wagons, were mostly tribal women, until in some of the larger mines, these operations were mechanized.

A vast industrial complex, beginning from the jute mills and the engineering industries around Kolkata, now extends up to the steel plants and other industries at Durgapur and Burnpur. Numerous new townships have sprouted around the factories, the power plants and the collieries of Dhanbad, Raniganj, Jamshedpur and Rourkela, and have reached out to some of the remote hinterlands of the tribes, changing their lives rapidly.

However, being numerically large among the tribal groups, these tribals have not yet been swallowed up and entirely assimilated. The structure of their rural, agricultural economy has not been disrupted by their migration in large

numbers to work as labourers in the new industrial enterprises. The new ways of life are not compatible with the simplicity they have inherited from a basically cooperative and non-competitive tribal society. I photographed them often during the hours after my industrial assignments, taking excursions away from the sites to nearby villages. Very often, the contrast between these simple folk from the forests and the structures and symbols of modern industry in which they were employed made interesting pictures. I remember photographing Ho girls and young men against a truck they were unloading for the Hirakud dam project. It was all in the day's work for me, to seek out and photograph the Oraons, Mundas and Santals in mines, steel plants and factories, and to pursue them into their nearby villages. I followed up the acquaintances I made in the work-sites and found much joy in going to their villages. But I always felt a twinge of pain to find their primitive but superior ways of structuring human relationships giving way to our so-called 'advanced' way of life.

Below right:
Blacksmiths in a Santal village.

Below left:
Munda girls operating their dhenki—a home-made rice threshing machine (the Mundas are a sister tribe of the Santals).

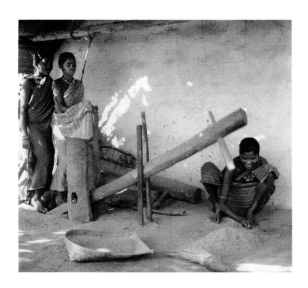
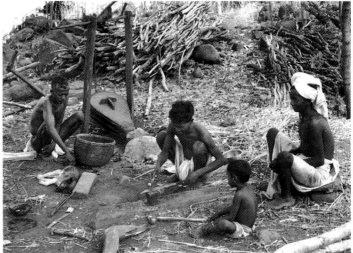

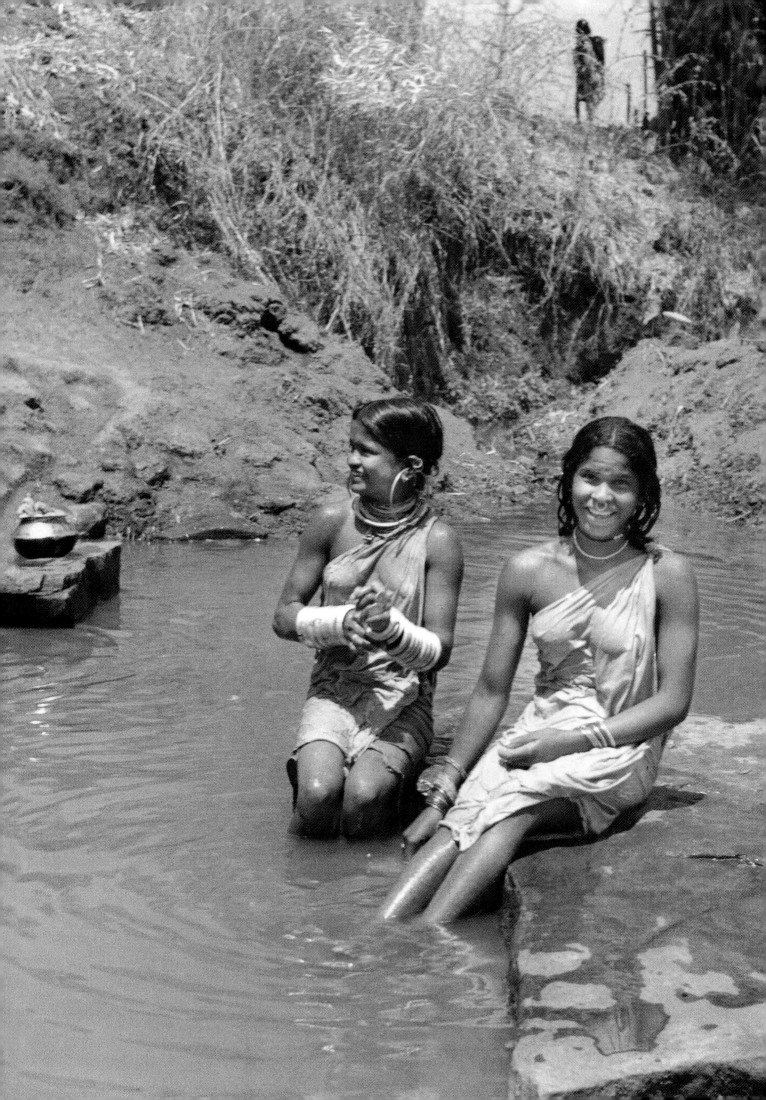

THE GADABAS:
THE PEOPLE OF THE GREEN RIVER

Between the arid brown hills of Koraput district in Orissa, a narrow valley of terraced paddy-fields winds along like a green river. So startling is this lush green against the barren landscape, that the tribe which cultivates this valley cannot fail to arouse the traveller's curiosity. Yet the Gadabas are one of the few tribes in India about whom little has been written. In one lavishly produced book of colour photographs published in France, the Gadabas occupy one chapter which contains only photographs with captions, and a Gadaba legend; it gives little information about them. Dr Verrier Elwin, who visited the tribe, has made only occasional references to them in his works. Considering that they live in accessible areas, this neglect seems unaccountable. It is possible that they are not remote enough to be fascinating.

Like all tribal people, the Gadabas are shy but they cannot be called reticent. They love to talk and if it is about themselves, most of it will be sheer invention. One has to winnow out the truth from an astonishing mass of fiction.

The Gadaba lets his fancy spin a story as he talks, and it can be a different story another day, in answering the same question. It is hard to explain what motivates him to do this; perhaps he is gifted with a kind of imagination which revels in fibbing ad lib—something civilization has now quite forgotten to appreciate.

When you approach a Gadaba village, you are given a touching reception. Groups of women meet you with platters of moistened rice with which they

Facing page:
Gadaba girls bathing in a stream.

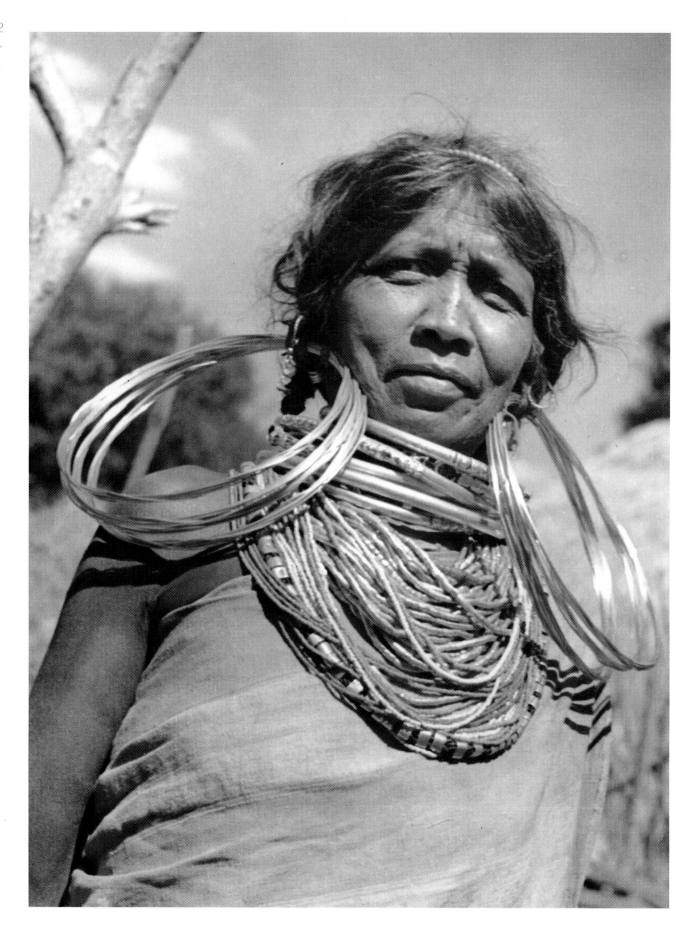

liberally plaster your forehead. You fold your hands and they bend down to touch your feet. Then everyone stretches out a hand and you are expected to give them small sums of money which, when added up, becomes a substantial amount. If you wish to be accepted by them, you must make your contribution justify the welcome you get. But then, unless you have unlimited resources, this discourages you from visiting more than two or three villages!

Gadaba villages are enclosed by walls of rough-hewn loose stones or are fenced with bamboo wicker-work. Their mud huts with thatched conical roofs are within the enclosed area, and similar fencing surrounds the compound of every house. There are no gates; only the fence is a bit lower where a gate should have been. These stiles keep animals out, and steps on both sides of the fence help people in climbing in and out easily.

Every village has its *Sadar*, the Village Council-house, which is usually just a rostrum, under the shadiest tree in the village, with large flattish stones

Facing page:
An elderly Gadaba woman wearing her enormous earrings and necklaces.

Gadabas in their Sadar.

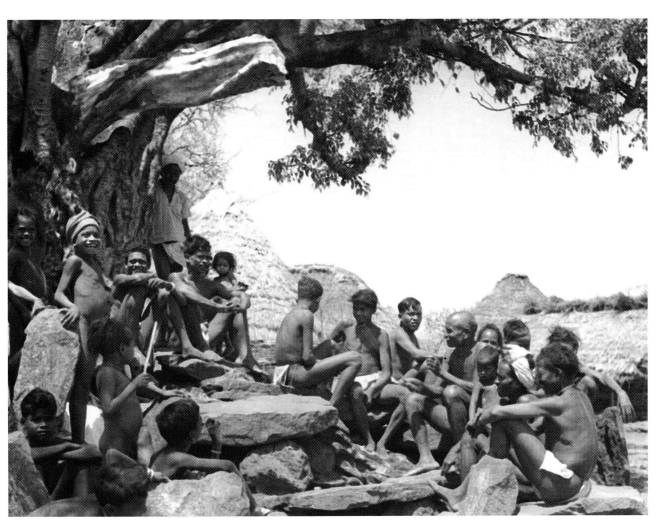

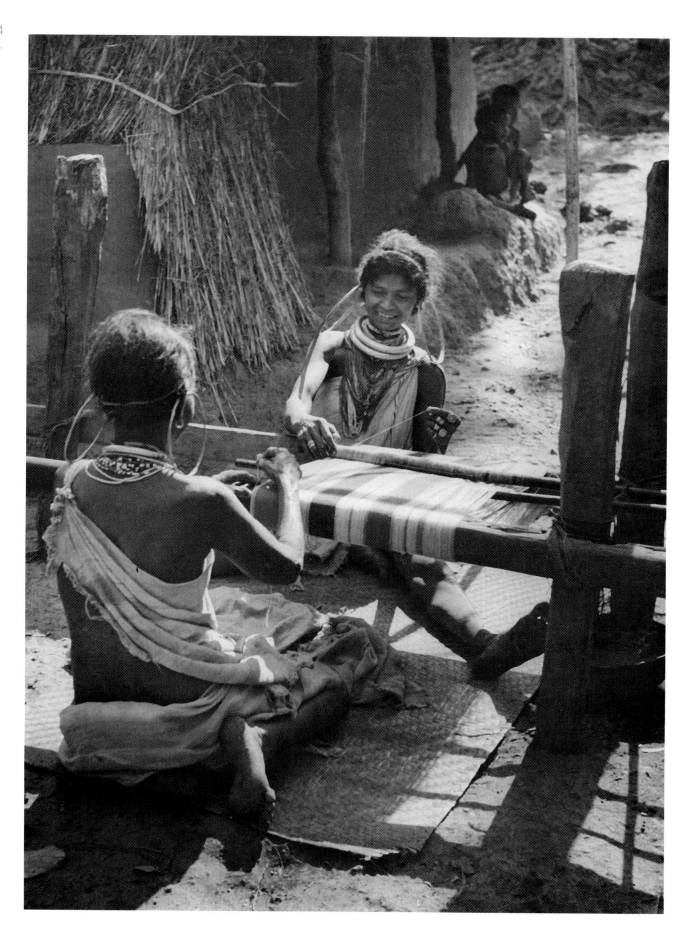

to serve as seats. Here, the elders assemble, and with much noise, spitting and tobacco-chewing, rule the village with undisputed authority. All ceremonies and sacrifices also take place near this Gadaba parliament, thus elevating the spot to the level of sanctity.

After a period of initial distrust when you get acquainted, you earn the freedom to visit their homes. You can then roam about, or sit in their porches and watch the women weaving their striped multi-coloured *kerangs*. There will be a great deal of noisy conversation around you, but you need not be alarmed as the Gadabas never talk, they shout. You may expect them to come to blows any moment. But all the pushing and jostling is in fun: just the excitement of living! Even the dignitaries of the village, shrivelled old men, will wrestle with vigour and roll with laughter at every fall. It is always noisy in Gadaba country. The people laugh and argue; the looms rattle, and the farm-animals make noise, and then the drums and the dancing continue till late at night.

The clothes the women wear are also loud—broad stripes of blue and vermilion on the white kerangs and masses of jewellery—large silver bangles which cover their entire arms, great loops of brass on their ears and loads of bead and silver necklaces. Unfortunately, the kerangs are disappearing; I could not buy any, for very few were woven those days. I was told that they could not obtain the herbs with which they made the dyes. An over-zealous Forest Department prevented them from collecting those plants.

The girls dress up with great care, washing and doing their hair in keeping with their elaborate trinkets. Giggling at boys is their favourite occupation and the boys respond with gallantry. They collect rings from the girls as souvenirs which are sought with great ardour. A boy who has twenty brags to those who have only fifteen. These rings are given only as tokens of accepted admiration and are not exactly symbols of conquest.

The Gadabas are excellent dancers and some of their group dances are the most fascinating in tribal India. The kerangs on the girls make a riot of whirling colour. The dances are very vigorous and have difficult steps which take many years to perfect. The Gadabas love to dance and never seem to tire of it.

Most of the musicians in Gadaba villages who are constantly needed at the dances and festivals are *doms* by caste and do not belong to the tribe. But they live in these villages and are usually the intermediaries between the villagers and

Facing page:
Gadaba women at a loom weaving their striped kerang, Orissa.

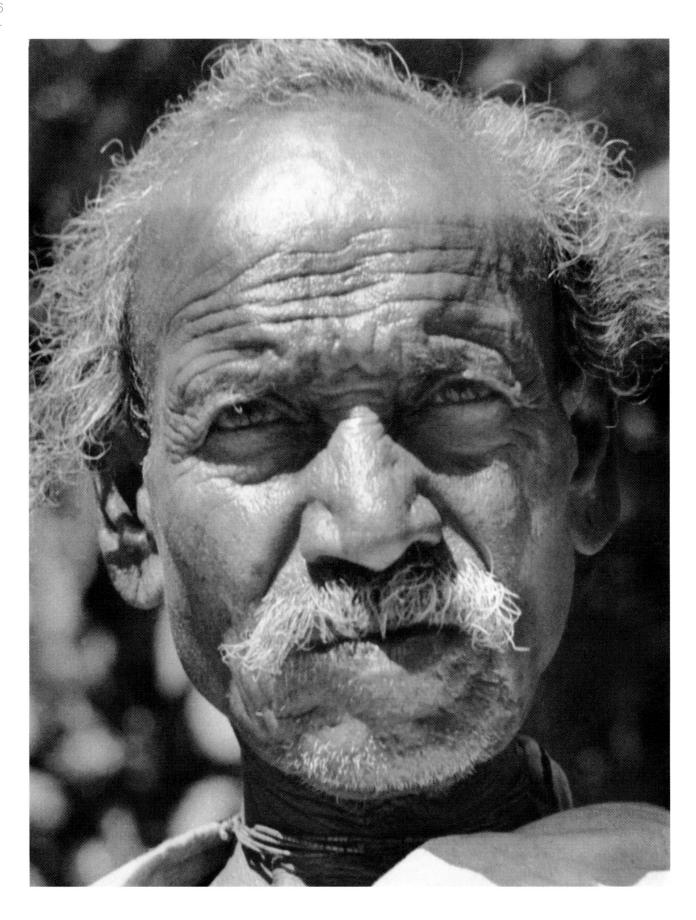

Facing page:
A Gadaba village headman.

Right:
The Gadaba 'green river',
paddy-fields in the valley, fertilized
by the top soil washed down by rain
from eroded hills, Koraput,
near Orissa.

Below:
Gadabas dancing.

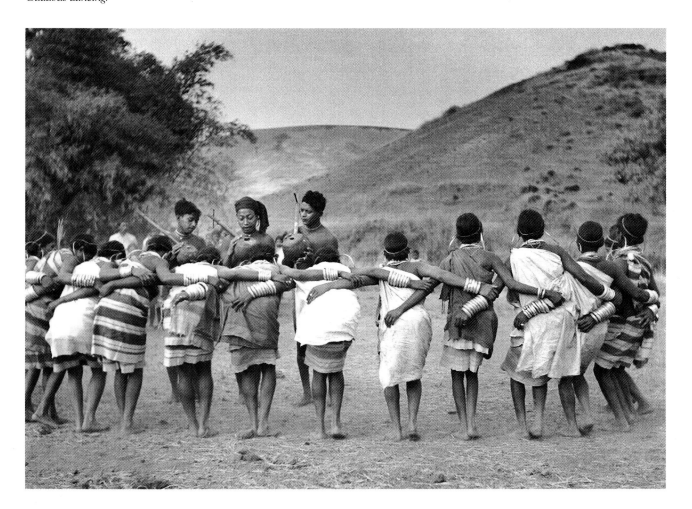

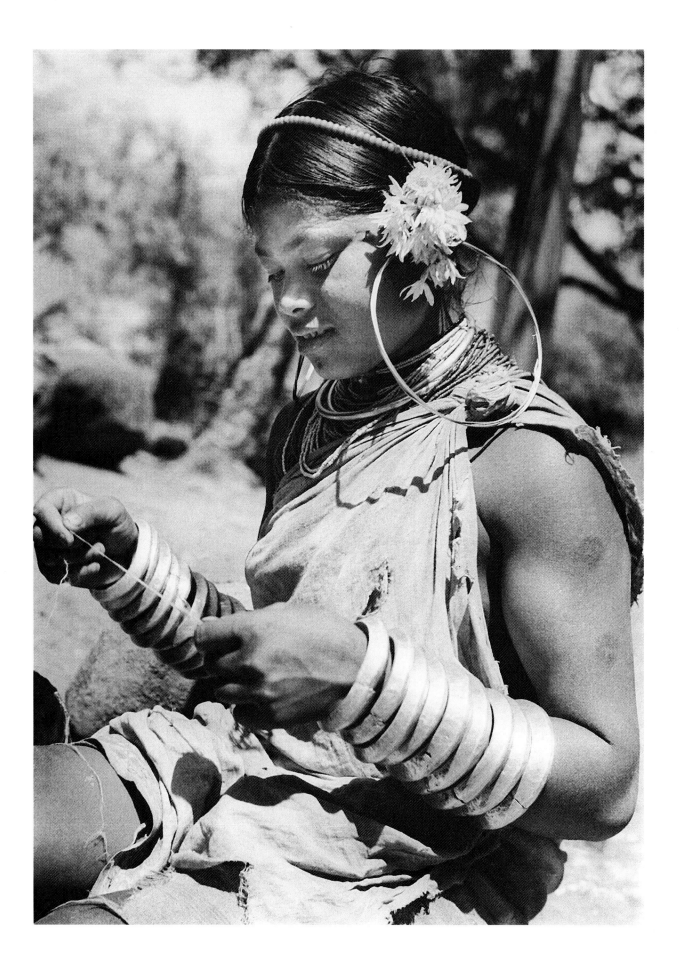

the outside world. As such, they are in a position not only to extract money from the Gadabas, but also to dominate them in many other ways. They participate in all their tribal festivals as do the neighbouring but rather colourless tribe of Parengis. In these festivals, bulls and buffaloes are sacrificed and there is a great deal of feasting and drinking of rice-beer, and of course, continuous dancing.

All this gaiety is hard-earned, for like most tribes, the Gadabas have a difficult life. Everyone goes to work from a very early age. While the boys work in fields or graze cattle many miles away, the girls are busy with spinning and weaving and also their domestic chores.

The Gadaba paddy-fields are very carefully terraced so that the water which drains down the denuded hills during the monsoon flows along the terraces instead of forming a rushing stream which dries up as soon as the rains cease. At one time, the hills surrounding this country were inhabited by the Kond tribe, who practised only *jhum* cultivation by burning the hillsides and

Facing page:
A Gadaba woman.

Below:
Gadaba village, showing typical cone-shaped huts.

sowing on the cracked earth. This gradual deforestation without any protective terracing soon eroded these hills and rendered them barren. The Konds withdrew into the interior jungles, while the Gadabas were the beneficiaries of the soil deposited in their enchanting green valley of the dead hills.

The Gadabas, to a certain extent, have already been influenced by Oriya customs. Now a hydro-electric station has been built at the lovely waterfall at Machkund and a project township has grown, connected by new highways to Koraput right across the Gadaba country. Civilization is coming too near them to leave the pattern of their lives undisturbed. Very soon, the Gadabas will perhaps be indistinguishable from their neighbours.

Facing page:
Gadaba girls in front of their hut.

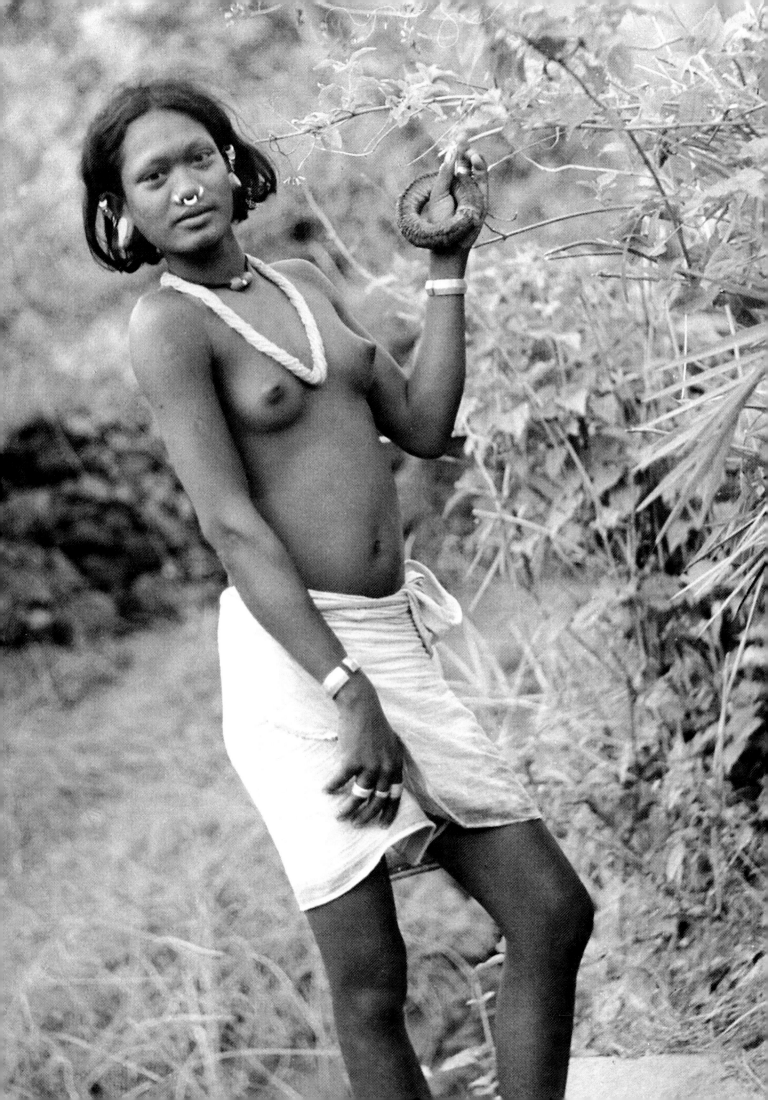

THE SAORAS OF ORISSA

Professor Karl Gustav Itzikovitz, who was the head of the Department of Anthropology at the University of Gottenburg in Sweden, came to India to work on some of our tribes, and the first man he decided to see was Dr Verrier Elwin. Verrier promptly suggested that he should go to the Gadabas—a tribe, so far, untouched. I was there when they met. I liked the man the moment I saw him. He was a big, robust and jovial scholar with a volatile temper which subsided quickly after each explosion. So when he suggested I accompany him to take some photographs and make a short documentary film for him, I agreed immediately. We spent three eventful weeks among the Gadabas, and he decided to visit the neighbouring Saoras in the Parlakimidi hills in Orissa. We had heard about a Miss Monroe who ran a Christian Mission among the Saoras. Prof. Itzikovitz had received an invitation for both of us to stay with her during our work among the Saoras. Although she, like all missionaries, wanted to convert the Saoras to Christianity, she did not, in any way, interfere with their usual lifestyle by imposing unnecessary puritanical restrictions on their way of life. She had done a great deal to help them by establishing a hospital, a maternity home, child welfare centres and schools. But she did not try to dress them up or persuade them to abandon their customs and their dancing.

We got out of the train at the Palassa Railway Station, close to the Andhra Pradesh border, and had a comfortable ride in a station-wagon up to Parlakimidi. Beyond it, a rocky track wound up the hill to Saora country, and heavy lorries

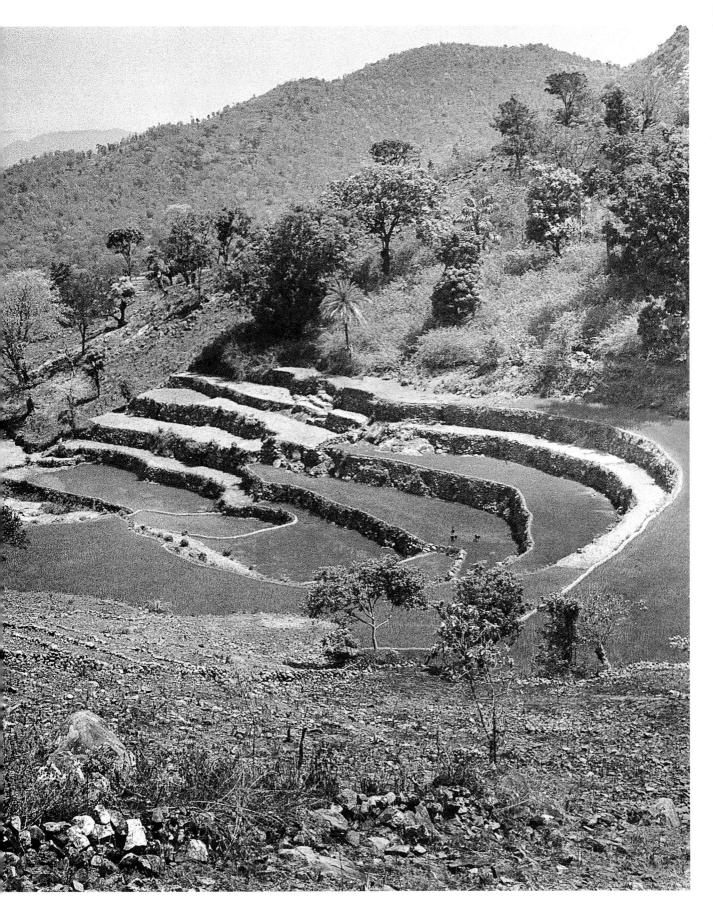

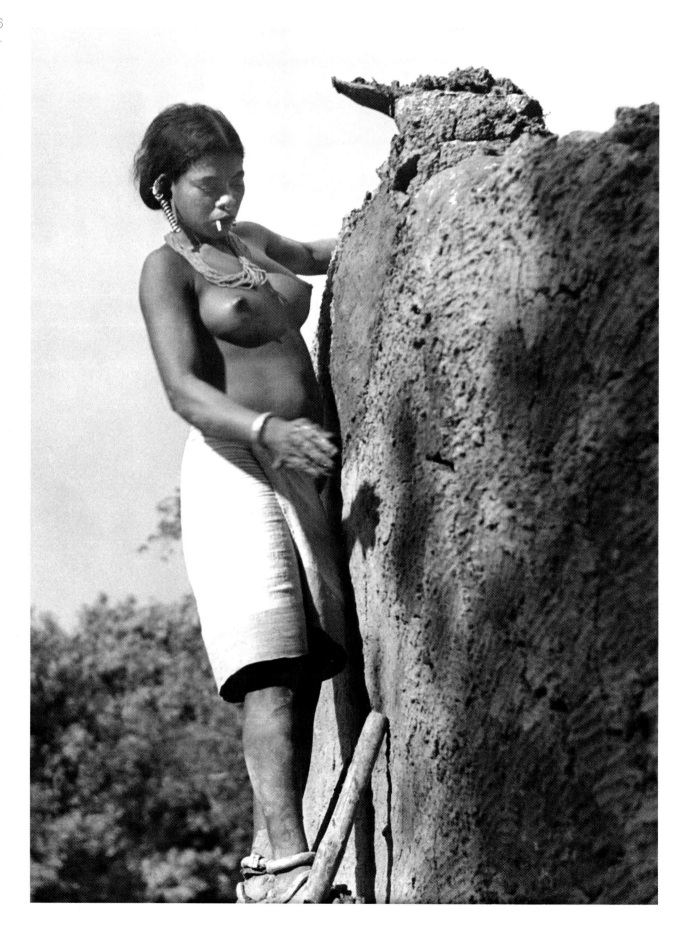

could not get beyond the forests in the lower altitudes. Only a jeep could venture up the hazardous track to the top of the hill, where the mission was. We were greatly relieved to find that Miss Monroe had thoughtfully sent us a jeep to fetch us from the bus station. The driver had little difficulty in locating us in the small town of Parlakimidi, as one of us was a foreigner. Before we started, he sat still at his wheel and quite audibly sent up a long prayer to Christ and Mother Mary in his native Oriya, saying that although he had gone up this dangerous road many times, by the grace of Mary and Jesus, he had always been able to reach Sarango safely; this time too, he was praying he could take these two Sahibs safely to his Memsahib. When we began to climb, we realized that such earnest solicitations for divine aid were entirely justifiable. Never had I been on a worse road in my life. Precariously hugging the edge of the hill, it was full of boulders and deep pot-holes and at places climbed almost vertically. The turns were tortuous—down one minute, then uphill again and it was a miracle that we did not tumble downhill at any stage. It was almost evening when we reached Sarango, where we found a properly constructed wide road. The Mission house was clean and tidy, with the school, hospital and dispensary around it. Large areas had been levelled and made into vegetable and flower gardens. Miss Monroe greeted us with a warm smile.

Till then I had never availed myself of the hospitality of religious missions of any kind in the tribal country. Most often, they were obstacles to our kind of work. The dubious benefits of their doctrines among the tribals were overshadowed by the cramping of their ways of life which interfered with their naturalness, simplicity and innocence. But here, amongst the Saoras, we found that Miss Monroe's missionary organization had not tried to reform them by banning their very few pleasures—dancing, singing or their moderate habit of drinking their own home-brewed wines. Nor had she tried to clothe the semi-nude Saora men and women.

Saoras have been known for a very long time in India's legends and history. The story of Savari in the Ramayana is known to every Indian. Savari, a tribal girl, waited from her childhood with the offerings of fruit she collected every day for a visit of Rama she had dreamed of. Her desire was fulfilled in her very old age when Rama, during his exile in the forest, came and partook of her devoted offerings.

See page 54 left:
Saora village deities on the road to ward off evil spirits, Orissa.

See page 55 right:
Terraced paddy-field in the Saora country.

Facing page:
A Saora woman plastering her hut with mud. She stopped her work to ask me for the cigarette I was smoking; and then carried on with her work taking no further notice of me.

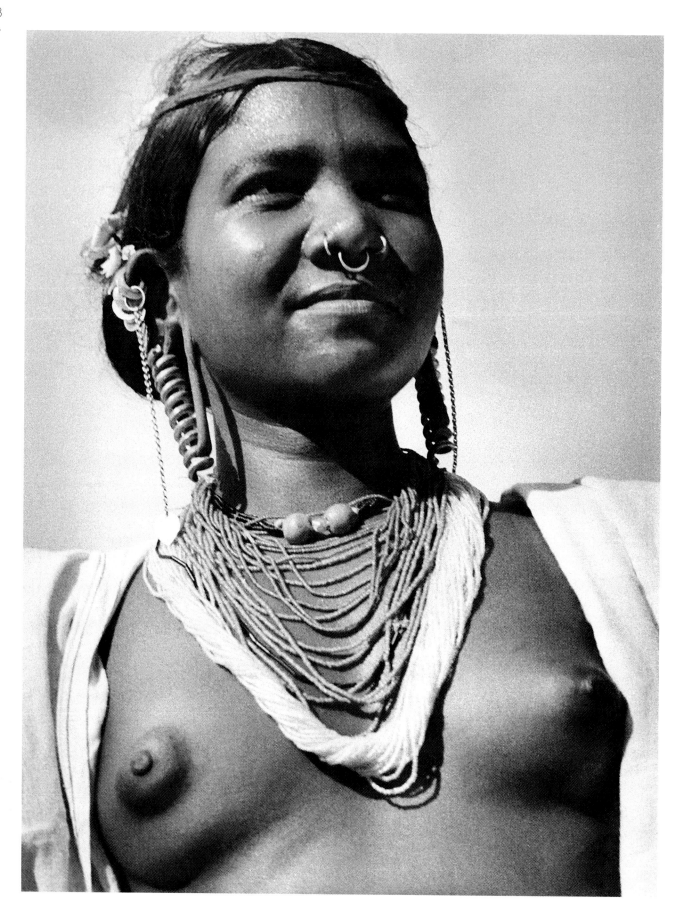

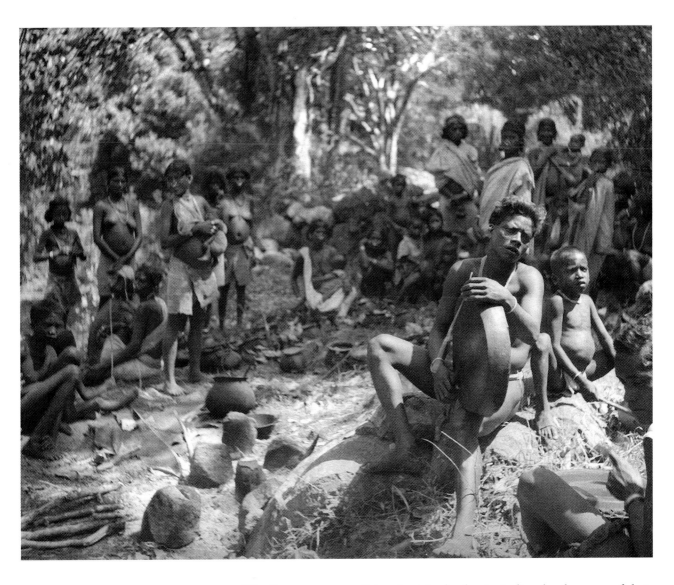

Top:
Saoras performing Pur-Pur,
Orissa.

Facing page:
A Saora girl in dancing dress.

The Saoras are one of the aboriginal tribes in India who, because of their continuous contact with the Indo-Aryan conquerors, have left unmistakable traces in the cultural life of the Hindus in Orissa. The literal meaning of the word *Saora* in Sanskrit is hunter or forest dweller. Legends claim that their kings were once the rulers of Orissa, until they were driven out by the northern invaders into the forests in the hills. Some of the principal religious cults of Orissa today bear the imprint of the Saoras. The worship of Jagannath could be traced to a Saora king by the name of Basu from whom priests, sent by a Hindu king, learnt the rites. In the great temple of Jagannath, the 'Lord of the Universe', on the beach at Puri, the descendants of Basu still enjoy certain privileges. This temple is the only one in India which admits people of all castes, creeds and colours, including the so-called 'untouchables', which most of our tribals are. In the

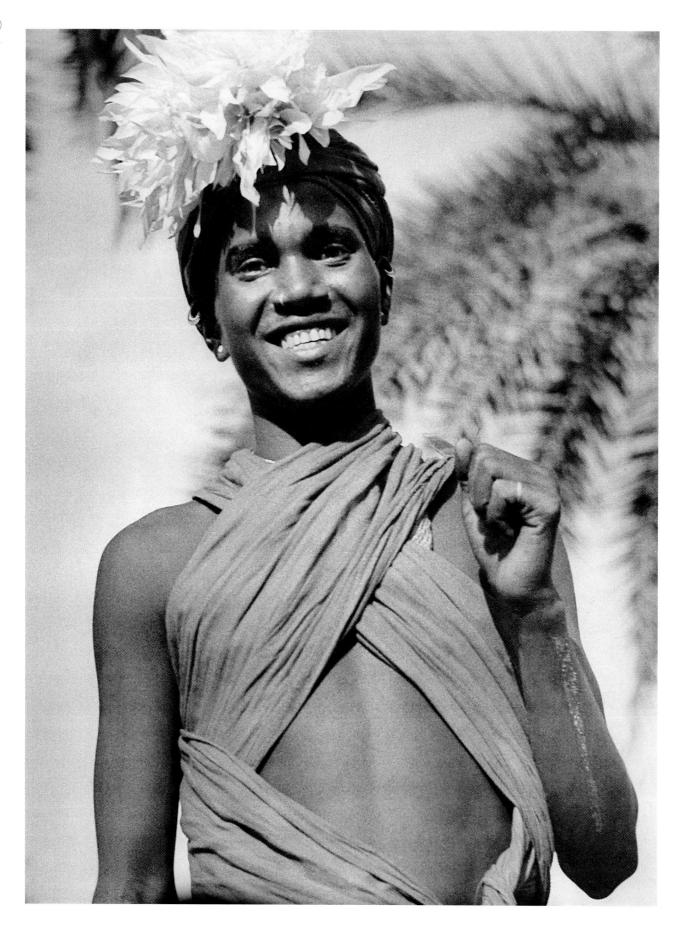

fabulous Sun Temple at Konarak in Orissa, I have seen hairstyles and ornaments, particularly of the ear and nose, which are exactly like the ones worn by the Saora women even now.

Their rock-bordered hill terraces, and methods of diverting streams to water their terraced fields demonstrate highly developed engineering skills in a primitive agricultural community.

Despite these engineering skills, their lives are unhappily dominated by a great deal of superstition and fear, a retrogression to their pre-agrarian culture. One cannot wander through a Saora village without finding small groups of people sitting around doing their day-long *Pur-Pur* rituals, placating the gods and the evil spirits of their villages and forests. Various kinds of food offerings in little leaf-cups are laid around an altar. Three priests swaying to the beat of drums chant *mantras* for hours to drive away the evil spirits. At the village crossroads one comes across miniature huts thatched with straw, all of which are shrines of gods guarding the people against devils. Crude wooden idols of these gods with their stumps fixed to the ground, abound in the villages as well as on the forest tracks, to keep evil spirits away. A vague fear overshadows their lives which makes them melancholy and introspective, in sharp contrast to the usual gaiety and carefree laughter of the people of most of our tribal villages. There is much less sexual freedom among these tribals. However, during our visit, when

Facing page:
A Saora youth dressed for dance,
Parlakimidi, Orissa.

Below:
Saoras dancing.

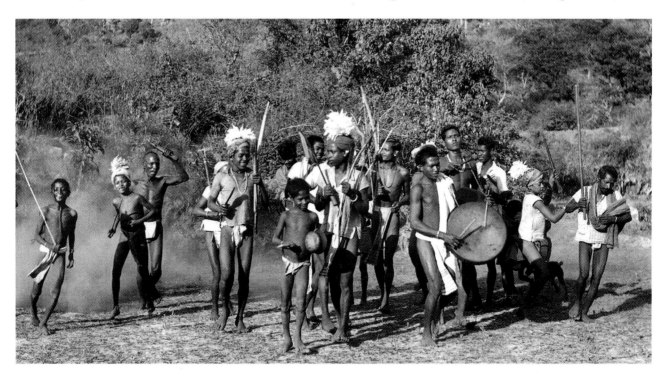

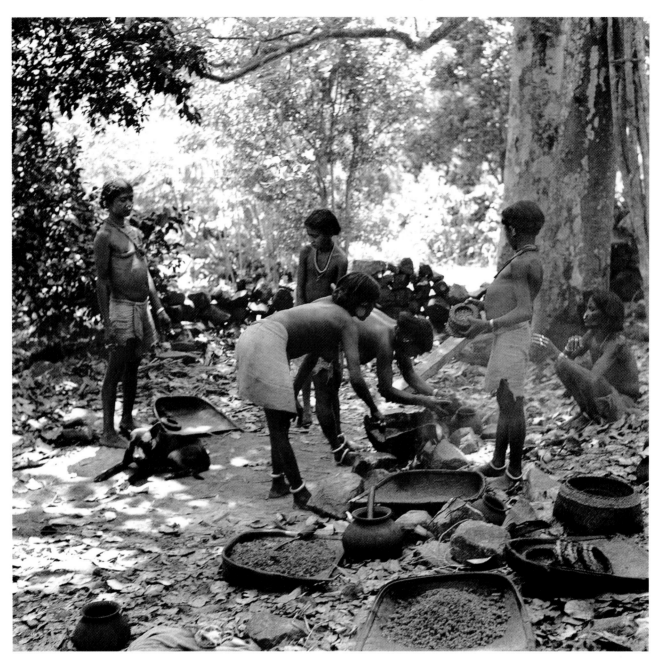

Another view of the Pur-Pur ceremony.

we recorded their music and played it back to them, they roared with laughter at the erotic passages and the young men and women kept coming back to us to listen to these recordings.

The greatest achievements of the Saoras are the laboriously built terraces on the hills. These terraces are supported by blocks of solid stone and it must have taken the labour of generations to build them. The stone lining of the terraces lasts for decades and is constantly repaired in order to preserve the surface soil of the rocky hills. In the Gadaba country, I have seen the hills made barren by the jhum cultivation of the Konds, the loose soil being washed away by

rain. Not far from these barren brown hills, the Saora hills remain perennially green. No one knows who taught these primitive tribes to preserve their only wealth, the soil. However, despite their labour and intelligence by which they have made their land cultivable, they are still no less poor than the other tribes. They have to buy things they do not produce and the little money they get from selling their surplus crops and vegetables is not enough. The laws of the Forest Department also interfere with their old ways of life, restricting the cutting of wood and hunting of animals in the forests. It is only because of their comparative inaccessibility that they have managed to retain a separate identity as one of India's oldest tribes.

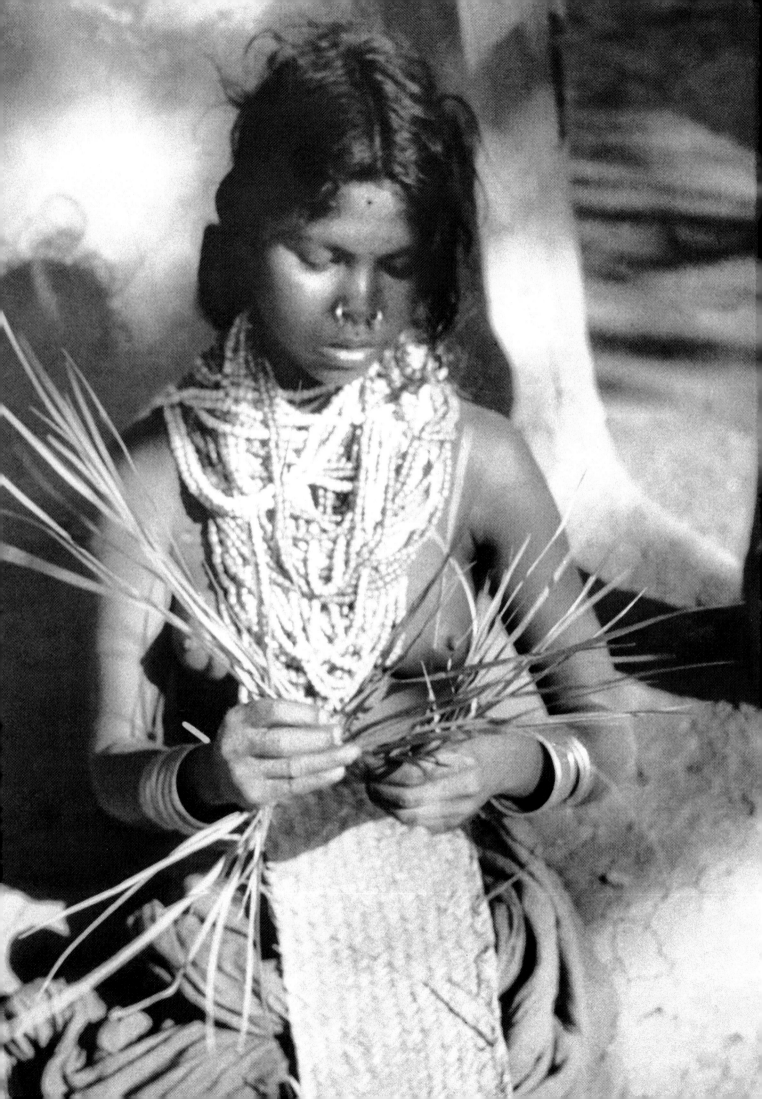

THE LEAF-CLAD JUANGS

Looking at Verrier Elwin's photographs of the Juangs of Orissa, which were mostly processed and printed at the photographic establishment I had in Kolkata at that time, I had made up my mind that I would take the first opportunity to visit them before this very small tribe became extinct. I got the chance in an unexpected way. I was commissioned to photograph the collieries and iron ore mines owned by Bird & Co., a British firm based in Kolkata. All these mines were located in the tribal belt in the border regions of Jharkhand and Orissa. I happily accepted the assignment knowing that it might give me an opportunity to visit some of the tribes and perhaps even the Juangs.

I viewed all executives of mercantile firms with deep suspicion. It was not allayed when I first met the tall, aristocratic moustached Englishman stepping out of his air-conditioned compartment to meet me on the platform of Jamshedpur's railway station. We became good friends later, but that is another story. He was to direct me about all the photographs needed, as he was in charge of the mining department of the company. In the car during the sixty-mile drive to his iron-ore mine, I found out that his father, who was a sculptor known for his pieces in one of the public places in London, had also done some of the British proconsular statuary lining Red Road across the *maidan* in Kolkata. Noticing the gleam of interest in my eyes every time we passed the tribals working in the fields, he asked me whether I had ever photographed them. He confessed that his job interested him mainly because he found these people fascinating.

Facing page:
A Juang woman weaving a basket, Orissa.

A friendship which developed quickly led me to suggest later on, that we could perhaps visit the little-known Juangs who lived close by. He happened to know an American who had sought his help to work among this tribe for his Ph.D. in Ethnology. The rest was easy to arrange. One of the company's jeeps was to take us across a distance of a mere 150 miles on a good road from the mines, after which we would branch off on rough roads to the interior up to the village where this American had installed himself. The journey, in which my wife accompanied me, was not without incident. Monsoon clouds were gathering darkly overhead when we left our mining camp and the rain came in blinding torrents as we progressed slowly through the hilly terrain. When we took what the Americans call a dirt road from the asphalt of the highway, the rear wheels of the jeep got stuck in the mud in a pot-hole. The driver, a Bengali, came out with a string of profanities and his exasperated efforts in trying to get the wheels out of the hole were as ineffective as his prayers and curses were. It was getting dark and curious villagers began to assemble around us, willing to help, but not

A Juang tribal village, Orissa.

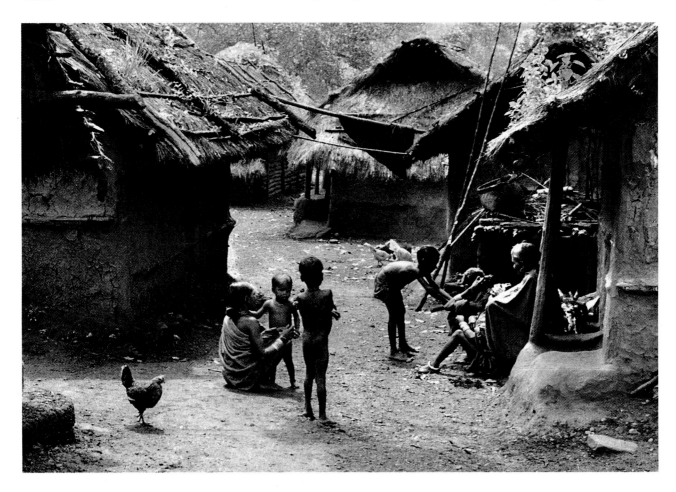

knowing what to do. Pushing us out of the ditch needed the strength of a battalion and we could count about fourteen heads, including five children. Eventually, a stout branch of a tree was cut down and used as a lever to raise the rear wheels, the front-wheel drive pulling us out into mobility. We were drenched in the rain and plastered with the mud flung about by the wheels while we were trying to push the vehicle. The twenty odd miles we now had to drive through seemed too formidable as it was pouring. We did not want to go back after getting so close to the village we had planned to visit.

It was drizzling when we reached an embankment, half a mile away from the village, beyond which there were no roads. The young American was there with two of the villagers, waving a flashlight at us. He didn't seem to mind the three hours of waiting. As we found out later, being a Calvinist he would willingly suffer what fate handed out to him, but would stand nothing contrary to his principles. When we reached the village, we found that his leaf hut had ankle-deep water in it. We took shelter in the community house. The smoke of the log fire burning there nearly suffocated us. We laid ourselves down in the open front porch; the leaf thatching was adequate to protect us from the drizzle. The rain stopped soon after we had finished with the courtesies of introduction, and had eaten the sandwiches we had brought along.

It was a fresh, bright and cloudless morning when we woke up. We brewed our cups of tea in a kettle provided by our American friend. The presence of my wife made it easier for us to go into the village. We had no interpreter, but having a woman with us seemed to assure them that we were not dangerous. The

Top:
Juang drawings on a wall.

men spoke reasonably good Oriya, which for a Bengali was easy enough to understand. Coming from a district of Bengal, bordering Orissa, I could manage to speak broken Oriya to make myself understood. We got along excellently, delighted by their welcome and their acceptance of us. There was a small clear stream running through the village on a bed of pebbles. Children splashed about in its shallow water, women bathed and washed clothes and utensils, while the men took quick plunges, scrubbed and dried themselves, and sometimes came up to us for a chat.

It was very pleasant to sit under the shade of an enormous banyan tree, lazily watching the ripple of water over the semi-nude brown bodies, and occasionally taking a photograph. I was told that trekking a few miles uphill would take us to a *gomukh*, the source of the stream. The gomukh was a small cave shaped like the head of a cow from the mouth of which emerged this stream. Next morning we packed our lunch—boiled chicken, rice and onions—in a basket and set off on the trek. No one was around when we reached the place. Our clothes were sweaty after the hot, arduous climb. We took them off and plunged into the clear water for a swim. Some Juangs collecting firewood appeared unexpectedly. Instead of fighting shy of us, they gathered round to

Juang young men spinning cotton.

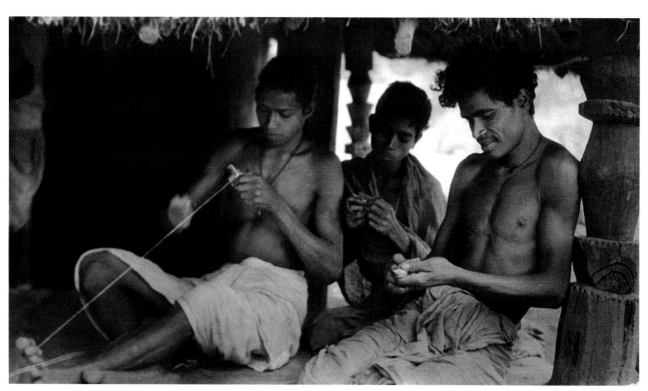

watch us with merriment and tried to push each other into the stream. Three of them, two young men and a girl, stripped and splashed in to join the fun. No one minded when I got out of the water to take some photographs. This would be unthinkable anywhere in India except in these tribal havens of naturalism.

Orissa has abundant mineral resources. Its harvests of grain from the fields, fish from the sea, timber and forest produce from its hills, and its tourist attractions should have been enough to create a thriving economy. But unfortunately it remains one of the poorest states of the Indian Union, and this remote tribe is certainly among the most impoverished of its people. The barren, unirrigated soil, with the scarce rainfall produces no substantial crops, nor does it favour the growth of enough fruit trees in the forests. Wildlife has become almost extinct thanks to the 'hunting licences' and the illegal wildlife trade.

The food the Juangs lived on was mostly edible roots they dug out, the sparse grain from their arid fields, and the few fish they could catch in their fast streams. Nevertheless, they organized a big feast for us on our last night with them. We had asked the headman to buy two pigs and several pitchers of mohua wine from a nearby licensed distillery as our contribution towards the feast. He refused even to hear about our paying for the rice and the vegetables. While we were talking that evening, he said: 'Do you not know that the *sat,* the truth, that lived amongst us, left us when we were forced to abandon our leaf dress to wear this woven material? We have to wash and preserve these, but the leaves we could discard any moment. Leaves dry up and crumble. It is so with all things in our lives. Why should we want things other than what we need in order to live? If you buy for us what we cannot offer you, it is all right with us. But should you refuse to accept what we can give ?' I was deeply impressed by this illiterate, poor Chief's wisdom and quiet dignity.

Verrier Elwin had photographed the Juangs only ten years earlier when they wore nothing but leaves strung together around their waists. This garden of Eden disappeared when Block Development Officers arrived, and merchants initially distributed clothes free, thereby establishing a market. The older Juangs detested clothes. 'We can make some leaf dresses tomorrow', the headman told me, 'and you can photograph us as we were.' Nothing could have

pleased me more. But we made the mistake of telling the American student about this. His sense of propriety soared to indignant heights: 'What do you think you are doing? I have to live and work among these people for three more months and if the government learns about this obscene display you are contriving to arrange I may be thrown out as an undesirable alien.' I tried to argue with him calmly, saying that I knew our tribal people much better in the thirty years of my intimacy with them, than he could possibly have learnt. Not only would they not resent wearing their leaf dresses once again, but it would be for them a kind of celebration. It was useless for me to argue. He was too rigid. He had even forbidden the buying of any mohua wine for the feast that night. But necessity prevailed and later in the evening they readily agreed to let our driver take the jeep with two men equipped with two pitchers large enough for the drinking needs of the adults in the village. The modest feast consisted of barbecued pig, boiled rice, wild roots, potatoes and a very pungent variety of horse-radish.

We had planned to leave the village by mid-day. Before we could, the women, very pleased with my wife for having danced with them, decided to do up her hair

Juangs washing in the village stream.

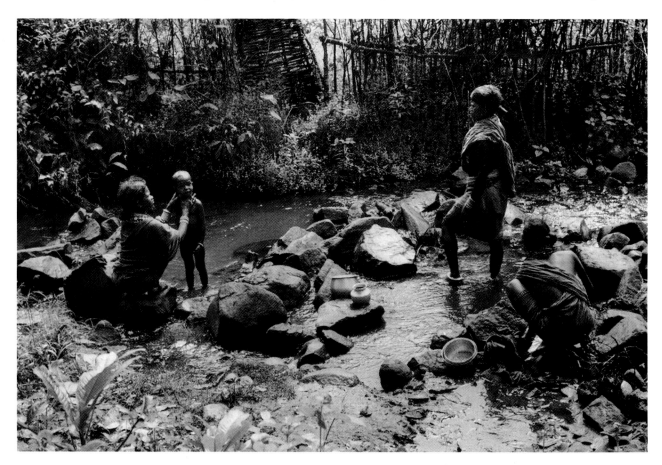

Juang style. The strong odour of the oil which they rubbed into her hair, was not particularly pleasant but the fragrance of their affection was. When my wife emerged with her hair oiled and plaited, dressed like them and adorned with their ornaments I could hardly recognize her. It seemed that I was looking at her as she might have been when the world was young.

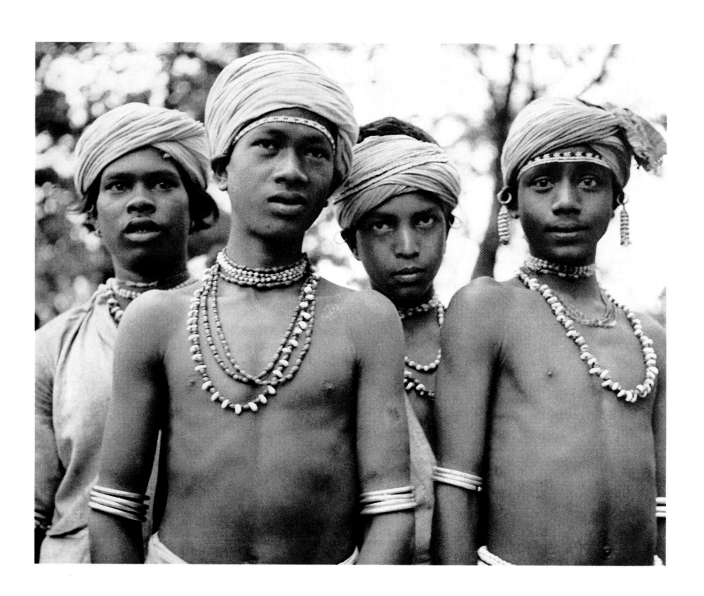

2

CENTRAL INDIA

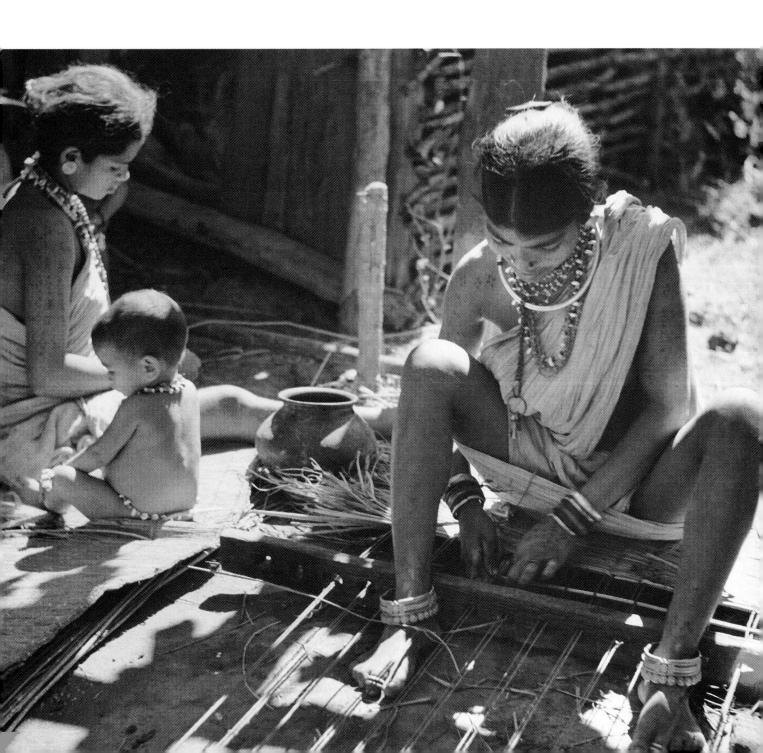

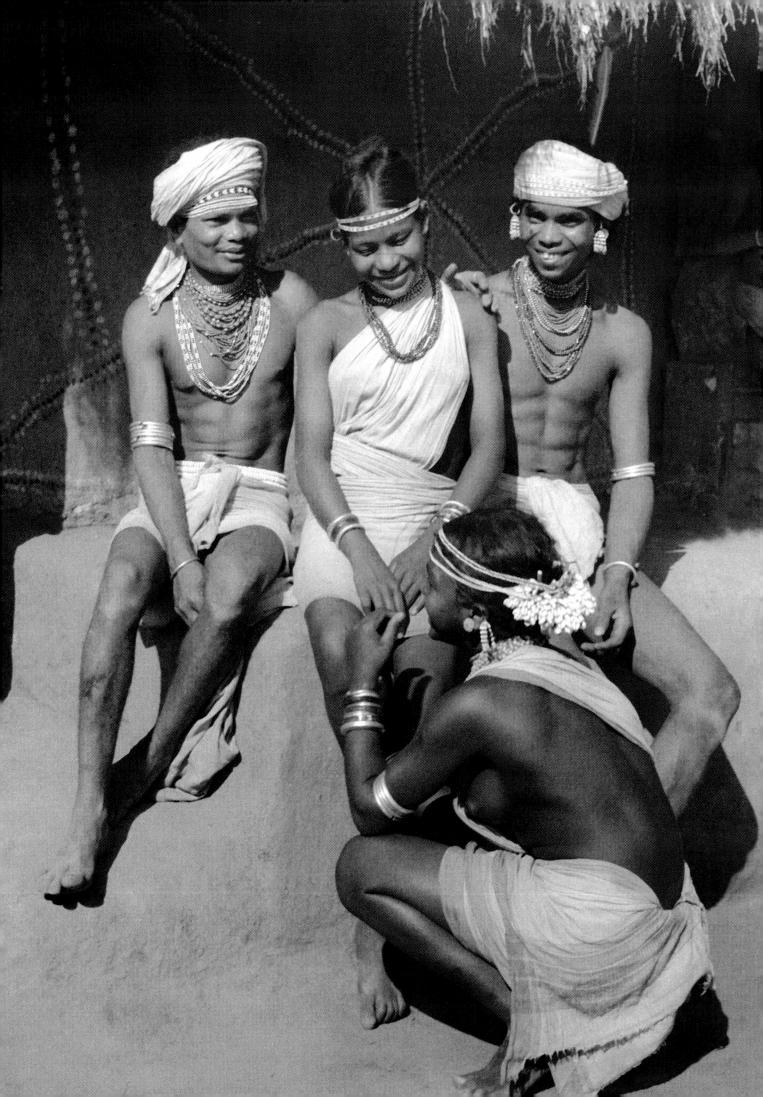

See page 72:
Muria boys (Cheliks).

See page 73:
*Muria women preparing the loom
for weaving, Bastar,
Chhattisgarh.*

Facing page:
*Muria Cheliks and Motiaris in
their ghotul.*

Of all the tribal areas in India, I have found Bastar in central India the most fascinating. In the tribal belt within the borders of Bengal, Jharkhand, Chhattisgarh and Orissa, mines and industries have affected the tribals' ways of life. Some, like the Mongolian tribes in the eastern region, have either been converted to Christianity by European missionaries, or, as in the north-east, have remained rooted to Tibetan Buddhism. In Rajasthan and the south the tribals have been similarly influenced by Hinduism. Only in the hills and forests of the Bastar Plateau, have they retained almost entirely, an older primitive culture, remarkably free from the established and puritanical norms of traditional India.

It is a long way to Bastar from the railhead town of Raipur in what was then Central Provinces. One has to drive across miles and miles of hot, dusty plains passing dismal villages until one reaches the hill barrier of the Keskal Ghats. The jeep begins to climb the winding hill roads through the green forests with sudden splashes of the fiery red blossoms of *palas* and gulmohar trees. After you cross the Keskal Ghats, as Verrier Elwin writes, 'the countryside breaks into song'. You are in the Bastar Plateau and among the beautifully bedecked, gay and charming tribal people—the women and girls with their beads, cowrie-shell and silver necklaces and armlets, and the men with colourful strings of beads, sporting peacock feathers on their turbans. You pass groups of laughing, cheerful people

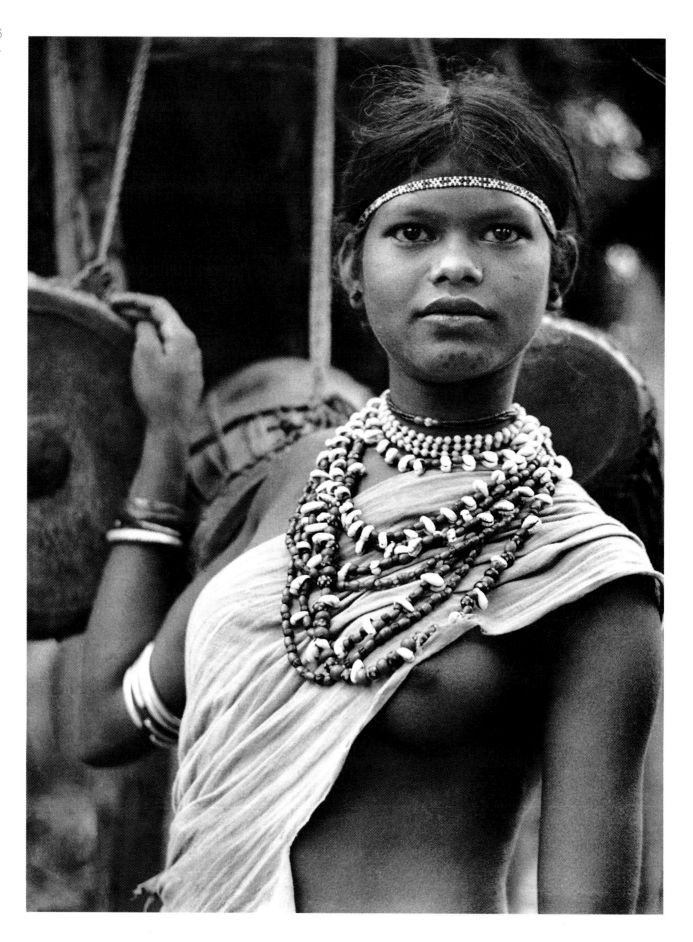

carrying firewood, fruits, brooms made of wild grass, and sometimes animals and birds that they have trapped.

The Muria villages which have more or less retained their tribal character are to be found at some distance away from the main road between Narainpur to Jagdalpur, the last semi-urban outposts. They are usually within a three or four mile walk. It is not the walking you mind, but transporting your equipment and necessary baggage becomes a problem. You have to leave your van along with the driver to the mercies of the nearest approachable village; but you may be sure that both man and vehicle will be looked after with unfailing kindness until you come back. It is not easy to get porters to carry your luggage as the tribals have enough work to do in the fields, forests, and in their homes. Money is not enough inducement to make them leave their usual activities even for a day. However, if you are lucky, you may find young boys who do it more for the fun and adventure than for the money. They provide excellent company during the journey from one village to another, which may sometimes be a very long distance. Their company gives you a ready introduction to the villages where they are known. This pattern of response made it possible for me to be sure of finding hospitality in all the tribal villages in Bastar.

In any tribal village, the first person that you usually have to ask for is the headman. Once you are in his favour, you become an accepted and welcome guest. If there is enough room in the village dormitory—the *ghotul*—you will naturally be taken there. They may or may not provide a charpoy, a string bed, for you to sleep on, but the floor is swept clean every morning and if you spread your mattress, it is comfortable and hygienic enough. In winter, you have the warmth of the log-fire they burn in the middle of the hut and in summer a cool breeze comes through the highland forests. All the Bastar tribals are extremely hospitable. In villages where they do not have any dormitories or permanent guest houses, they will even build overnight a log hut for you to stay in.

The Murias have an institution which is unique among our tribals—the institution of the ghotul, a dormitory for their young people. A hostel for adolescent boys and girls in a village is not uncommon among the tribes, and can be found in places as far apart from each other as the North-East Frontier and

Facing page:
A Muria girl standing
near the drums in her ghotul.

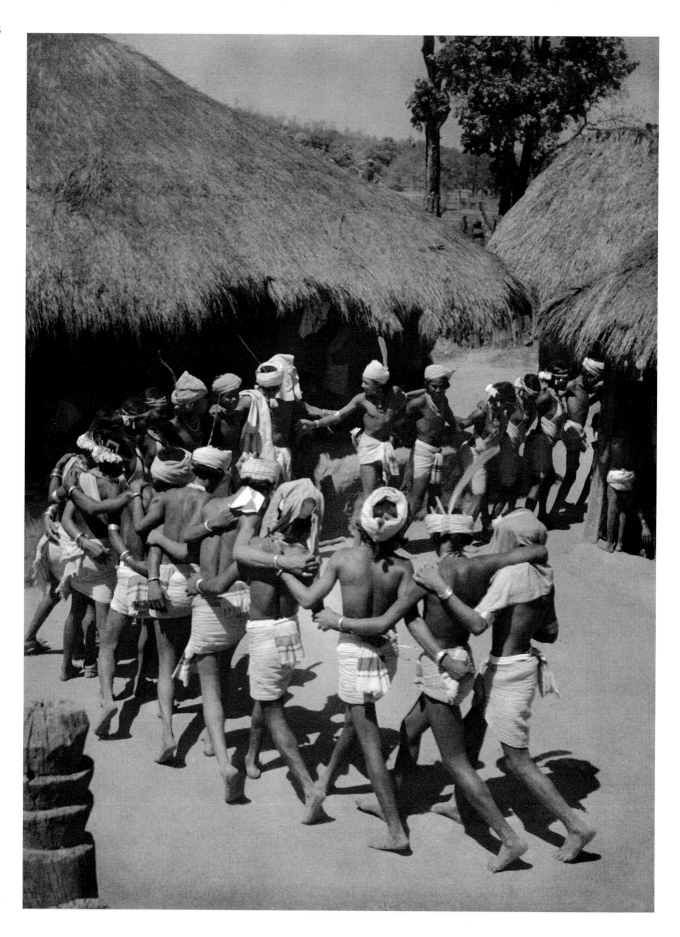

Bastar. As tribal households are small, they rarely have extra rooms for growing boys and girls. Again the young men are required to protect the village from the raids of animals or hostile neighbouring tribes. So this institution of having a large group of huts within a fenced compound for the younger men to live in until they marry has been prevalent among many tribes from time immemorial. The youth hostel has always been and still is located near the entrance of the village. It also serves as a shelter for visitors from other villages or other friendly tribes, including complete outsiders like myself. It therefore serves three purposes: firstly, as a club for the young men to have a life of their own with companions of their own age; secondly, as a guest house for the village; and thirdly, as a fortress to protect the village from any attack by wild animals or enemies.

The Muria ghotul, however, differs fundamentally from these youth hostels of all other tribes. It is reserved not only for the young men, but also for all the young unmarried girls of the tribe, between the ages of nine and eighteen. But sometimes an older girl or a boy may continue to stay in the ghotul even after their teens.

The distinctive function of the Muria ghotul—which had first attracted the attention of ethnologists, and later, the curiosity of the world—is that it is a school for marriage. There are no restrictions on the young boys and girls sleeping together. There is no domination of one sex over the other; they have to court each other, and relationships must be based on mutual consent. There are two distinct types of ghotuls depending on the customs and habitat of the tribal sect. The *adal-badal*, meaning exchange, makes changing of partners obligatory, and unwillingness to do so is regarded as a decision by the couple to marry and they are asked to leave the ghotul. The other permits some exclusive attachments until the couple either decide to change or to marry.

There are certain similarities between the Muria ghotul and the 'Bukumatalu' of the Trobiander islanders in Melanasia, as described by Malinowski. There, the youths form a juvenile commune where groups of adolescent boys are joined by willing girls. They have social sanction for this custom, but unlike the Muria ghotul, the young men have to rent a venue for their courtship.

Facing page:
Murias dancing in the compound of their ghotul.

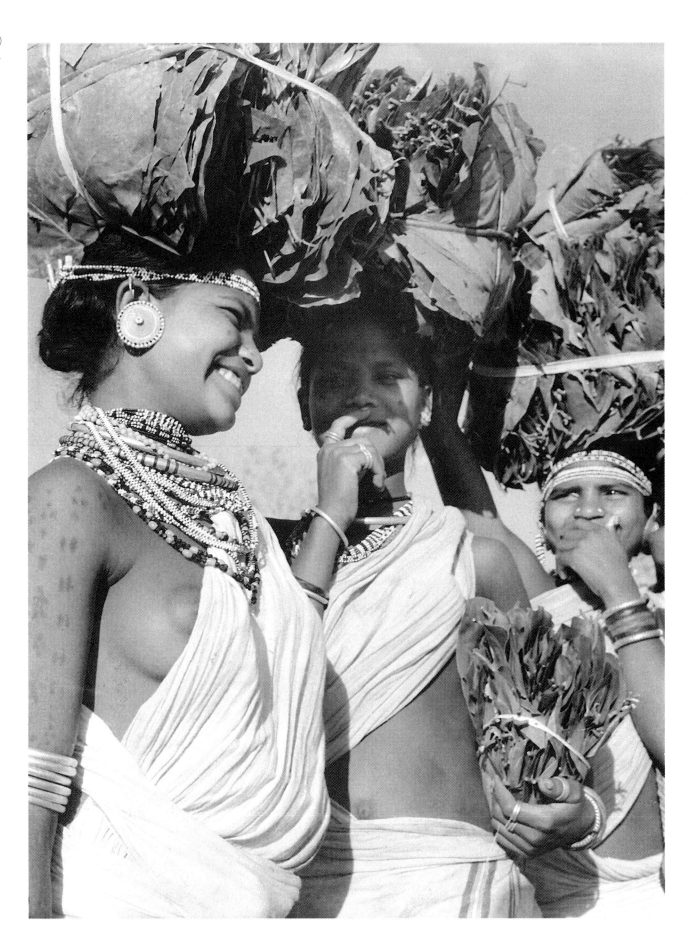

The ghotul members are each given a particular task, such as the maintenance and the thatching of huts, cleaning and sweeping of their large courtyard which serves as a dance floor for their festivities, maintaining the stout wooden fencing made out of tree trunks, keeping the bows, arrows and spears used for hunting in proper condition, collecting firewood and leaves from the forest to make drinking cups, fetching wine from the licensed vendors, getting food for feasts, gathering fruits, hunting and fishing and so on. In addition, there is the music for which the drums and flutes have to be made and kept in good order. Songs and dances need never be rehearsed since they form an integral part of their lives; all children learn them effortlessly as they grow up.

The members of the ghotul are given names quite different from their real names in order to protect the highly valued privacy of their life within the ghotul. They are given titular names representing their functions in the ghotul or sometimes fanciful ones, such as Laharu which means 'dandy'. The girls are all called Motiaris and the boys Cheliks. The headgirl is called Belusha, the loveliest one, and the headboy, Kotwal (meaning literally a magistrate), the keeper of ghotul laws. They are democratically elected functionaries and failure to do their duties leads to their demotion within the ghotul. It is an entirely self-governing institution in which the village elders never interfere. They are not supposed to know any details of what goes on in a ghotul.

After their day's work in the fields with their parents, the boys gather in the ghotul and the girls join them after performing the chores in their households. Log fires are lit, mohua wine or rice-beer is poured into cups made of folded leaves. The girls massage the boys to help them relax after a hard day's work in the fields. Visitors like us were not denied this privilege but our pleasure became pain when we felt the unexpected muscular strength of the girlish hands kneading our flesh.

The rounds of their games and dancing begin after the boys are thus revived. Later, they sleep together on the grass mats spread on the ghotul floor. The physical intimacy that Murias permit between the sexes, is however, no licence, as is imagined. Free sex with strangers is strictly prohibited. The Murias will not

Facing page:
Muria girls bringing leaves from the forest. They would stitch these leaves to make cups and plates. A festive evening was being prepared for.

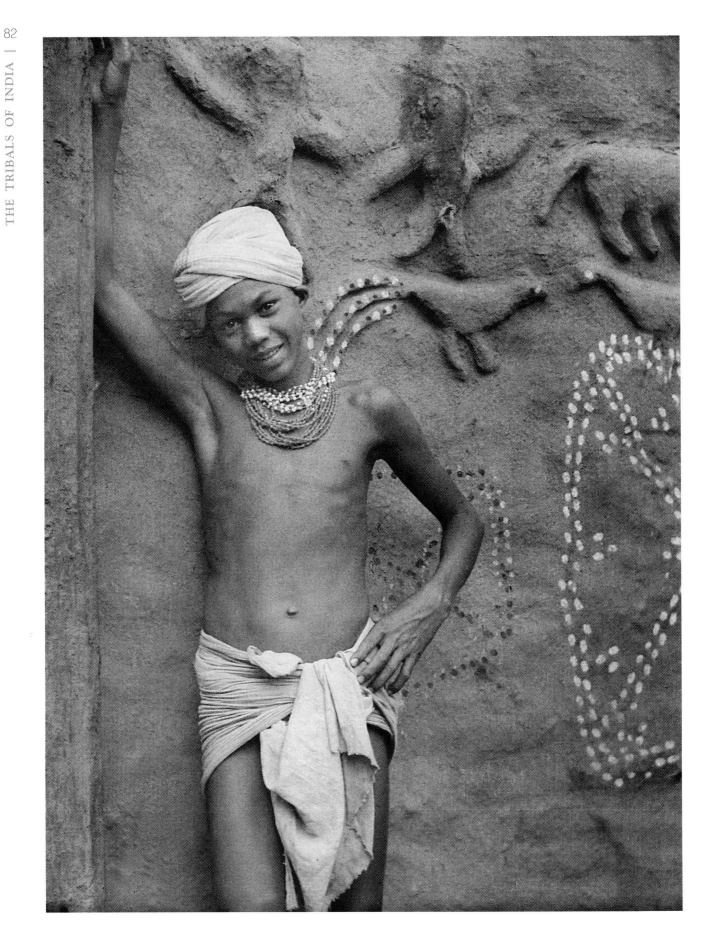

hesitate to kill anyone from the outside world taking liberties with their women.

Once, we had borrowed a vehicle from our friend Mr Blackburn to go to a Muria village. Mr Blackburn was an Englishman who had chosen to settle in Raipur for his love for the unspoilt country and its people. He earned his living as a timber contractor. The driver, who had lived most of his life in central India, had never before spent a night in a tribal village in Bastar. The drinking and the mixed dancing that he watched during the evening gave him the impression that they were *junglie* girls who could easily be taken advantage of. He tried to waylay one of them in the forest. The following morning I came to know that the elders had assembled the previous night and had judged the driver's behaviour unpardonable and decided to beat him to the point of death. 'If he survives', they said, 'it would be his luck'. We had a trying time convincing them that the fellow should be forgiven as he was in a drunken state. He was not used to drinking and he had drunk too much of the mohua which they had served him so generously. We offered a feast as compensation to propitiate the offended gods. The gods were of course no other than the tribals themselves.

After this amicable settlement, we woke up the condemned man, who was unaware of the sentence, and sent him walking back to Narainpur to take a bus to Raipur. We sent a note to Blackburn to send us an older driver.

My fascination for the Murias took me to them three times within a period of four years. During the second visit I was accompanied by my wife and our old friend from Kolkata, Victor Sassoon who was also a fellow member of Dr Elwin's Tribal Welfare and Research Unit. During this trip we came upon a village paradise beside a lovely stream surrounded by green hills and forests. The paddy-fields were golden in the afternoon light and the tidy huts with clean well-fenced courtyards were an invitation to quiet bliss in the heartland of Muria country. We decided to camp there for the remaining four days of our trip. We had the usual feast laid out for us in the evening and we showed the villagers the pictures in Verrier Elwin's book, *The Muria and their Ghotul,* and some of the photographs I had taken during my earlier trip. There were titters of merriment every time they recognized someone they knew in the photographs. The book passed from hand to hand until an old man held the

Facing page:
A Muria boy standing against the decorated wall of the ghotul.

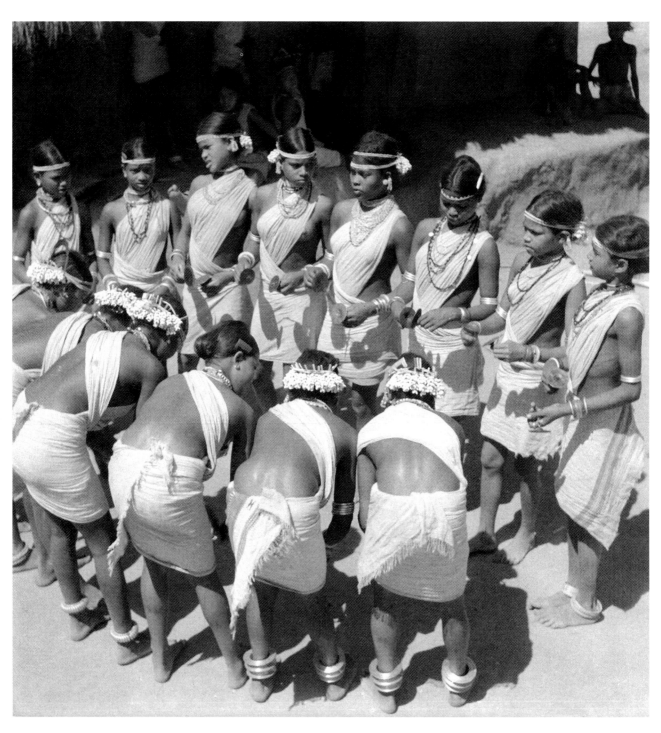

Muria girls dancing in their ghotul.

book and a group of them looked at the pictures as he turned the pages. The light from a petromax lamp, which we had brought along, illuminated the scene. We were lying lazily on the string beds under a starlit sky. Victor suddenly said to my wife, 'Sobha, do you see what I see?' We turned to look. My wife is a doctor, but even we didn't fail to notice the collapsed nose-bridge and the stubby, rotted out fingers of the old man, the unmistakable signs of leprosy.

In the morning, when they danced so that I could take photographs, courtesy demanded that we join. We could see the red patches and the unnatural, swollen faces of many of them. They had leprosy at its infectious stage. This disease has attacked these poor innocents, because they knew nothing about how to avoid the infection, nothing about its prevention and cure.

Our 'reformers' go among them to stop their drinking and dancing and the 'immoral' institution of the ghotul, but never do they think of what the tribals really need—doctors and hospitals, education in hygiene and in better methods of utilizing their resources. We impart our falsely assumed superior morals but none of our useful knowledge.

We left the village with sad hearts and went back to the roadside village of Markavera where we had left our vehicles. This village had always been the starting point of our tours and everyone there, particularly the headman, regarded me as an old friend. They were surprised at our early return but were overjoyed when we declared our decision to stay with them for the next two days before returning to Kolkata.

My last trip, however, was the saddest of all. Some priests of the Raja of Bastar had been persuaded by reformist zealots to call an assembly of village

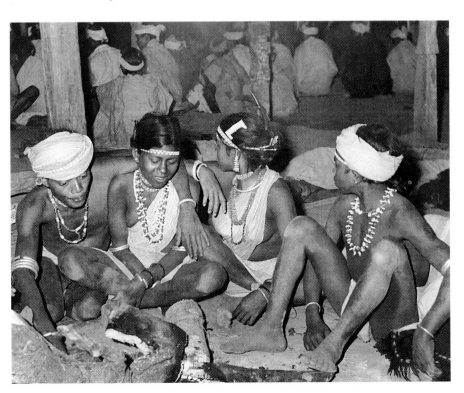

The inside of a Muria ghotul at dusk, Chhattisgarh.

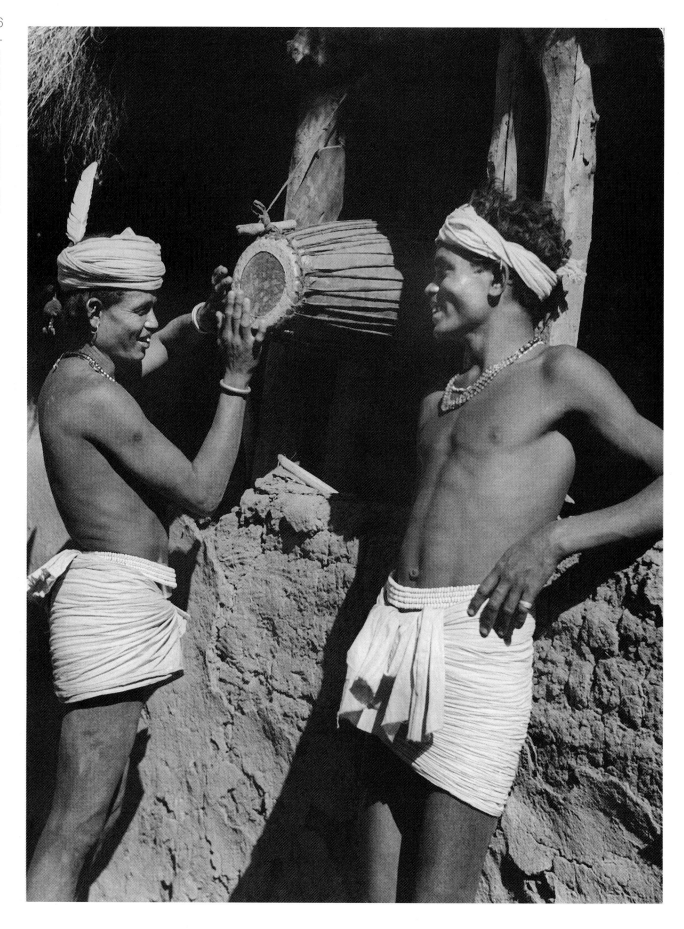

elders from every Muria village, to instruct them to ban the ghotul system. The tribals had no choice but to bend to authority. However, in spite of this, the ghotul prevails and the elders are wise enough to turn a blind eye to this. The difference is that now the girls do not go to the ghotul openly, but sneak in after nightfall. What was once a joyous gathering and their birthright, has now become surreptitious, furtive and guilt-ridden.

Facing page:
Young Muria men. Drums hang from the posts in a ghotul, ready to be played on.

Clockwise from right:
The Pyramid game in a Muria ghotul.

Washing hands with water from a gourd-shell water pot, Bastar.

Serving mohua wine in a Muria ghotul.

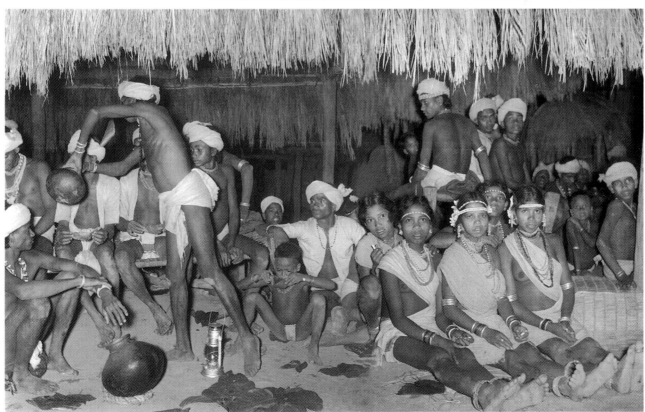

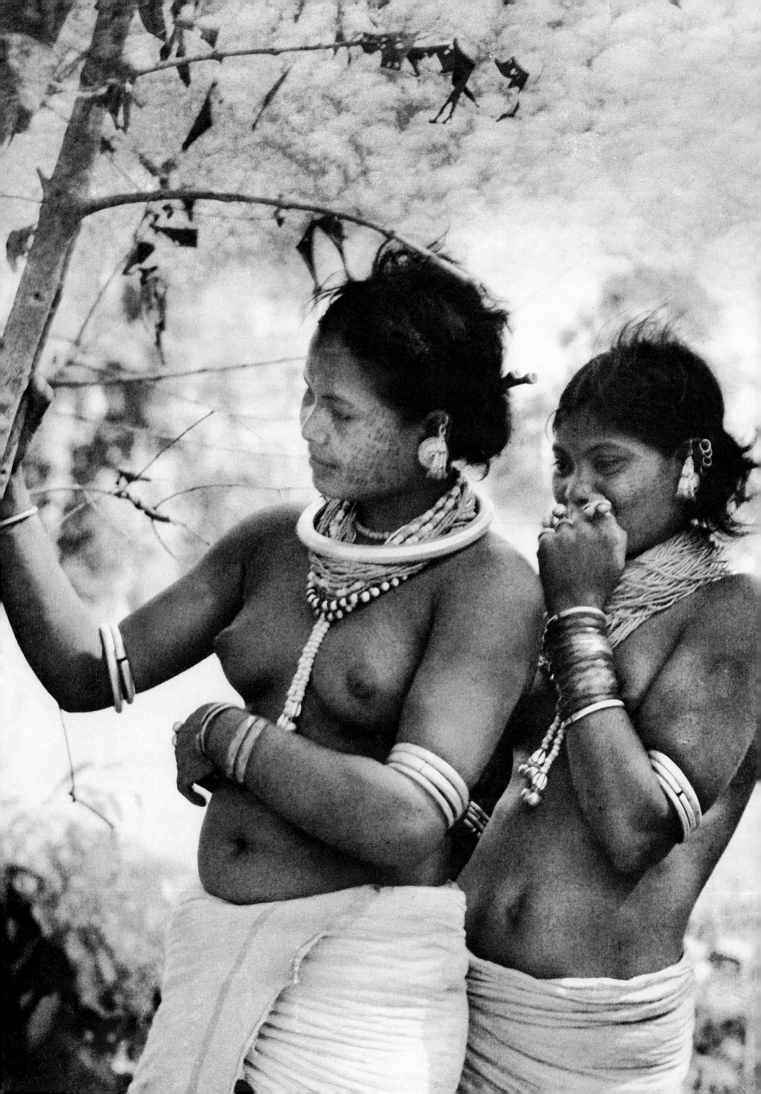

The Hill Marias and the Bison-Horn Marias

The Hill Marias, as their name indicates, live in the hills of the Bastar Plateau in southern Chhattisgarh with the Murias as their neighbours in the flat lands. It is clear that they originally belonged to the same tribe but their way of life has evolved separately because of differences in habitat and agricultural methods. The Marias have remained more primitive. They depend only on their shifting cultivation in the hills while the Murias have become settled cultivators. From the town of Narainpur in Muria country, two roads lead to the Maria hills. The one in the south goes past the hill called Chota Dongar (literally, little hill) and enters the wild and beautiful Marian gorge between the steep hills which cradles the falls of the Gudra river.

The road going westward from Narainpur turns north-west along the banks of another hill stream snaking its way through the Abujhmar hills. Soft green forests rise from the river bank to the crest of the hills and flocks of noisy birds presided over by splendid peacocks put all the sound and colour you need into the silent green landscape.

These hills are covered with forest. The forests hide the Maria villages consisting of a few ramshackle huts. Often no more than four or five such huts constitute a village and sometimes, after taking the trouble to trek strenuously uphill to visit a cluster of huts that you have spotted, you find an abandoned village. Because of their habit of shifting cultivation, they do not stay in the same

Facing page:
Hill Maria women, Bastar.

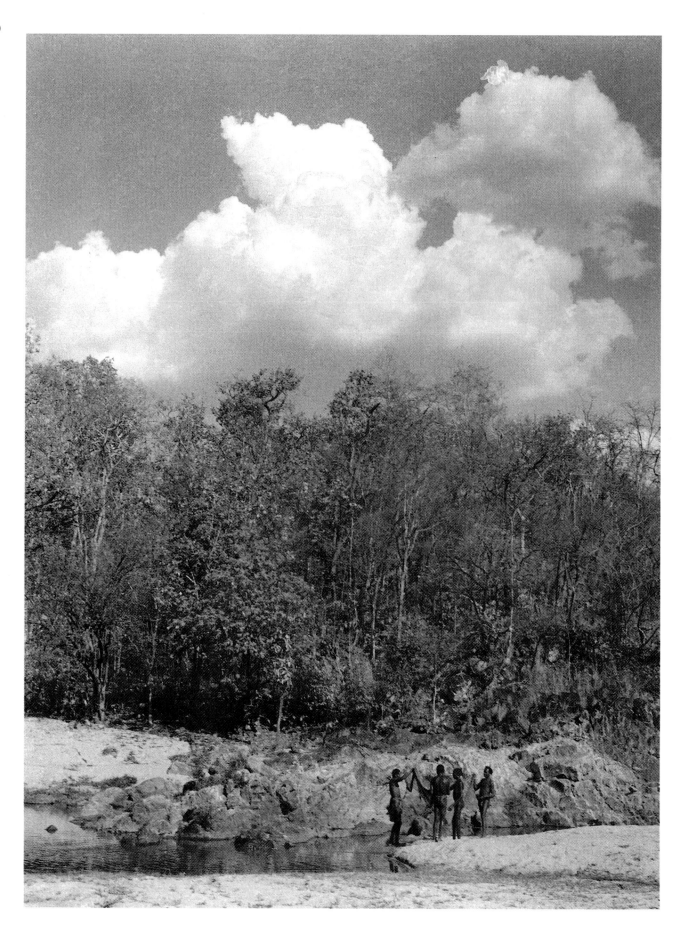

place for long. They leave as the deforested hill slopes lose their fertility after a season or two of jhum cultivation. Fortunately, there are some large permanent villages, such as the village of Orcha, situated near the confluence of the rivers Gudra and Indravati.

My first encounter with the Marias was rather strange. Leaving the jeep at the edge of the road, I climbed uphill on the forest tracks with my guide, to meet the headman of Orcha village. When we were close to the village, we found a group of Marias along with the headman himself coming down the path. The moment they saw us, everyone except the headman vanished into the forest. We quickened our pace and introduced ourselves to him. He asked us to follow him, and began shouting at an admirably high pitch summoning the others to come back. No one responded. It was only after repeated assurances from the headman, that one or two faces did appear between the bushes, looking at us suspiciously and obviously intending to disappear again if we made any move to come closer. It took us quite some time to dispel their fear. It was necessary because distances between the Maria villages could be anywhere between three to fifteen miles, and we did not wish to go on chasing the elusive Marias for days. Besides we had to find a place to sleep before nightfall. Their shyness persisted even after we had assembled in the spacious courtyard in the centre of the village. The young women took longer to overcome it. I had to woo them every time I approached them with my camera. It was an exhilarating exercise because every photograph taken seemed a hard-won achievement.

These forests have wild animals. Nobody goes out at night, and every village has a shelter for visitors and travellers to rest for the night. The villages are usually built near the hill streams far away from any semblance of a road. The Marias sometimes have to walk a good thirty miles to and from the weekly bazaar at Narainpur. During the absence of responsible adults the village has to be protected, and this is left to the youth. They live apart in a cluster of huts near the entrance to the village. These huts are also called ghotuls, the same name that the Murias use for their youth dormitories. The difference is that these ghotuls are not meant for girls at all.

Facing page:
Hill Marias preparing to fish in the Marian gorge.

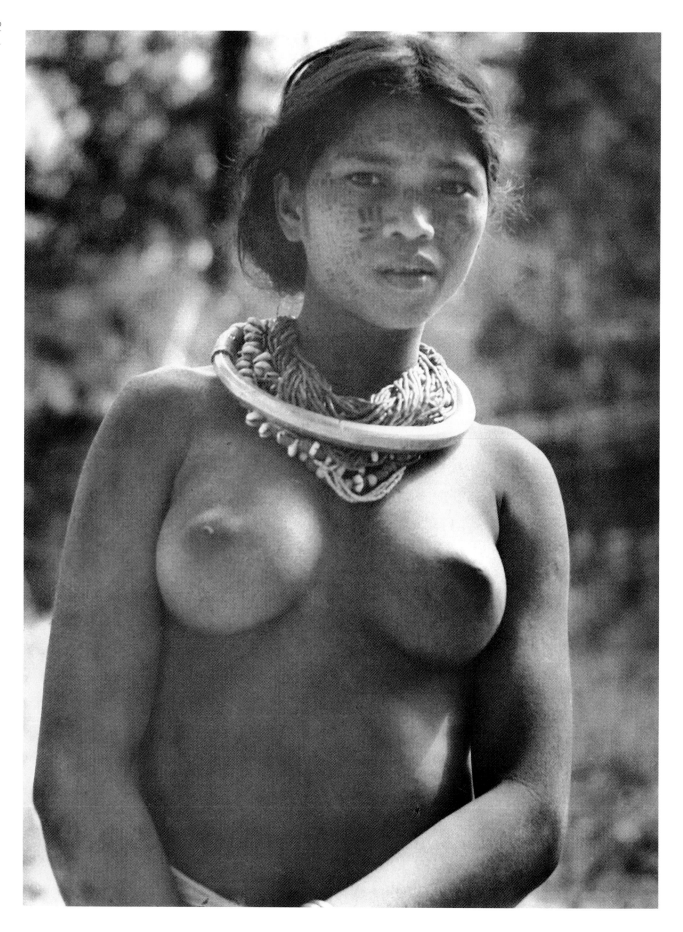

The Marias wear the usual bead and cowrie-shell necklaces; bell-metal bangles and the earrings like those of most Bastar tribes, and they put on nothing but a narrow strip of cloth around their loins. Their nakedness greatly disturbs the administration. A rather comic consequence of this had taken place when President Rajendra Prasad came to visit Bastar. The government officials went round the villages and distributed blouses to the Maria women so as to maintain propriety before the revered President. Immediately after the visit the girls merrily rolled up the blouses and put them on their heads as additional padding underneath the straw rings they used to support the water pitchers and bundles of firewood that they carried. The long-term effects of such absurd meddlings may not, however, be so amusing.

None of our forest tribes have any firearms, and their only way of killing a tiger or any other dangerous animal on the prowl is to trap it. The trap is usually a deep hole dug in the ground, covered with freshly cut branches and leaves, with a meat bait placed on it. The hole is too deep for the tiger to climb out of it. The whole village usually assembles to participate in its killing with shouts of joy and triumph. It is speared and shot with numerous arrows. Like some of the tribes of the North-East Frontier, the Marias eat the meat of the tiger or of any other animal they trap. This need not worry the conservationists, as the Marias kill only those which turn dangerous.

During my travels in tribal India I have come across very few communities as isolated and as primitive as the Hill Marias, even though they have the advanced agricultural communities of the Murias and the Bison-horn Marias as their close neighbours. It was in a Maria village that I saw the most primitive way of making a fire by rubbing a wooden stick against another piece of slotted wood. After a few vigorous strokes the dry leaves placed alongside the slot catch fire, and the fire is nursed to light all the fires in the village. I still regret that I could not stay more than three days with the Hill Marias. The jeep we had borrowed was to be returned and I never again had the chance of going back to them.

My disappointment was even greater for not having spent more than a day with the fabulous Bison-horn Marias. We reached one of their villages in a valley

Facing page:
A Hill Maria woman.

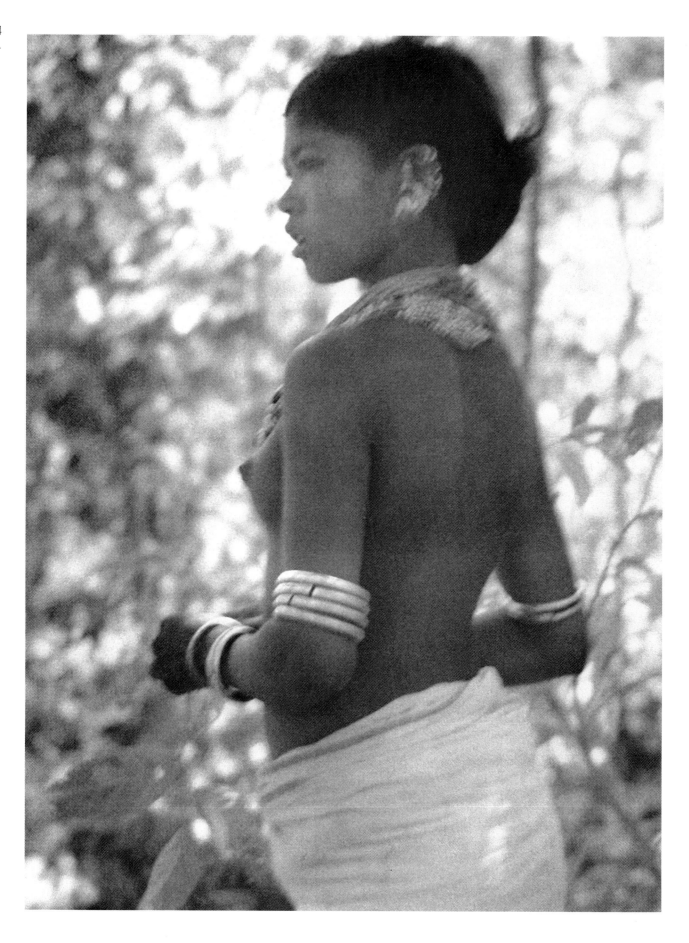

in Dantewara after crossing the Indravati river. The huts in the villages were not built close to each other in clusters but were spread out. Each had vegetable patches and grain fields around it. The sheds for cattle were built at some distance away from the dwellings which made a marked improvement in sanitation and cleanliness, compared to that of other tribal villages where the animals were sheltered under adjacent roofs.

There is a great deal of similarity, physically and in dress, between the Bison-horn Marias and the Koyas of Orissa and Andhra. The first thing one notices is that the women of both the tribes wear a brass tiara and cowrie-shell bands on their heads. Bison-horn Marias and the other two Maria tribes are ethnically no different from each other, but they are culturally extraordinarily distinct. Apart from some of their common beliefs there is little to establish any affinity between the two tribes bearing the same name.

Other than the manifest differences in dress and ways of life, what distinguished the Bison-horn Marias from the Hill Marias is their dance. The Hill Maria dance consists of a mere swaying and stepping sideways with all the

Facing page:
A Hill Maria girl.

Below:
Hill Marias making a fire by
striking two pieces of wood.

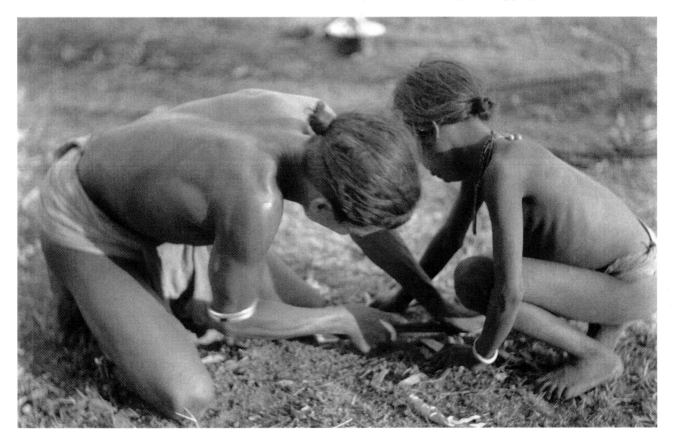

participants in a line, arms around each other's waists and holding hands. The Bison-horn Maria dances are quite different. The dancers form a circle with men and women standing alternately. The dance is unique because of the fantastic ceremonial headdresses worn by the men which are made of a pair of bison horns and an assortment of cowrie-shells, beads and feathers. Strings of beads are wound all around this headgear which partly cover their faces. The dance begins with the men and women forming a great circle with arms linked around their waists. The men put on their splendid bison-horn headgear and the girls their lovely tiaras and arrays of necklaces, each one looking like a tribal princess. They are bare up to the waist, as they usually are. The music, the singing and the intricate, precise and vigorous movements of the dance begin in a slow leisurely

Bison-horn Marias dressed for dance.

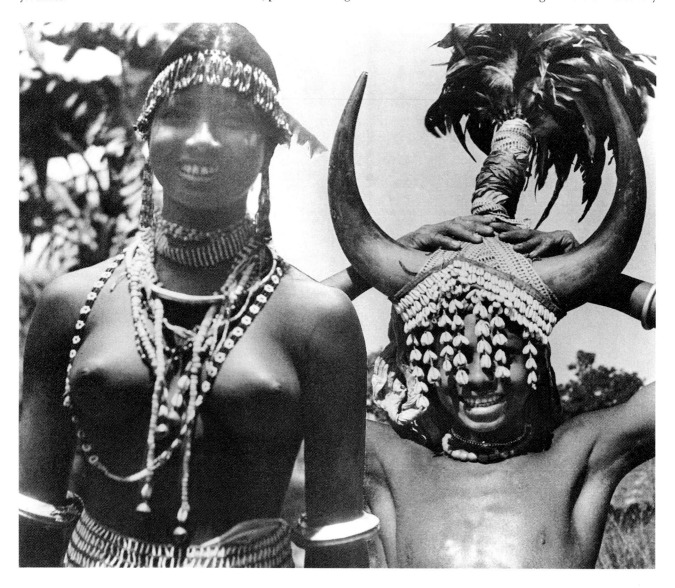

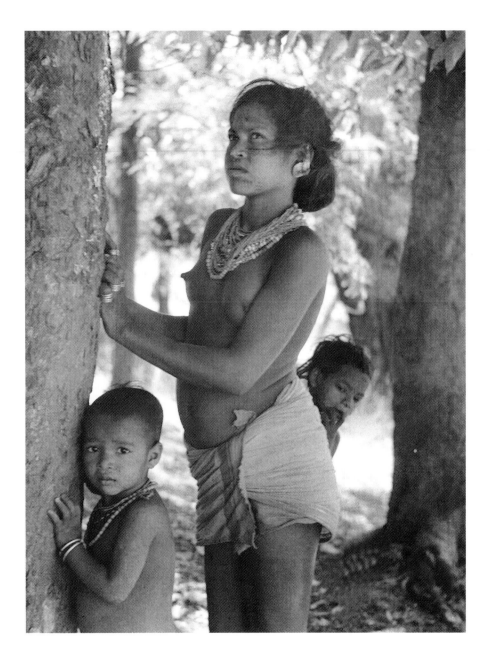

A Maria young girl and two children.

pace but the tempo rises as the night progresses, while the drinking of small leaf-cups of wine continues after each arduous round.

The frenzied climax—the stamping feet, the glistening, sweating bodies, the furiously swirling skirts, feathers and beads and cowrie-shells on strings—as though caught in a whirlwind, and the final crescendo of the music, is one of the most exciting and memorable of my experience of our tribal world. Their dances are an important part of their lives. Except during the rains and the sowing season, any night is good enough for dancing and no invitations or preparations are required when the big drums boom.

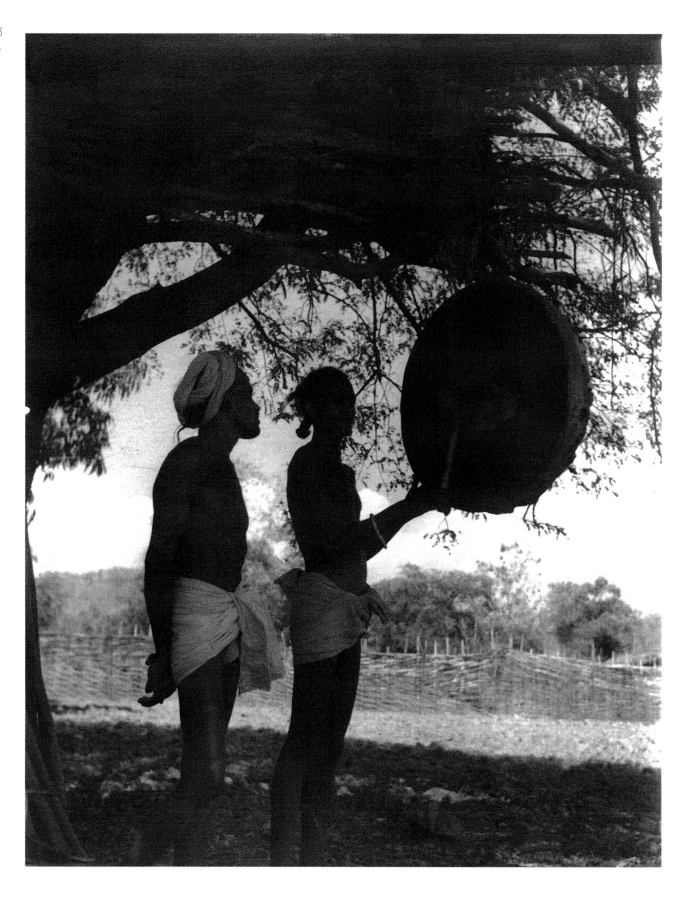

The bison-horn headdress has earned these Marias their distinctive name. They have a more advanced way of life than the Hill Marias, and are settled cultivators. Because of their omnivorous food habits, the Bison-horn Marias, despite the meagre cultivable land, have survived better than the neighbouring Hill Marias and Koyas. They eat not only what grows in their fields and forests, but also most things that walk, crawl, swim or fly. Field rats and frogs are eaten with as much relish as are enormous pythons and boa constrictors they sometimes hunt in the forests. Even squirrels are caught for their meat, and fish are speared in the hill streams. The Bison-horn Marias and the Murias are delightful, remarkably honest, gentle, artistic and industrious people. Their high spirits, dignity and generosity may have been derived from their nurture in their non-competitive, loving and caring communities.

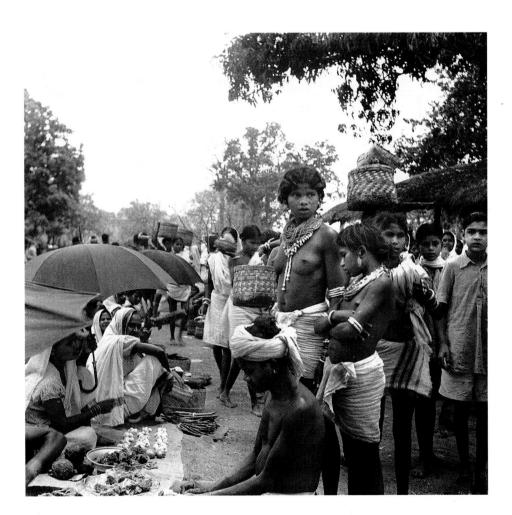

Facing page:
Hill Marias sounding a gong suspended from a tree in their village.

Right:
Hill Marias in a Bastar market-place.

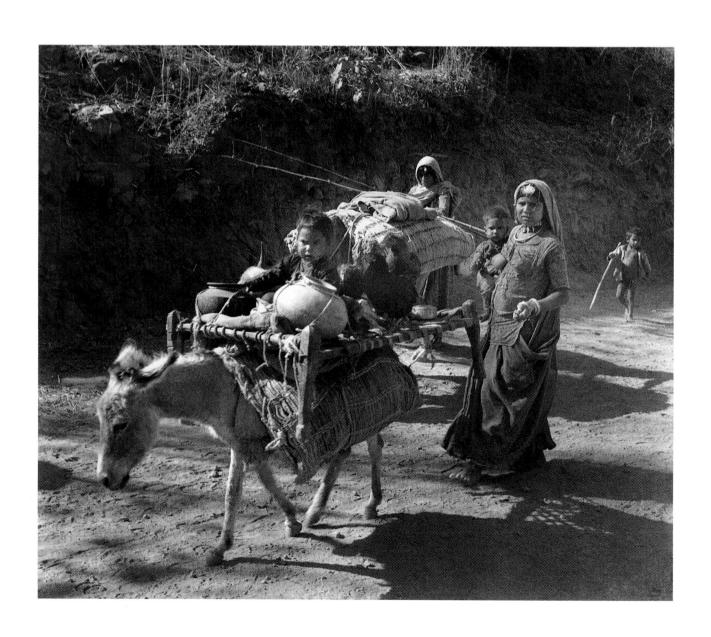

3

RAJASTHAN, THE WEST COAST AND THE NILGIRIS

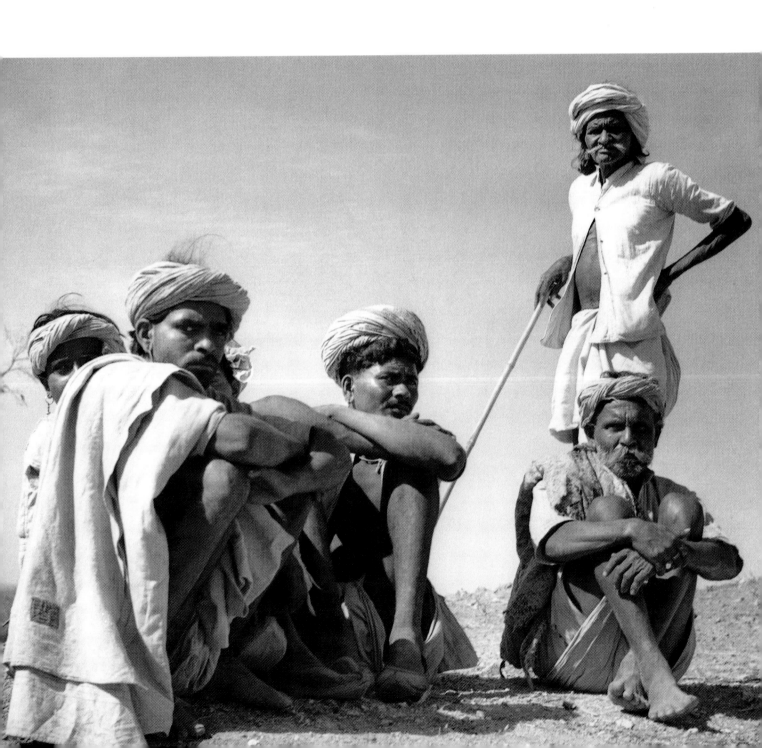

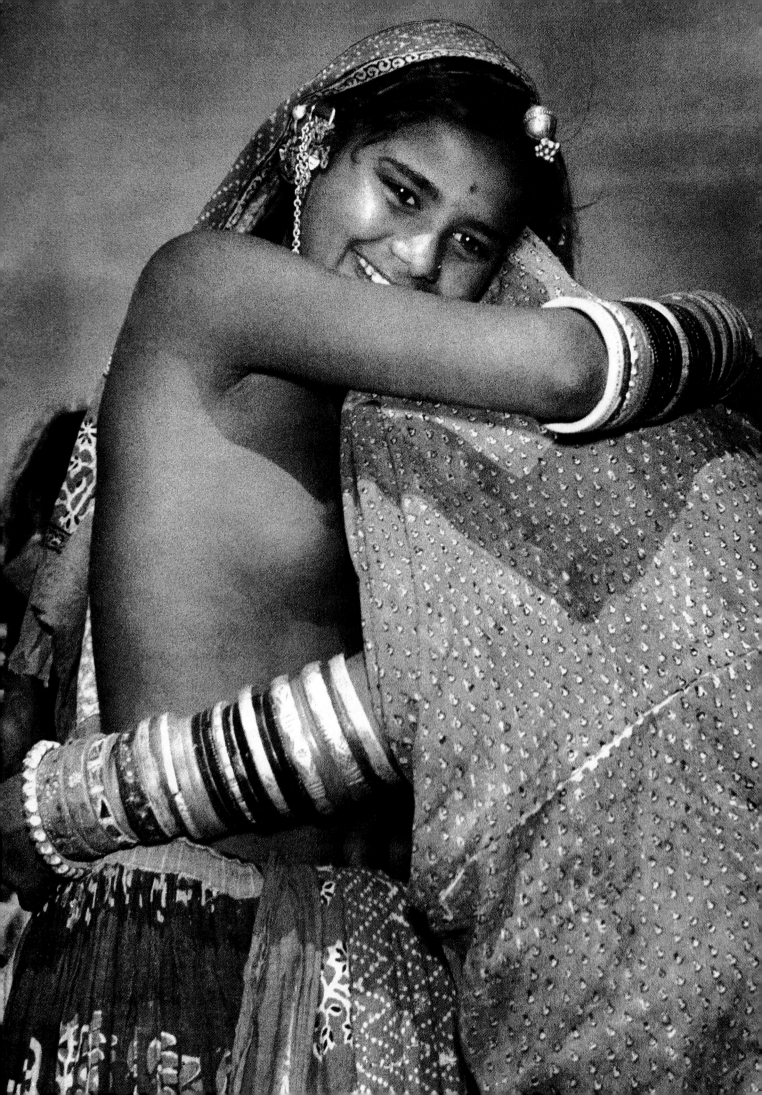

THE BHILS OF RAJASTHAN

See page 100:
Banjara gypsies on a trek
near Udaipur, Rajasthan.

See page 101:
Bhil men, Rajasthan.

Facing page:
A Bhil girl embracing her married
sister who has come for a visit.

On the royal crest of Udaipur there are two figures, one of a Rajput and another of a Bhil. This is a unique honour considering that in India the aborigines have never been treated with respect. However, the Bhils have the distinction of being one of the very few tribes that have been glorified in our history and legends. Rana Pratap of Chittor, the unhappy hero of Rajput resistance to Muslim conquest, lived among the Bhils when he with his followers took shelter in the Aravalli hills. They were his brave and devoted allies. He lived on the bread made of millet that the Bhils offered. He cut his wrist to mingle his blood with the Bhil chieftain's, pledging blood-brotherhood. Thus the tribals were honoured as equals and Brahmanical codes of caste and racial superiority were flouted by a king, now regarded as a national hero. Until the merger of the native states with the Indian Union, the Bhils used to be invited to the palace of Udaipur on all State occasions, particularly on the birthday of Rana Pratap. They were treated as honoured guests of the city. The chivalrous Rajputs never forgot their old debt to these humble people. Even now no true Rajput despises the Bhil for his poverty or primitive ways of life.

Udaipur is now famous as a beautiful city of palaces and lakes, but in the days of Rana Pratap, the place lay in wilderness. It was his son, Amar Singh, who built a capital there. The Bhils live far beyond the lakes and palaces of Udaipur, in the arid highlands of south-western Rajasthan, which slope down into Gujarat. As

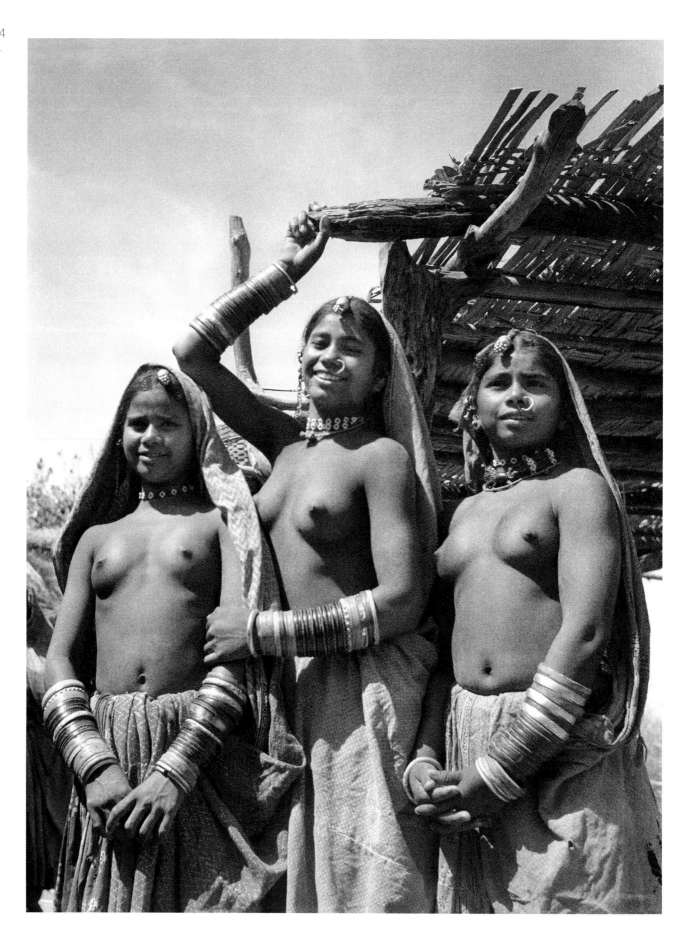

you travel in this harsh country of rock, sand, and cacti you cannot fail to spot the Bhil women in their flared skirts as startlingly coloured as the cactus blossoms in the sun-bleached landscape. As you pass roadside villages, you see men loading grain in great wicker baskets, children watching you wide-eyed as they cling to the overhanging roots of a banyan tree, old men driving bullocks round and round a 'Persian wheel', and women carrying loads of firewood.

I could not have travelled to the Bhils in the remote interiors, without the help of officials in the government of Rajasthan. Rajasthan was maligned for being orthodox and backward. But I found that the officials engaged in social welfare were sensitive and did not believe in the destruction of tribal ways of life.

They directed me to the Bharatiya Kala Kendram in Udaipur, a cultural organization which was in close contact with the Bhils. I had an introduction to an official of the Kala Kendram from my good friend Govind Vidyarthee of the Sangeet Natak Akademi in New Delhi. I met this young official and when I introduced myself and expressed my interest in the Bhils, he said he would be visiting some Bhil villages with two of his colleagues the following day, and would be happy to take me along. I had not expected such luck; but I was not alone— I had my wife and our young son with me. All three of us were readily invited. There was plenty of room in the large van and we fitted in quite comfortably. The road from Udaipur to Lake Jaisamand, where we stopped for lunch, was fairly good. It became rough soon after but that was no indication of what we were to go through in the next hundred miles or so. There was practically no road but desert trails, winding uphill and downhill, across dry river beds and through rocks, boulders and man-high spiky cacti. Besides, our excellent driver was perilously drunk, cursing continually the obstacles he met. He stopped by a village at least once every hour on some pretext, to obtain fresh supplies of liquor, until mercifully there were no villages but only wilderness. On our way we came across some of the other tribes inhabiting this barren country and also the nomadic Banjara gypsies, crossing the desert with their caravans of loaded donkeys. The mellow light of the afternoon sculpted them beautifully against the hills and their unexpected willingness to be photographed delighted me. When

Facing page:
Three sisters. The tall girl,
the eldest of the sisters, was
persuaded by my wife to come
for the photograph.

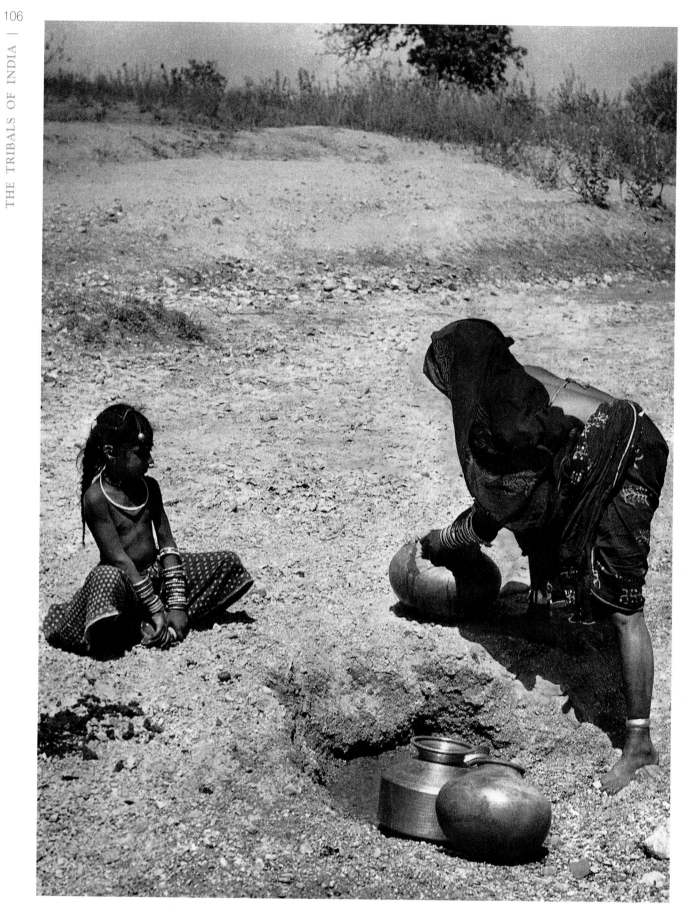

we reached our hosts' camp in a Bhil village, dusk was setting in. The stark silhouettes of the tall cacti stood out against the magnificent sunset-sky.

We settled down in the tent allotted to us and rested our weary limbs after this long bumpy journey into the deep interiors of Bhil country. The dinner was one of the best I have ever had among the tribes. Balls of mixed wheat and millet-flour dough were covered with a thick layer of clay and thrown into an open fire. They were picked out after some time with long iron tongs. You were to break the hot baked clay, extract the steaming bread, dip it into a bowl of *ghee*, and eat it with lavish helpings of hot and spicy vegetables. There were also small bowls of *dal* (boiled lentils) served to each one of us. This was the best feast a Bhil could

Facing page:
A Bhil woman trying to collect water from a hole dug into a dry river bed.

Below:
A Persian wheel on a well-irrigated wheat field in the Bhil country, Rajasthan.

Above:
Wall painting on a Bhil hut.

Facing page top:
Bhil women grinding grain.

Facing page below:
Bhil woman cleaning grain.

give his honoured guests. Meat was never served, nor was their home-brewed liquor, as that might be unacceptable to some people, and might even offend them. So the Bhils let themselves become vegetarians and teetotallers expediently when entertaining guests.

The arid tracts of Rajasthan hardly yield anything except coarse cereals and some lentils, although wheat grows abundantly in the neighbouring states. The Bhils have to work very hard to raise their scanty crops in the few cultivable fields they have. In the village we visited, the wheat crop was then being harvested. I photographed the happy men and women engaged in winnowing, threshing and putting into their granaries the crop they were so proud of.

It was a pleasure to walk about in the village photographing the people. All the men had turbans and loin cloths and wore embroidered waistcoats

when they wanted to, with their traditional Rajasthani shoes curled up at the toes. All the young women were bare-breasted while the older ones wore blouses. I was photographing three young girls, who were sisters, in front of

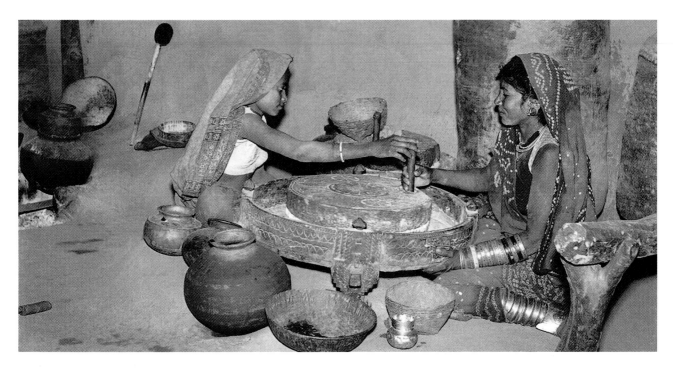

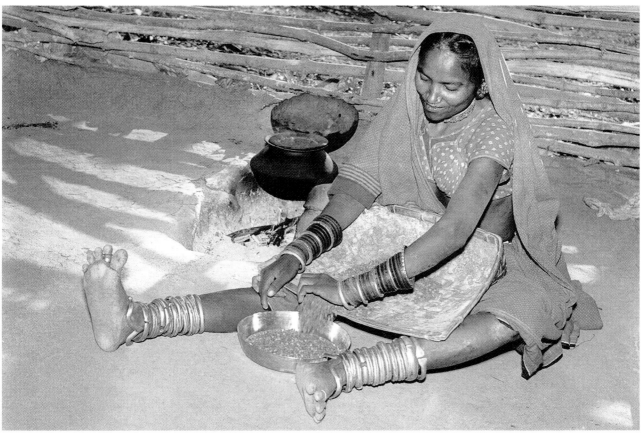

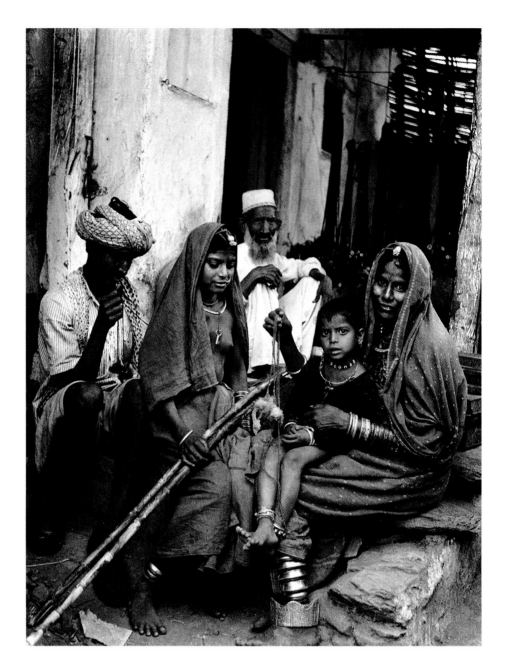

Bhil family shopping for ornaments at a silversmith's shop in Udaipur.

their hut when the eldest and the most attractive one bolted away and hid under a bed until my wife coaxed her to return to her place. It turned out that she was shy not because of her nakedness but because she was not married although she was old enough to be.

Later, I learnt that the wearing of blouses was a status symbol. Only the married women, irrespective of their age, were expected to and had the right to wear them. There was an obvious aesthetic reason for it, as one of their very articulate old men explained to me: 'After child-bearing and nursing, a woman's breasts are no longer beautiful. She may cover and hide them then.

But why should she do that in the bloom of her youth?'

In the afternoon I walked down to the dry river. A woman with a child and several clay pitchers at her side was digging up the sand with her bare hands. She found some water trickling up into the hole. She began to ladle it into her pitchers. Filling them up would take her many hours. I took a photograph.

Carved stone images of snake-gods in a Bhil place of worship.

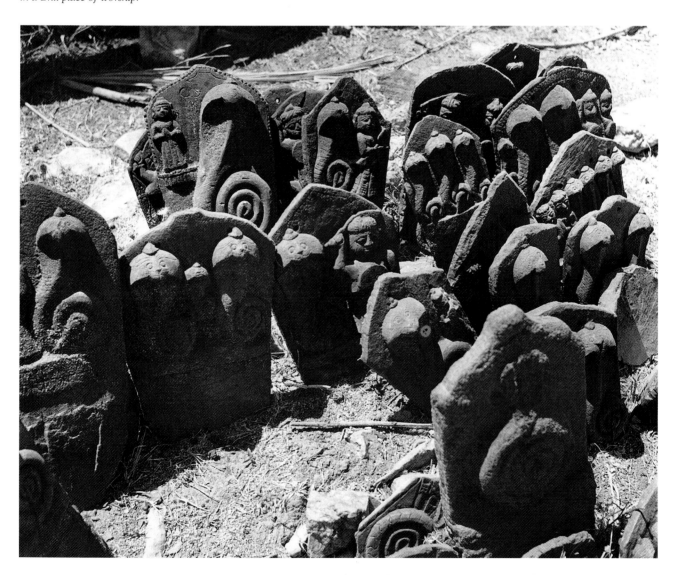

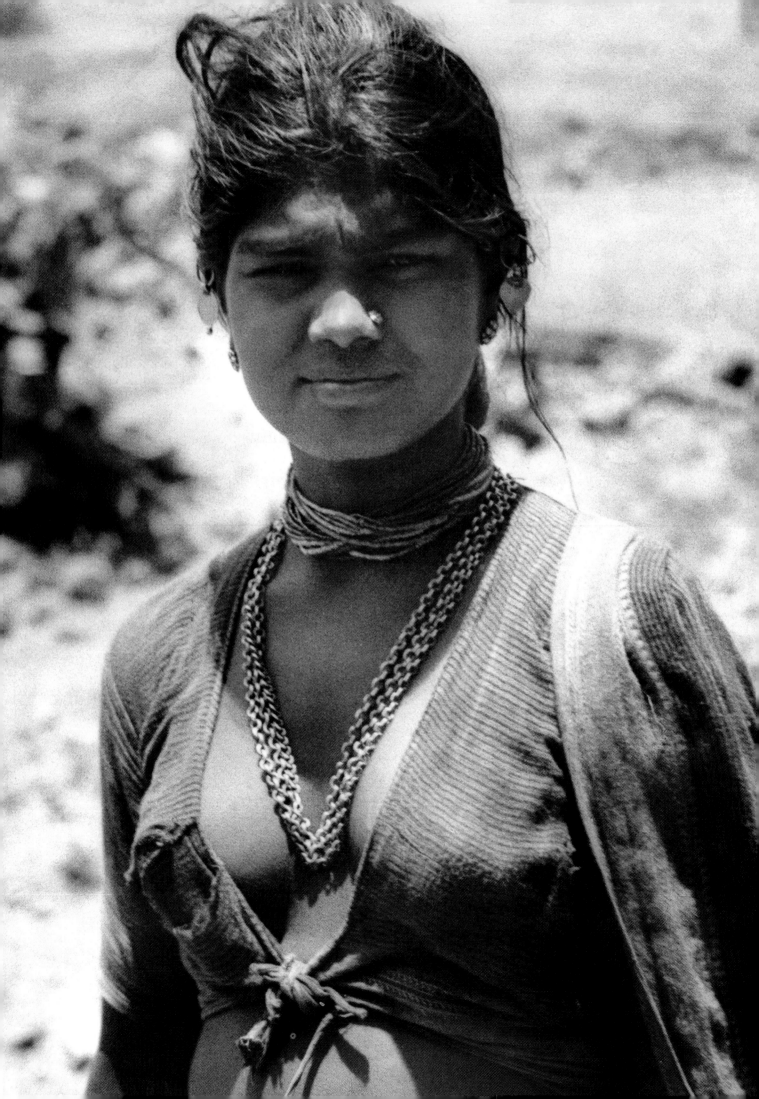

THE WARLIS

The tribals inhabiting the Western Ghats, the mountain range along India's west coast, are less numerous than those in the Eastern Ghats. In Maharashtra, people of the plains refer to them as the *Ghatis* or literally, the hill people. The Warlis, inhabiting the foothills, were the easiest to visit from Mumbai. I was pleasantly surprised to find that such a primitive tribe could be reached within a few hours from this modern megalopolis. My escort and companion was Mrs Godavari Parulekar, a well-known communist leader at that time, who was working for these impoverished tribals. We took a Vadodara-bound train from Bombay Central. More than an hour's ride later we got off; and after a twenty-mile bus journey over rough roads we reached a coastal fishing village.

The nearest Warli village was an hour's walk across the narrow coastal strip between the Arabian sea and the rocky foothills of the Western Ghats. It was past two o'clock in the afternoon when we reached there. The village was almost deserted except for a few old men and women who were looking after small children. Everyone else had gone out to the fields or the forests. I could not but observe the stark poverty. The low mud-huts thatched with reeds and grass were at some distance from one another and the yards around them were fenced with untrimmed branches of trees. Light and air could enter these huts only through the doorways. There were no windows. The land, a scrub forest on the rocky foothills, was equally bleak.

Facing page:
A Warli woman, Western Ghats.

There were about 75,000 people of the Warli tribe spread over the coast of Maharashtra, Surat district and Daman.

Tilling land in rocky soil is a laborious process and none of the tribals can afford bullocks for their ploughs. A few hire them for the tilling season from their better-off Marathi neighbours. But they depend much more on jhum cultivation, the primitive method of setting fire to a forest patch and sowing on the cracked soil. In consequence, the land erodes and soon becomes infertile. The sparse forests do not have much game. Any animal they may hunt provides a good supplement to their meagre diet of rice, pulses, wild roots and some vegetables. Wild boar, deer, birds and even jackals and monkeys are good for the stewing pot if they find them. Expeditions to the nearby sea sometimes yields a surreptitious catch of fish, though that is resented by the coastal fishing communities. Driven by poverty, many of the young men and women go to work in the textile mills of Mumbai. Strangely enough, few of them continue staying

Warli men on a hill top.

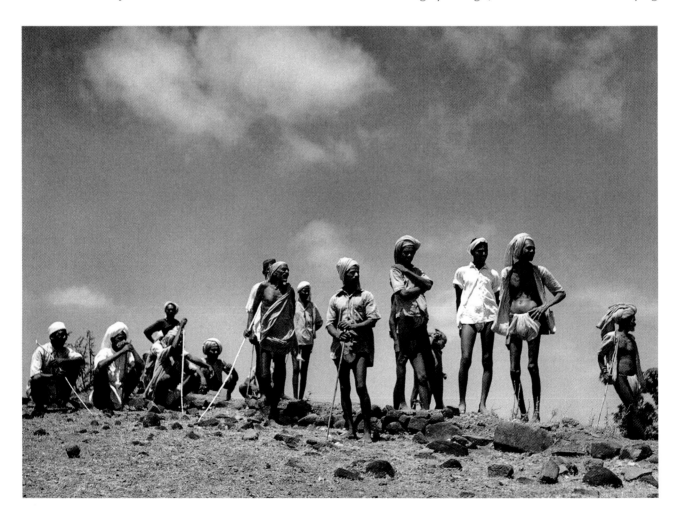

there in the dismal city slums; almost always they come back, after making a little money. During my trip when I asked one of these young men, he told me that he would prefer his poorer life in the affectionate company of his people to anything the city had to offer. I found a confirmation of this spirit on my way back from the village, when I found another youth blissfully asleep on the branch of a tree, utterly oblivious of the danger of falling off. They felt safe and secure in their familiar world, however precarious their situation seemed to us.

The fences around the huts provide a picturesque background to the village of the Warlis. You find cattle, dogs and chicken roaming around and groups of children and adults gossiping, eating or drinking. Like most other tribals living in

A young Warli man setting fire to the forest to make a clearing for jhum cultivation.

the warm regions of our country, the Warlis wear a minimum of clothing. The men wear short *dhotis* and often short embroidered waistcoats. The saris used by women are brief too, reaching only up to their knees and worn in the Marathi style. The half-sleeved, embroidered *choli* they wear is tied with a knot in the front.

Mrs Parulekar, watching me photograph a particularly attractive young girl, jokingly remarked, 'Sunil, you are in Shakuntala land!' Shakuntala is the name of the heroine of the classic Sanskrit play *Shakuntala,* written by the ancient Indian poet Kalidasa. It is about a girl brought up in the forest by a sage, who dressed simply like tribal girls. A great king who came to hunt fell in love with her and married her and promised to send for her when he returned to his capital. As

Warli young men sleeping and resting on the branches of a tree.

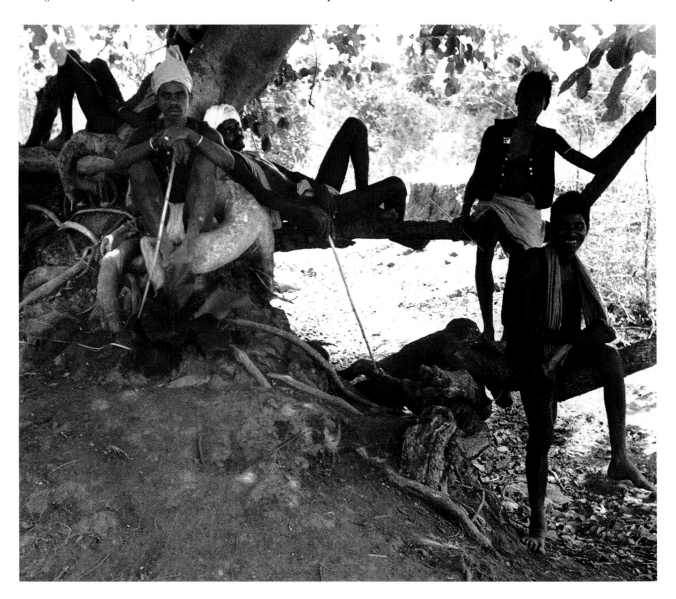

in all love stories, many misfortunes befell them before they were reunited. Ever since, this popular heroine of our classics has become in my mind a Warli girl.

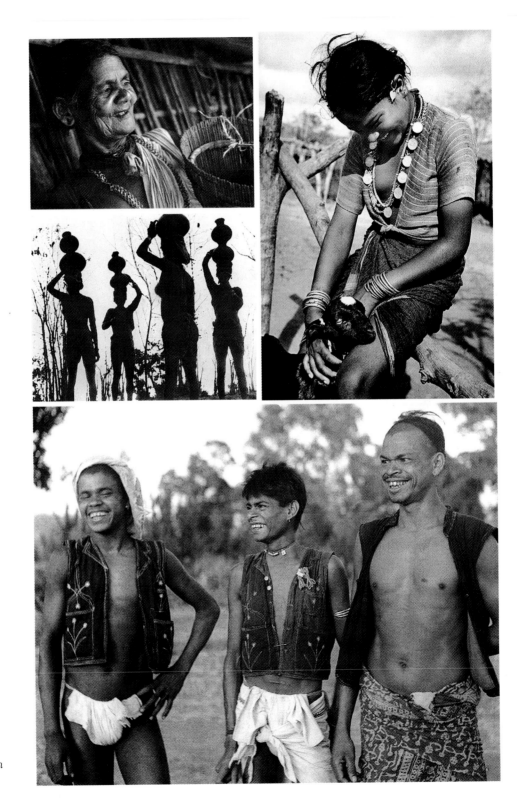

Clockwise from top left:
A Warli grandmother.

Warli girl and her pet kid.

Warli men.

Warli women fetching water in
pitchers from the river.

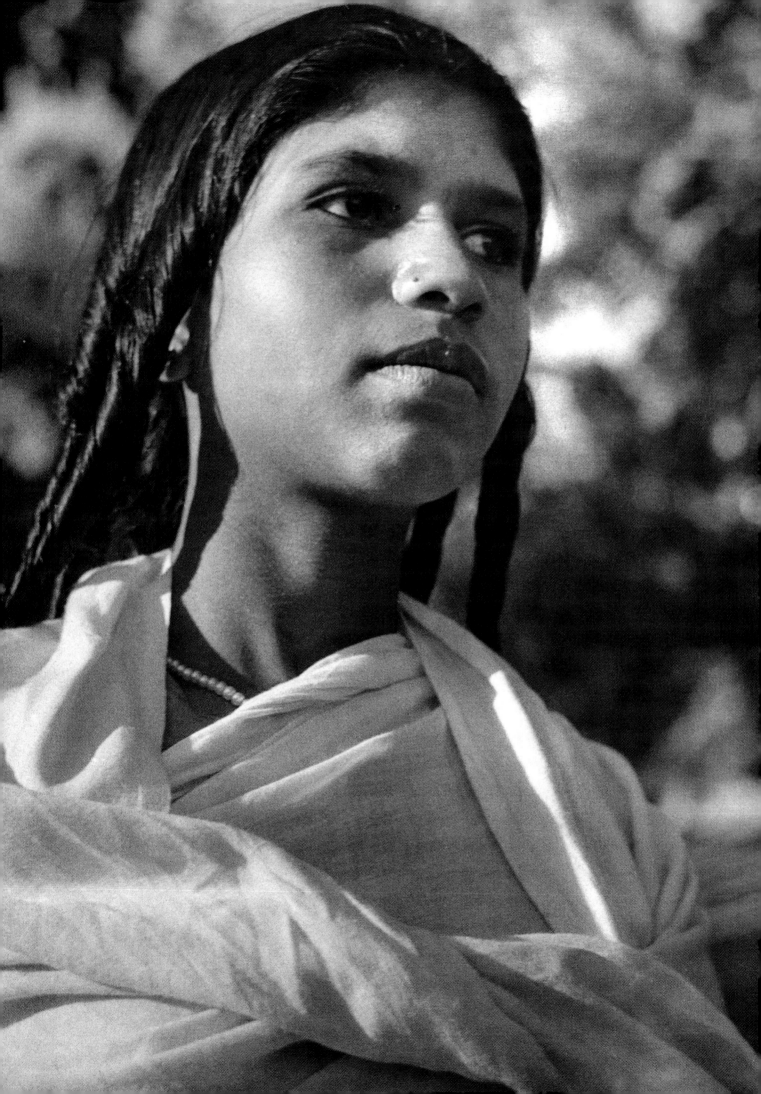

THE TODAS OF THE NILGIRIS

The Eastern and the Western Ghats, the hill ranges along the two coasts of India, meet in the plateau of the Nilgiris—the 'Blue Mountains'—in the south. In this highland, walled in by ever-green hills, lives the small population of the Toda tribe. According to the 1951 census, there were only 879 of them distributed over a few villages.

The Todas therefore constitute an insignificant minority of the tribal population of India, but because of their unique way of life, this small group has always attracted the attention of the outside world. The Todas have forgotten their ancient history and even their legends do not recall their past and their origins. They are dark-skinned and sharp-featured with prominent noses, large eyes and bushy eyebrows. The men look venerable with their long curly hair and flowing beards, giving them a very imposing presence rather uncommon among our other tribal people. The men cover themselves from shoulder to foot with a wrap which looks like a Roman toga. This is always white and has a red and blue border. The Toda village elders look like characters from the Old Testament and have the gravity and dignity befitting ancient sages. The women wear the same handwoven material, but more like a sari than a wrap. Their ornaments are sparse, a silver necklace or two, with perhaps one or more strings of shells and beads. They plait their sleekly-oiled hair in a number of ringlets resembling Rastafarian and some other African hairstyles. They look very elegant and well-

Facing page:
A Toda girl, the Nilgiris.

groomed but they radiate a smell which is far from enticing. They anoint their hair and bodies with butter. The odour of rancid butter pervades their homes, and one may say, their entire village.

The villages consist of not more than five to six strange-looking, tall, conical huts, ten to twenty feet high. The base may have a large diameter but the entrances are incredibly small, narrow and low, and you have to crawl in. There are no other doors and no windows. The huts are dark—and as the cooking is also done within them—grimy and always smoke-filled.

The Todas have remained pastoral and their wealth consists of herds of buffaloes. Although they drink milk and make butter, cream and cheese, they do not eat buffalo-meat. It is strange, however, that they sacrifice buffaloes during their rituals and festivities. There is a symbiotic relationship between them and the neighbouring Kotah tribes who are their blacksmiths and musicians. The Kotahs bring and play their instruments—flutes and stringed instruments—for the festive dances of the Todas and take away the meat of the sacrificed animals. Until recently the Kotahs also supplied the Todas with spades, axes and knives, free of cost. Some hundred years ago, infanticide and polyandry—particularly one wife being shared by all the brothers of the family—were very common among the Todas. This custom, as well as strict endogamy within so small a community have led to genetic diseases; and of course, diseases caused by poverty, malnutrition and insanitary conditions have caused the steady diminution of their numbers. Endogamy has fortunately been long abandoned. But there are too few of them and their resources are extremely limited. They are an endangered group of people and they seem to be facing extinction.

Facing page:
Toda elders.

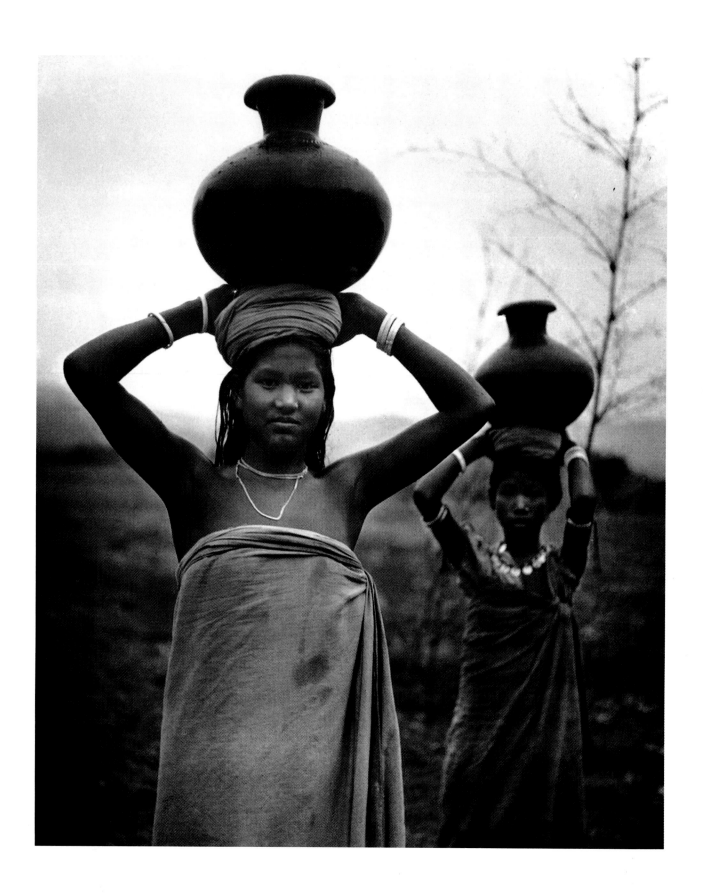

TRIPURA AND THE BORDER REGIONS
OF BANGLADESH AND MEGHALAYA

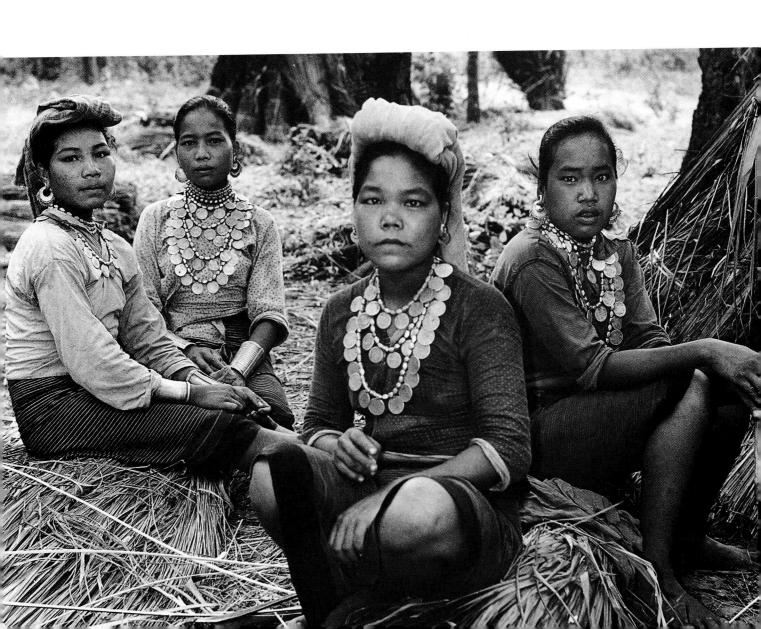

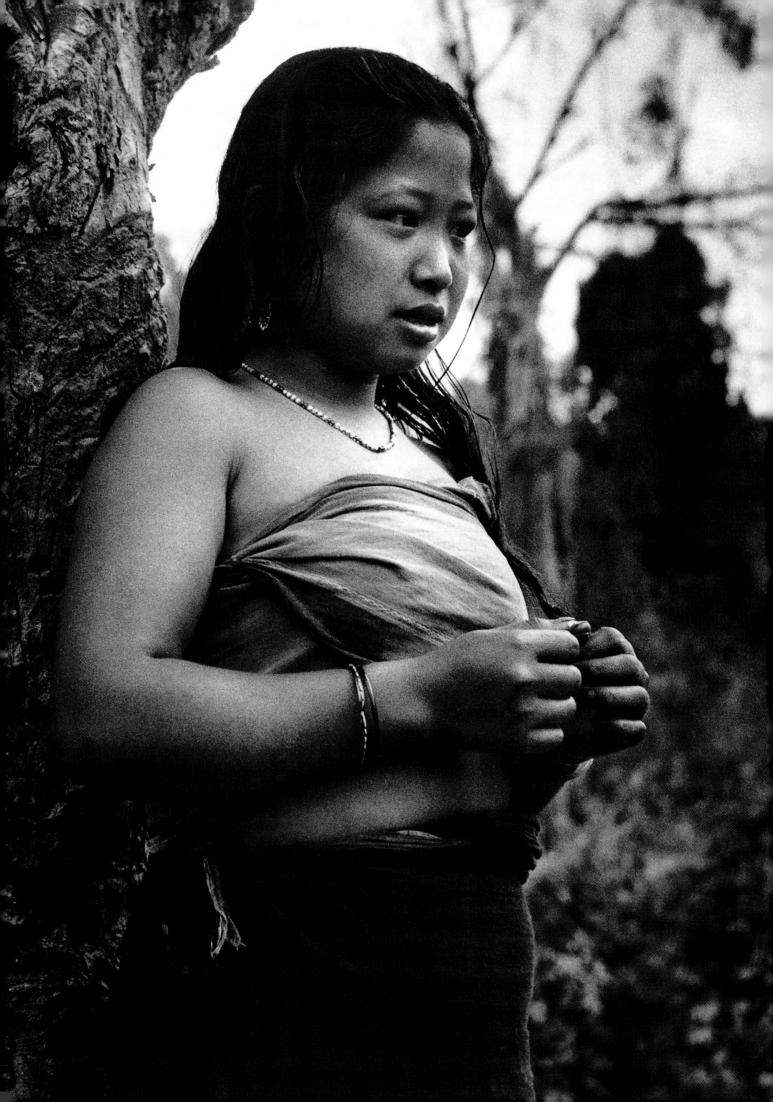

THE TRIBES OF TRIPURA

See page 122:
Hajang women fetching water.

See page 123:
Roang women.

Facing page:
A Chakma girl. We met her on
our way to her village.

I was in Agartala, the capital of Tripura, to photograph the wedding of its young Maharaja with a princess of Gwalior. I may say, somewhat apologetically, that this was the only assignment of its kind I have ever done, being induced by a good friend, who was related to the family by her marriage. The ceremonies had coincided with the Holi festival, and the revelries—including a dip in an indoor pool filled with coloured water—which I was not spared, left me rather exhausted. However, when a friendly young man offered to take me to some Chakma tribal villages a few hours drive away, I managed to get into his car fairly early in the day.

We were in the vicinity of the villages before mid-day and parked the car under a tree. Beyond this, the road branching out towards the steep hill and on to the village, barely a mile away, looked impossible for a car to negotiate. There was a plump young Chakma girl standing there as though sent to welcome us. She was contentedly chewing a *pan* and biting off bits from a dried tobacco leaf. She wore a light blue *lungi* around her waist and a pink piece of cloth with a light blue border was wrapped over her upper torso and tied at the back. My young friend asked me to photograph him with his arm around her shoulders. She complied with his wish without the slightest embarrassment or coyness and then led the two of us to the village. I was pleasantly surprised, considering that her first encounter with us, two complete strangers, hadn't been exactly conventional.

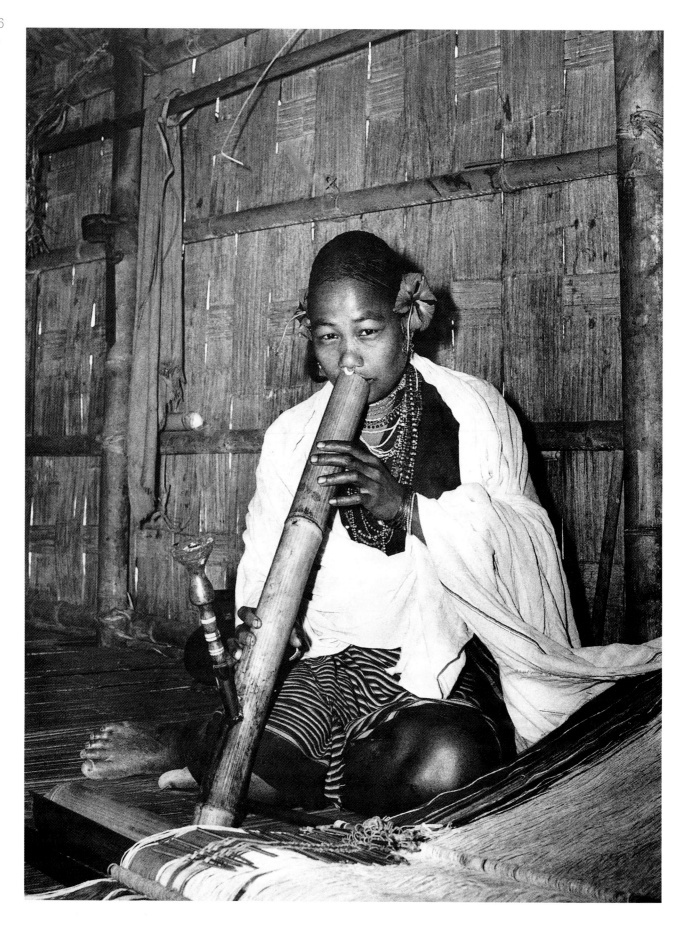

As in most tribal villages in the rain-sodden eastern-most corners of India, the straw thatched huts of the village were high above the ground on stilts, but not as high as those found in the hills of Assam and the North-East Frontier. There wasn't enough space below the huts to shelter their cattle or pigs. They were just high enough to protect the floors from the water during the rains. The walls were made of split bamboo, dexterously woven into broad interlaced bands. The village was on a low hill sloping gently down to a fordable stream and behind all the houses were pathways leading downhill to the stream. There were very few men around when we reached the village. The women were busy fetching water from the stream in pots and pitchers which they stacked in enormous wicker baskets carried on their backs, slung from a thick woven strap across their foreheads. All kinds of things—bags of grain and vegetables gathered from the fields, firewood from the forests and sometimes even babies comfortably swathed in a pile of cotton mattresses—were carried in these baskets. A young woman was sitting in her front yard winnowing grain; children who were sprawling all over the place came running and gathered around us, eagerly curious. It was unusual to find that all women were not similarly dressed, some preferred the style of the girl we had met first, some wore blouses and others were well covered in striped cloth, worn sarong-style. Most of the older women, however, were bare above the waist.

When we entered the first house, we came across an extraordinary sight. A woman was smoking a pipe bigger and broader than her arm while rocking a baby in the wickerwork cradle. The long stem was made of stout bamboo while another slender and shorter piece carrying a claypot with the tobacco in it was inserted into it at an odd angle. It seemed to be the most odd and cumbersome device ever made for smoking. She passed it on to another woman and a girl who were weaving on a loom installed in one corner of the bare and spacious room. I watched them puff blissfully, wondering how they could steadily hold its weight with one hand while doing a skilled job with the other. The sun was low over the hills and the men began to return by the time we had done our round of the village. They were tired and thirsty and took us to their pub, the community drinking house, to share their rice-beer with us. There were stacks of large

Facing page:
A Chakma woman smoking her bamboo pipe, Tripura.

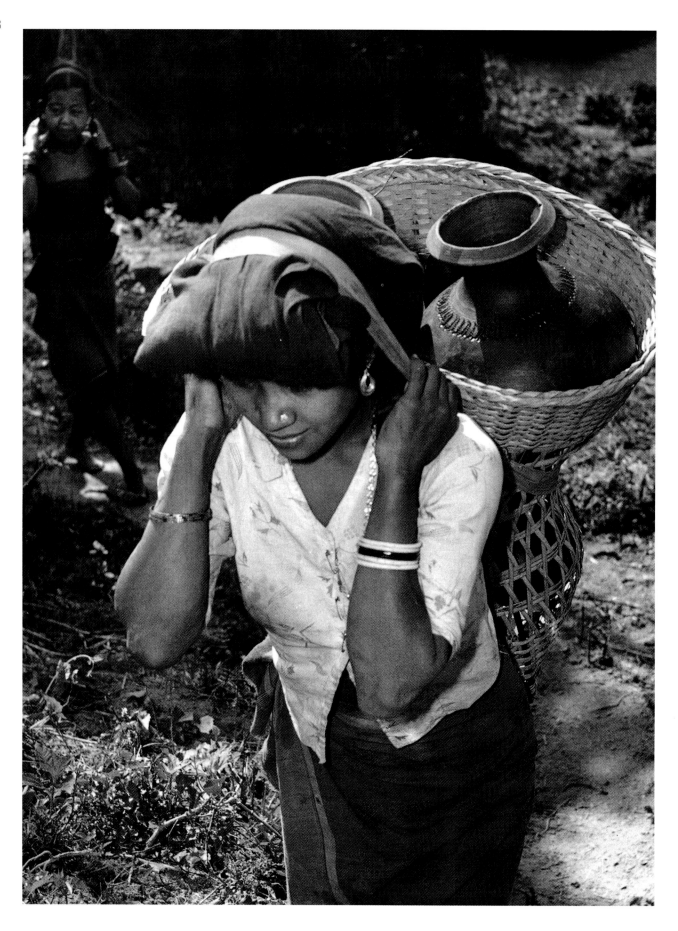

pitchers, cluttering up the place and groups gathered around those which had been lowered to the floor to drink from. No cups, not even leaf cups were used. Only hollow reeds cut into equal lengths were handed over to take draughts from the same vessel.

The flat lands of Tripura rise into the hills forming 'hill Tripura', which merges into the Lushai Hills of Mizoram, bordering Myanmar. There are many tribes in the high hills beyond the foothills. Many years after this brief encounter with the Chakmas, I returned to Agartala to photograph the refugees during the Bangladesh war. On my way from the airport to the town, I found some of these tribals as seasonal labourers, cutting grass, and I stopped to photograph them. But I never had any opportunity of going to the inviting blue hills in the distance.

Facing page:
A Chakma woman carrying water pitchers in a basket.

Below:
Chakma women working on the loom.

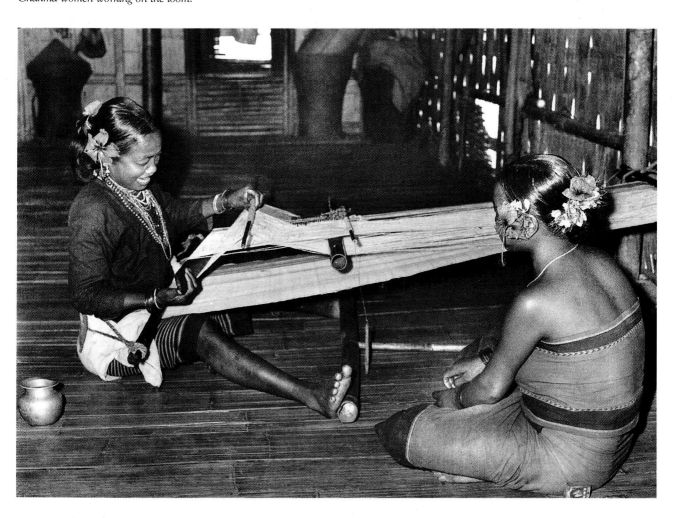

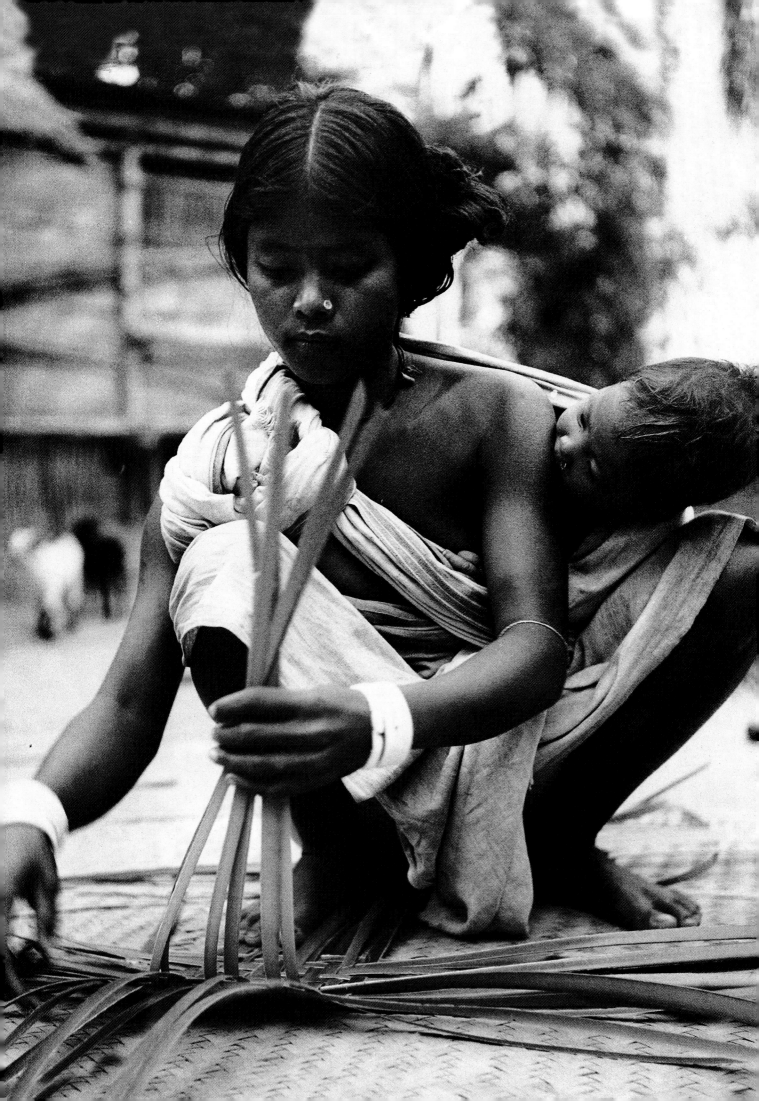

THE HAJANGS

I visited the Hajang tribal area in north Bengal to photograph the *Tonk* movement which became an open rebellion against the landlord there. Mani Singh, the son of one of the rich rajas of the district was the leader of this movement. I met him at Mymensingh town, in north Bengal (now Bangladesh), as was arranged, and then I went with him to the small town of Susong where father and son lived in rival camps.

Most of Hajang country is now in Bangladesh, but many of the tribals have taken refuge in Indian territory—in the Garo hills and in the northern districts of West Bengal.

I must explain the background of the Tonk movement. Most of the poorer peasants and particularly the tribals in Bengal, as in many other states in India, were agricultural labourers. The land they tilled and worked on belonged to the landlords and they were given one-third of the annual crops as their share for their year-long labour. The landlords were merely landowners and neither worked nor saw to the maintenance, irrigation and fertilization of the fields. The landless peasants backed by their organization, the Kishan Sabha, demanded two-thirds of the crops as their share. This led to the *Tebhaga* (the claim for two-thirds) movement all over Bengal. Many of the backward tribals and poor people did not even get their due one-third share because the granaries were owned by the landlords. In such poor farming conditions, a better deal for the share-cropper was to keep just a little more rice than the minimum for his own

sustenance, and to pay the landlord in cash for the remainder of the crop, this cash being gained by the sale of other produce.

Tonk is a local variation of the Bengali word *taka,* meaning money or rupee. The Hajangs, like all primitive, agrarian people, wove their own clothing, grew their own food crops and vegetables, raised their own cattle, and had the wealth of the forest—game and edible roots and fruits—at their disposal. They had little need for money, but they could not let most of their staple food, the rice they grew, be taken away from them year after year. So they decided to store up the harvest in their own granaries and not in the landlord's. There were meetings, demonstrations and processions: the tribals were armed with sticks and spears and there were incidents of violence and consequent fierce reprisals and repressions.

I set out from Susong at daybreak for Lengura village in Hajang country with Mani Singh and two of his Hajang companions. It was a dark and misty

Hajang girls bathing in a stream.

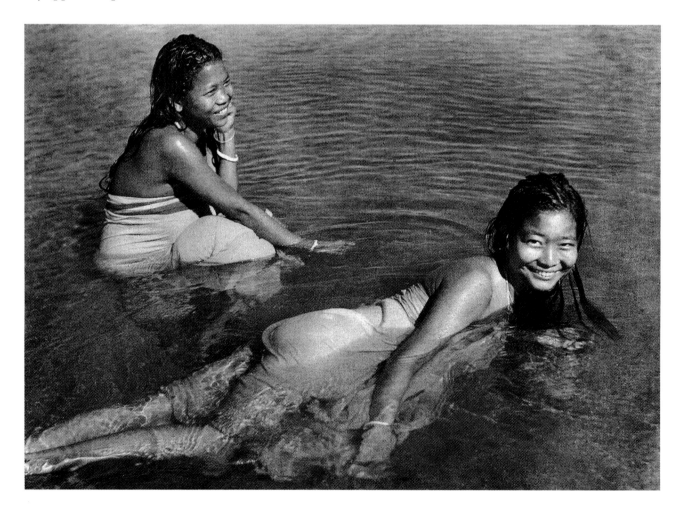

dawn and without a Hajang villager guiding us, we would never have been able to find our way. There were wide stretches of paddy-fields divided by embankments on which we walked. There were no landmarks to set our course by. The sun rose over the misty fields turning the eastern horizon a bright crimson; there were as yet no villagers in sight. When we reached Lengura village, it was nearly mid-day. A narrow stream, the Someshwari, descending from the Garo hills, wound its way through this village. There were settlements on both the banks. The shallow stream was easily fordable everywhere. Men walked across carrying their ploughs to work in the fields; women came to fetch water and bathe, and children romped around, rolling in the warm sand after a swim. The women were not confined to their households, but worked side by side with men in the fields.

We were welcomed with smiles and greetings for the sake of Mani Singh. We put up at the Kishan Sabha office located on the bank of the stream. Mani Singh's presence drew crowds of Hajang peasants all through the day. The village was bustling with political activity. Red flags with the hammer and sickle were flying from the top of the bamboo poles in courtyards and in the market place where a meeting was held in the morning after our arrival. Mani Singh

A Hajang farmers' procession protesting against the landlords.

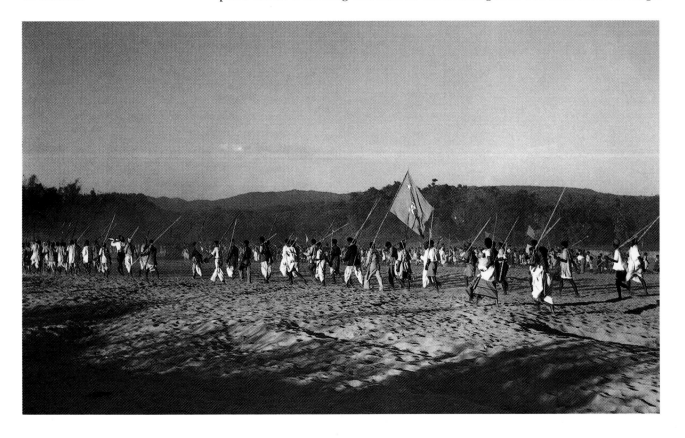

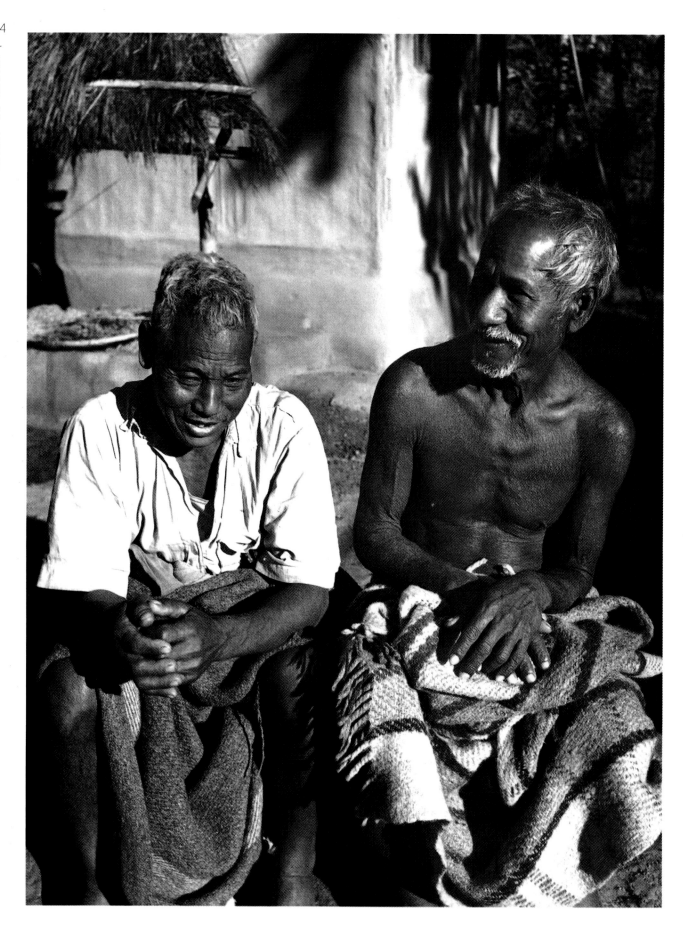

addressed a huge meeting, where thousands of Hajangs from neighbouring villages gathered to hear him speak. They came in noisy processions—men, women and even children, shouting slogans and singing songs—carrying festoons, banners, spears and sticks.

I could photograph little of the usual village activities during the first two days. When the village settled down to its normal routine, despite the apprehensions of fights in the coming harvesting season, I began to look around to take photographs. I was by then familiar with the villagers. Communication too was not a problem as the Hajangs spoke a dialect of Bengali. Lengura was a picturesque little village with neat thatched huts in rows with their own yards, cowsheds, and granaries.

The Garos were their nearest neighbours in the adjoining hills across the river. In the market place and on the village paths, there were groups of Garos exchanging fruits, vegetables, roots, wild honey, furs and handwoven cloth, for money or sacks of paddy. They brought rice-beer in long bamboo funnels and offered it to the villagers sitting down in groups for a chat and a smoke. The Hajangs reciprocated this friendliness and would go freely into the forests of the Garo hills to gather firewood.

During the remaining days of my stay, I was allowed to walk freely in and out of the courtyards and houses, and along the river bank, photographing anything and anyone. Even the women bathing in the stream were all smiles when I photographed them.

Despite the prevailing political tension, I found that they were relaxed and at ease. I was impressed by their calmness, their ability to face problems. I have never found such calmness during a workers' strike in Kolkata or Mumbai.

These people were not as insecure as industrial workers, totally dependent on the wages of their factory jobs. Nature had provided the Hajangs with most of their basic needs and they were not unduly disturbed by fears of the consequences of fighting with their landlords.

Facing page:
Hajang village elders,
Lengura village, north Bengal.

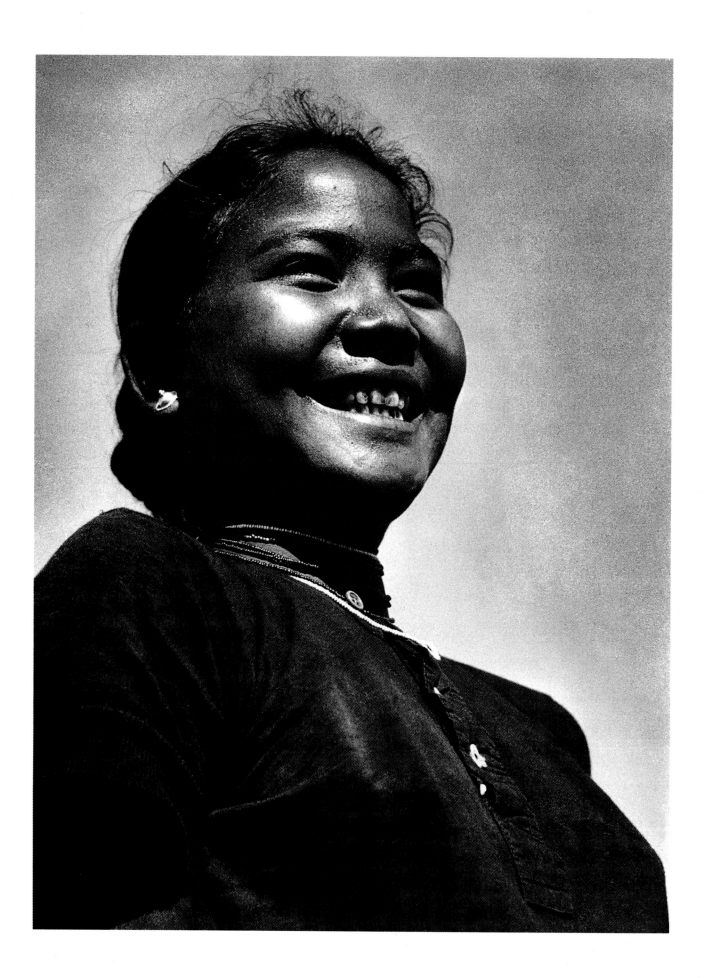

5

ASSAM AND MEGHALAYA

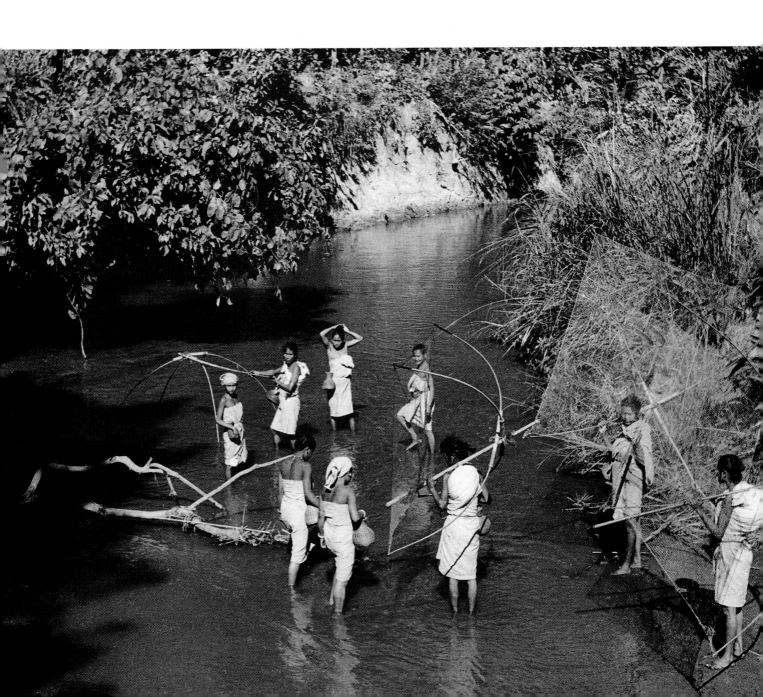

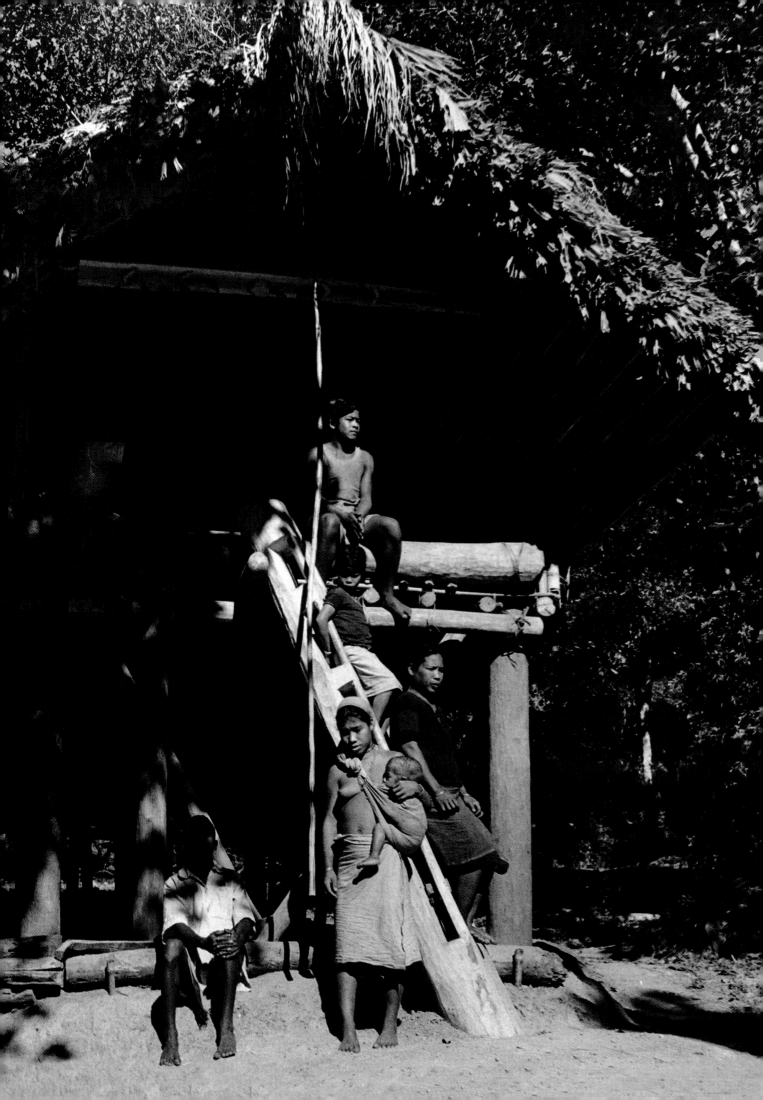

The Tribes of Assam and Meghalaya

See page 136:
Garo girl, Meghalaya.

See page 137:
*Kachari women fishing in a stream,
Meghalaya.*

*Facing page:
A Garo hut.
The strangest house I have ever
lived in.*

Most of the tribes living beyond the eastern borders of Bengal (now Bangladesh) were known as Assamese, although the North-Eastern Frontier Agency had been a separately administered area during the British days. Now Assam is split into various new states, namely, Meghalaya, Arunachal Pradesh, Nagaland and Mizoram. There are some tribes, however, who are still inhabitants of the Brahmaputra valley, which is the heartland of Assam. Among them are the Kacharis or Bodos, the Ahoms, the Lalungs and the Mikirs. Assam also has a large population of Miris and Garos, an overspill from the neighbouring states of Arunachal Pradesh and Meghalaya, and the Hajangs who came in as refugees from what was then East Pakistan.

The Kacharis or the Bodos are a populous tribe spread over the Goalpara, Kamrup, North Kachar and Nowgong districts of Assam. If you go to Guwahati, the capital of Assam, you may even find them fishing and working in the fields on your way from the airport to the town. I had been to Kachari villages for the first time, with Mr Phani Bara, then a young college student and later a Communist Party leader in Assam. I have pleasant memories of the bicycle rides in the mornings over rough roads to Kachari villages near Guwahati, eating a breakfast of bread and bananas on our way and relishing the fish curry and rice when we reached hospitable villages. Towards the end of the Second World War, I revisited the Kacharis. From Badarpur to Ramdin there was a hundred and

thirteen-mile long metre-gauge railway line going through tunnels, crossing small and large streams on its way. During the war it used to be a busy route and the trains were crowded. I remember waiting two whole days at Parvatipur junction failing even to get a seat. Finally I travelled sitting on a suitcase I had managed to push into the doorway of a carriage, leaving the door wide open. I got off at one of those temporary stations built for the army and walked down in the afternoon to a village with a friend who was a Railway employee.

The Kacharis looked so similar to the Assamese that visually there was little to distinguish them except their simpler style of dress, particularly that of the

A Mikir couple.
I found them doing up each other's hair.

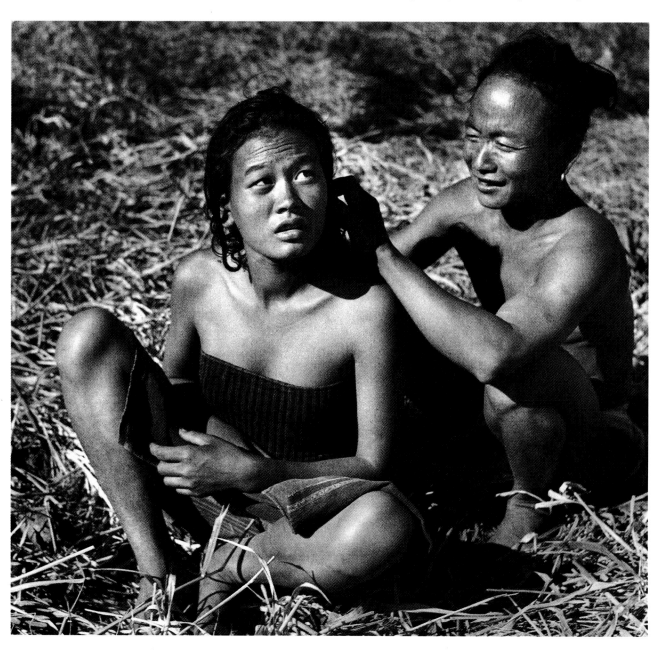

women. They wore only a homespun wrap tied around under their arms. The activity that fascinated me most in the Kachari villages was fishing. It was one of their main occupations, as well as their favourite pastime. The implements were rudimentary but very effective in the shallow streams. Nets were stretched on bamboo frames, attached to long bamboo poles and split bamboo fish-traps were set wherever the water was diverted into fields or passed through outlets under culverts across the roads. I had excellent opportunities of photographing the Kacharis engaged in their most passionate pursuit, intending to catch all the fish in their streams and pools.

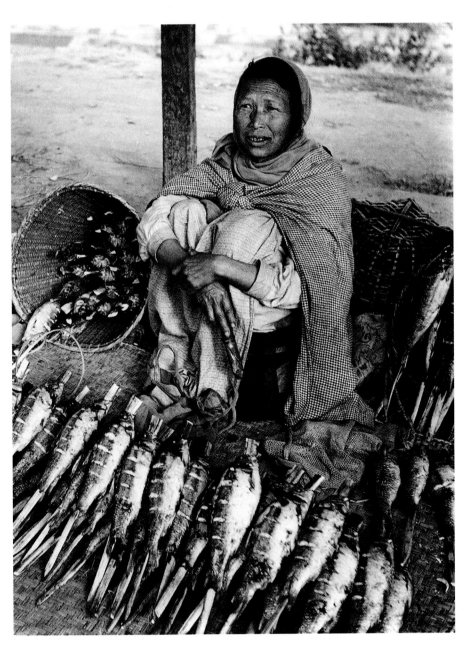

A Khasi woman selling barbecued fish in a Shillong bazaar.

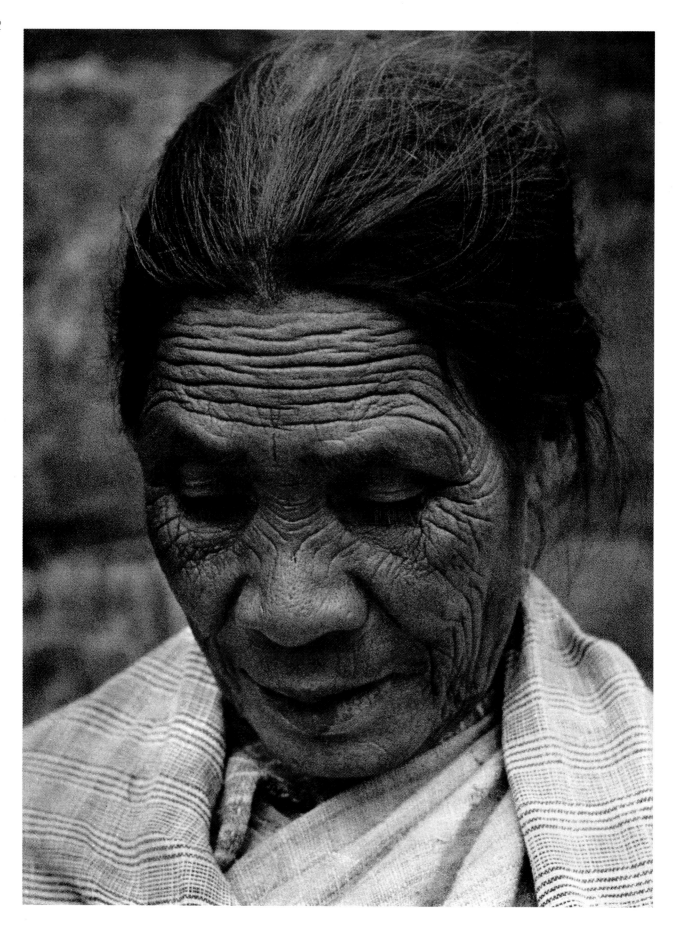

The Kacharis are on their way to becoming identified with the Assamese, as have the Lalungs and some of the Garos of the plains. Even now their villages do not present a remarkably different picture from those of their Assamese neighbours. The Mikirs, another tribe living in the hills extending to the edge of the Kaziranga Game Sanctuary, are unlikely to be confused with the Assamese. Although their hills rise from the heartland of the Assam valley they have remained a hill people, away from the influence of the people in the plains.

The Mikir hills have become quite infertile because of the practice of jhum cultivation. The soil on the hill slopes has eroded. So, like many of our tribes affected by this disastrous practice, the villages here have shifted to lower altitudes to grow their crops in the valley.

We reached a village at the edge of the hills, late in the afternoon. Every household had its vegetable patches, pigs, goats and chicken. They wove their own cloth and could more or less do without any outside contacts. They visited the bazaars only to buy salt, metalware and the irresistible plastic-wares. As a result, their style of dress, quite different from most of the neighbouring tribes, remained unchanged. The men wore embroidered jackets open in front, in addition to their loin cloths. The women preferred their two strips of striped cloth, the wider one worn as a short skirt and the narrower one tied at the back around their breasts like the fashionable 'halter', leaving the midriff bare. They continuously chewed pan, and consequently their lips were tinged a rich red and their teeth were badly stained. In the village I went to, I found a very handsome young couple doing up each other's hair. The only good photograph I took that afternoon was theirs.

I never went far enough out of Shillong into the Khasi and Jayantia hills. The experience of photographing the shy Khasis in Shillong's bazaar and in the villages outlying the town was in no way different from any amateur's taking photographs on a holiday. The photographs of the Jayantias were taken during the rehearsals of one of the annual Folk Dance Festivals in New Delhi.

The first time I went to the Garo hills was from across the border of north Bengal, from Lengura, a village of the Hajang tribes. We waded across the Someshwari river, wide but shallow in the summer months, and went up the

Facing page:
An old Khasi woman.

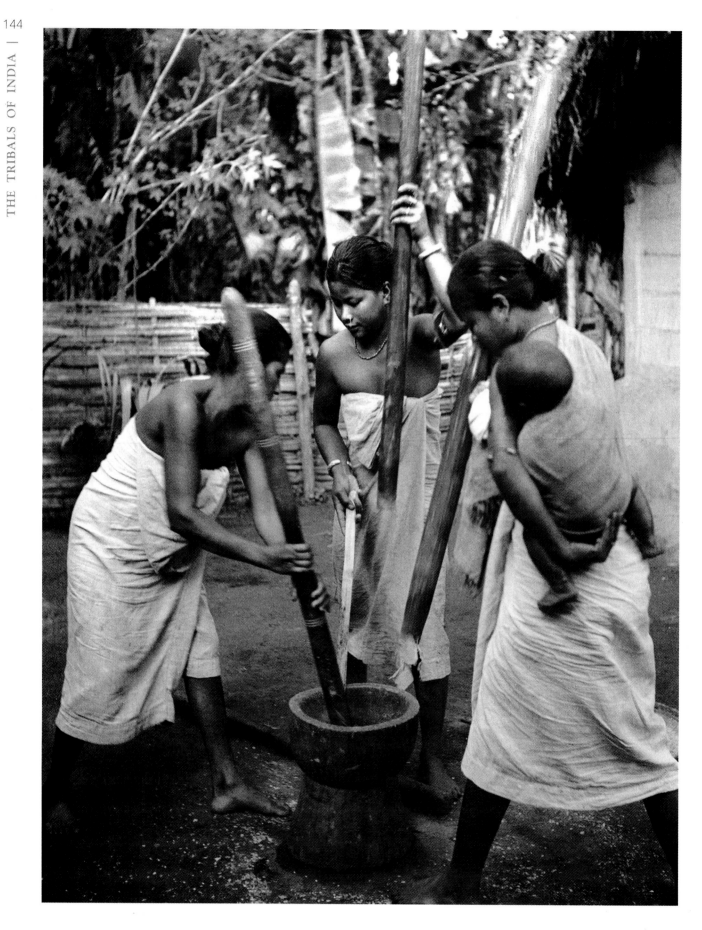

Garo hills. We walked uphill and through the forests for many miles and reached a small village at mid-day. There was no one there in the three huts and not knowing whether we would find any shelter in any of them for the night, we proceeded until we reached a larger village consisting of seven huts. We found ready hospitality and were housed in one of the sturdy log huts. It was built on stilts as most others in Meghalaya and Arunachal were, to keep away the wild animals. The ladders to the huts were tree trunks with notches cut in them, slanting up from the ground to the doors. Climbing up and down with shoes on was quite hazardous, but we managed without any mishaps.

According to old Garo legends, their original home was in the Tarura Province in Tibet and the Yangtze Kiang and Hwang-Ho basins in China. They migrated to India and built settlements for themselves around the Arabella hills and the Someshwari river. The yak is spoken of in Garo legends, but Garos have never seen one. From such legends as well as from other evidence, scholars assume that both the Kacharis and the Garos must have come into India along the Teesta and other minor river valleys along with many of the Mongolian tribes. Looking at all the Mongoloid faces around me, I thought that it could well be possible that it was so. The people of India are a mixture of all the ethnic groups of the world and we have no way of knowing for a certainty which came from where and when.

When we went out to take photographs around the village, we saw their ingenious water-supply system. The water was carried to the villages by split bamboo pipelines from clear mountain streams all over the hills. The forests were tall and dense. I was surprised to find many jackfruit trees, which I had always thought grew only in the hot fertile plains of Bengal and south India. After a pleasant walk of several miles in the shady forest paths, we came across another village where some young girls were bathing under one of these bamboo pipelines. As they saw us approaching, all of them ran off into the forest. Only one lone old woman remained, to whom we explained that we meant no harm but only wanted to take some photographs. She summoned up all the dignity of her age and ordered the girls to come back at once, and they came very meekly. They had put on their knitted black cotton vests and were quite self-conscious

Facing page:
Kachari women grinding grain.

at the beginning but they soon revived and although the photographs I took were posed portraits, I always treasured them. My favourite photograph of the Garos was taken the following day, on our way back to the Hajang village in the plains. It was of a group of Garo men and women carrying enormous basketloads of forest produce on their backs.

Facing page top:
Garos bringing leaves from the forest.

Facing page bottom:
Dancers from the Jayantia hills in
Meghalaya, rehearsing for the
Folk Dance Festival, New Delhi.

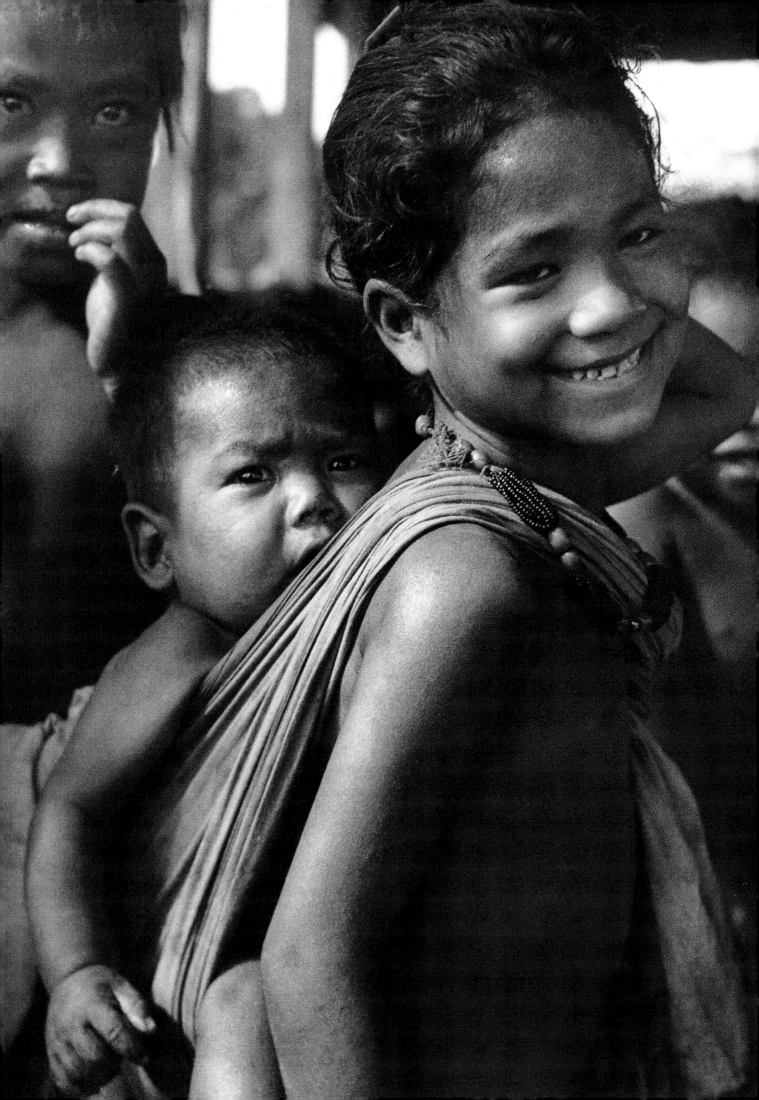

THE MIRIS

The Miris are one of the larger tribes of Assam. Their habitations extend to the far eastern regions of the NEFA (Arunachal Pradesh). Most of the Miris however, live in their villages on the banks of the Brahmaputra and its islands. They are isolated enough to preserve their beautiful customs and a compact tribal economy. The river Brahmaputra constantly erodes its banks and its bed often rises because of the silt deposit to form large islands. The Brahmaputra widens its course to flow around these sand-bordered islands.

We were taken upstream from Jorhat by boat to the largest of these islands—Majuli, a Miri island, lying between Jorhat and north Lakhimpur. It was a hard task for the boatman rowing against the rushing currents of the river swollen by monsoon rains. We were tired too when we had to walk many miles to the Miri village across the mud and sand of the river bank and the many water courses running through this island. We waded through some of them but others were too deep and too wide. It was one of those still afternoons in the open country when no leaf stirred and no birds twittered. In such silence our voices hailing the lone boatman on the other bank never failed to reach him and he hurried to take us across. We welcomed each such respite from walking through the ankle-deep mud and sand. These brief spells of rest after washing the mud off in the cool waters were delightfully refreshing.

When we came close to the village, Vekalimukh, the sun was about to set. The Miri huts built high on stilts, were silhouetted against the crimson sky.

People were coming back from the fields and the children were at play clamouring noisily. But as we came nearer they grouped together and watched us silently. The headman of the village, Karka Chandra Dalai, gave us shelter and overwhelmed us with hospitality. As I was a guest of the patriarch, I gained access to all the homes. I made use of this privilege and began going round the village to take photographs.

The village was scattered over a large area. Each house was a single long shack erected considerably high off the ground over a scaffolding of poles. Beneath this, all the livestock of the family had their quarters. The shack was partitioned into rooms leaving a narrow corridor running from end to end. The living area was very clean and tidy, but the area under the bamboo floor which sheltered the animals was literally a pig-sty. Water from inside the rooms trickled

Miri women weaving their traditional 'Miri-jean' with tufts of cotton wool.

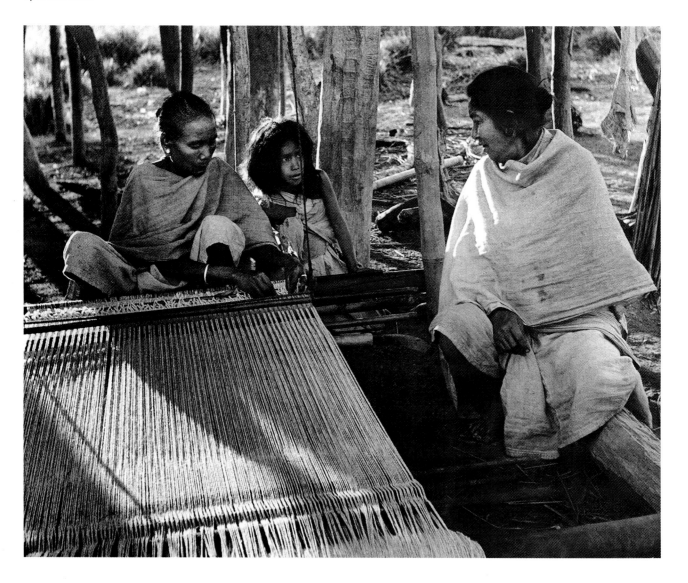

down through the floor and collected into puddles in which the pigs wallowed. The chicken and ducks too, scampered in and out of the place freely. It seemed strange that the people, personally so clean and wearing spotless clothes, could endure this filth right under their dwellings.

When we set out to go around the village early in the morning, the men had gone to the fields. The women were busy, sweeping their yards, scrubbing utensils, and minding the fowl, pigs and cattle. Some with shiny brass pitchers, bamboo fish-traps and baskets were on their way to the river to fetch water or to catch fish. Some were going to the forests to collect firewood, edible roots and fruits.

In a Miri household the girls help with the housework and also look after the small children. Almost every little girl, seven to twelve years old, has a baby

Miri woman sweeping the yard of her long house on stilts.

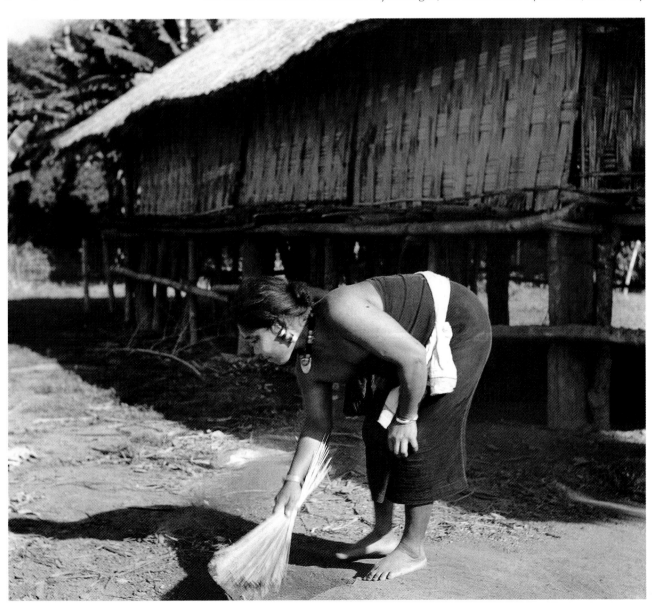

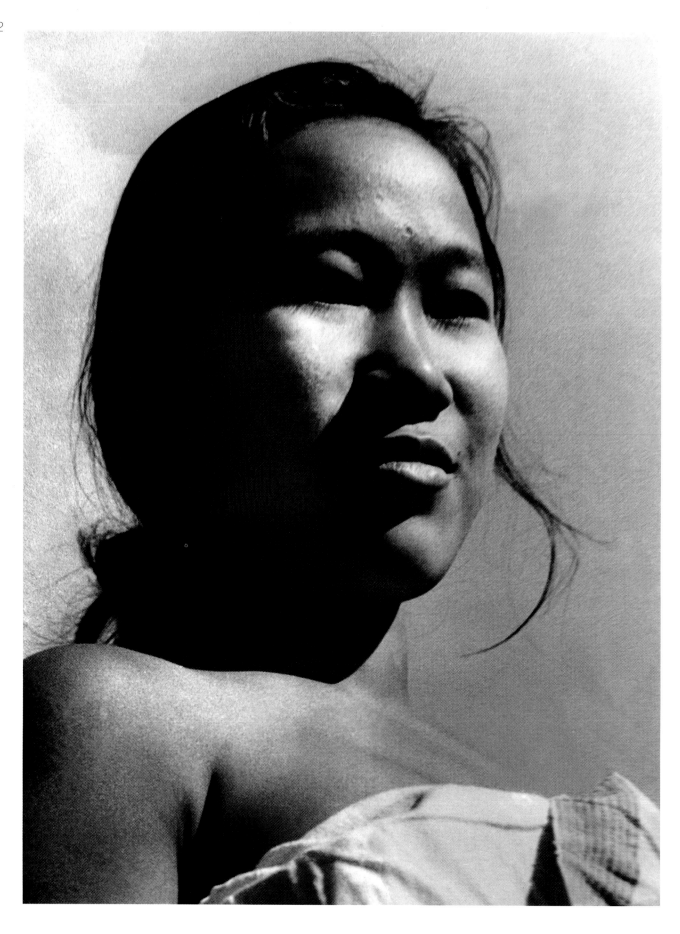

tied to her back while she placidly goes about her chores. The more industrious ones even spin yarn on their *takli*, a metal disc with a spindle in the centre. The mothers are content to leave their infants to the growing daughters, who have a wonderful time with the living dolls they look after and play with. Their motive is also to prepare the daughters for motherhood and the duties of being a housewife. The boys have it easier—they only tend the cattle, in long lazy afternoons riding bareback on the buffaloes, perhaps playing the flute made of papaya stems, or raiding a neighbour's orchard. Swimming for hours in the dangerous waters of the Brahmaputra is their most favourite pastime as the grazing grounds are always near the river.

Everyone comes back from the field for the mid-day meal of rice and fish with salt and chillies. This is accompanied by roots and greens, picked from the jungle or grown by them. There is plenty of *apang*—their mild home-brewed rice-beer to wash the food down. The older women are then left with the sleepy children and they often spend the afternoon at their looms weaving long lengths of fabric. 'Miri-jean', a light blanket with loose strands of cotton interwoven with threads, is their best-known handicraft. It used to sell all over Assam and Bengal before losing out to its factory-made equivalent.

In the evenings, the Brahmaputra looks like a silver ribbon beyond the vast sand banks in this island. The faint outline of hills in the distant horizon suddenly takes on sharp contours against the luminous sky. People begin to come back home. The women sweep the house again and light a fire and go to the river for a bath. Then, they all come back, and sit by the fire or in the open yard in the summer while the food is being cooked. This is the time for friends to pay a visit. They sit for hours smoking and gossiping, shouting at their wives impatiently if there is a delay in serving apang and the friends are not properly entertained. For such delays, a man may even beat his wife without social censure. The headman told me that this practice was not resorted to any longer: 'Beating a wife used to be a matter of right', he said, 'but nowadays the infuriated wife retaliates by beating her husband!'

There is no exploitation in the Miri social system. No Miri starves in his village. People are always prepared to help each other and the harvest is shared

Facing page:
The beautiful daughter
of my Miri host in Majuli.

by all the members of the community who work together on the land. This prevents great differences in wealth.

Miri boys and girls grow up together, mix freely and their marriages are of their own choice. Their elders seldom interfere. The boy courts and proposes, and sends gifts of betel-nuts and a pot of wine through his parents to indicate his intentions. When the girl and her parents accept him, they are formally engaged. If the negotiations break down, the lovers may elope. They run away from the village and come back after some days declaring that they have lived together as man and wife. Then they are accepted as married and nobody questions the legitimacy of their behaviour. Custom has granted equal sanctity to this as to the more ceremonial marriage which is often avoided merely

Miri woman and children picking berries from twigs.

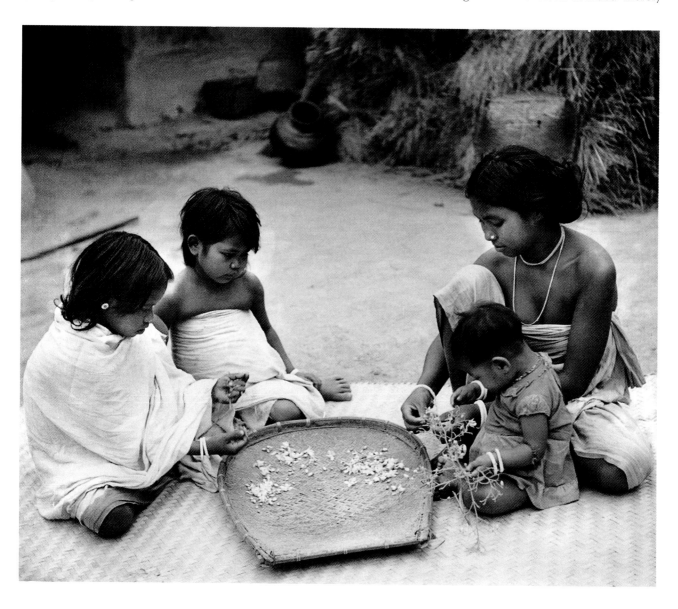

because it is more expensive. After each marriage of course, there is much feasting and drinking by all the villagers and that is why marriages are often delayed while the young lovers patiently save money to pay for the banquet.

Divorce is permitted, but the village elders must be convinced that it is necessary. Social disapproval is so severe that a runaway husband or wife living with another person finds life impossible. When a divorce is granted, the children usually remain with the mothers but the father has a right to claim them. He usually claims only the male ones, for the girls, when married, go to another home and are of no help to him in his old age.

The sons inherit the father's property. They have equal rights. The eldest becomes the trustee and if anyone demands a partition, the village elders assemble, headed by the *Gaon Bara* (village headman) to decide his share. They don't go to the courts unless they feel that some grave injustice has been done to them.

Although the Miris are Hindus, their forms of worship are different—the old Vedic rites, interpolated with tribal beliefs. The Sun, the Moon and the ancestors are worshipped in the festival of *Amrag-puchak*. Apang and pig's meat are offered, and the elders sit together and chant verses. In the evening, old men and women dress up brightly and dance together. The younger people do not take part; they are invited to watch, and share in the feast which follows.

Dabur, performed twice a year, is their most important ceremony. It is the worship of *Niranjan Nirakar* (God)—one who has neither form nor attributes—for the safe harvesting of crops and the driving away of all evil spirits from the village. All the young people set out in a procession early in the morning, carrying a lighted torch and bamboo-poles. They surround each house as they pass by it and beat the walls with their sticks saying aloud: 'We are taking away all the evil spirits; all your sufferings will be banished.' Then every family offers one chicken or eggs, a bowl of rice or a pot of apang to them and these are brought to an altar. The livestock is sacrificed with the chanting of mantras before Niranjan Nirakar, who is also known as *Karsing-Kartak*, the Supreme Being.

The chant says, 'Father Sun and Mother Moon, the trees, creepers and reeds, and the rivers and the fields, all bear witness: today, we have given offerings to You (God). Take away all the evil spirits from the village.'

During the day of the rite, on all roads leading to the village, canes are tied between bamboo poles to keep away, symbolically, all outsiders. After the rituals are over, people feast on the sacrificed meat and wine. For five days they abstain from eating certain foods which are considered to be impure.

The Miri language is merely a dialect. Assamese is the medium of education in all their primary schools and almost all the teachers are Assamese. Their constant contact with the Assamese has led to the gradual infiltration of Assamese cultural influences in their lives. In the villages close to those of the

Miri families taking shelter on high ground during the Assam floods.

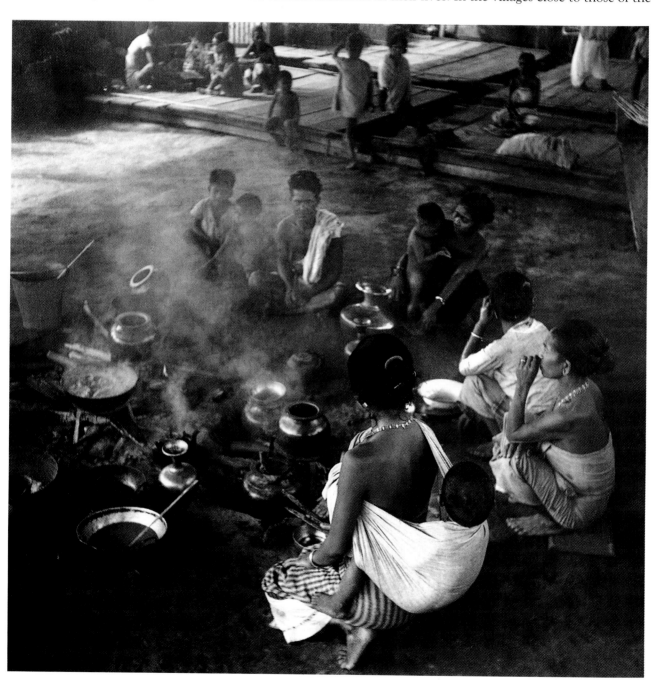

Assamese, the Miri customs are dying out. Their dances have disappeared under the disapproving frown of puritanical Hinduism, and the lovely, colourful sarongs of their women are also being discarded in favour of the Assamese *mekhala* and blouse. It is unfortunate that the tribals themselves have been persuaded to believe that this is a change for the better.

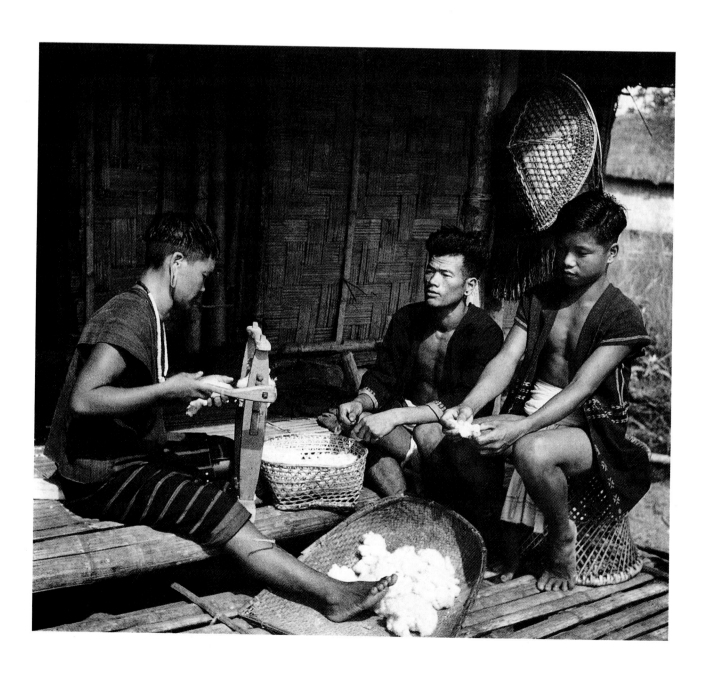

THE NORTH-EAST

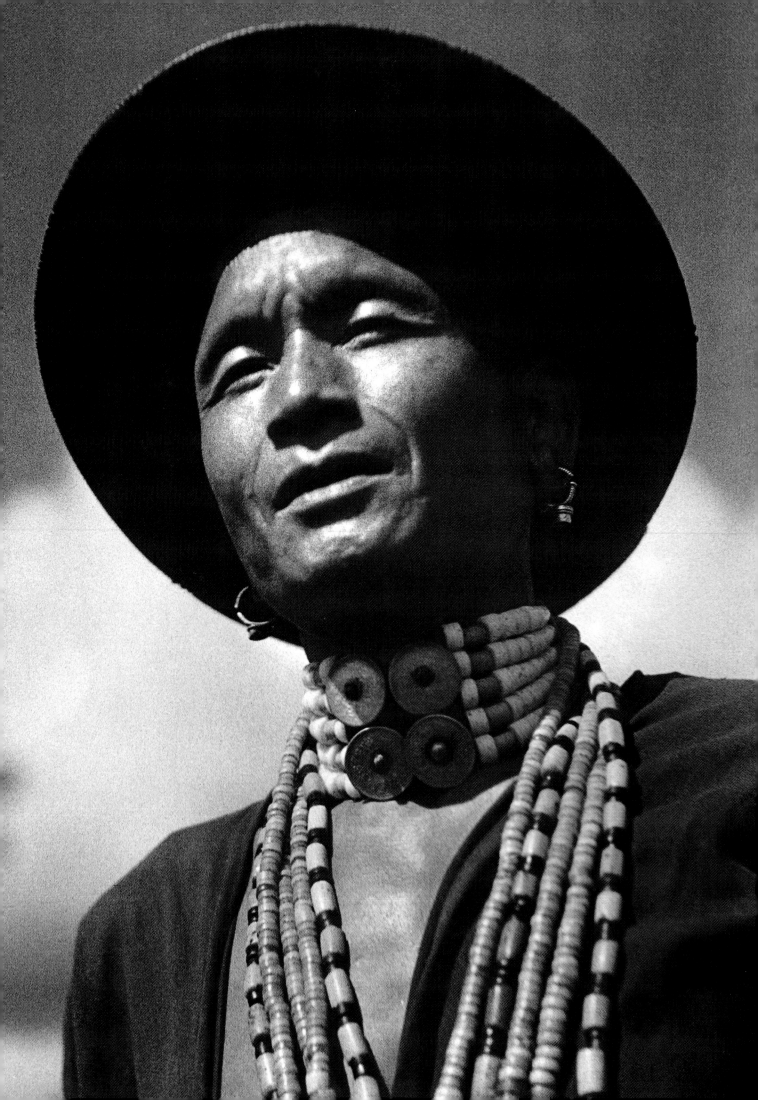

THE DAFLAS AND THE ABORS OF
UPPER ARUNACHAL PRADESH (NEFA)

The North-East Frontier of India is an inaccessible region. For me, it happened to be far more so, as I was there just after the Assam earthquake in October 1950. Bridges had collapsed and they looked like great humped sea-monsters half out of the vast stretches of water which flooded the countryside following the catastrophic earthquake. The roads were mostly under water and trains came to a halt in the most unexpected of places because the tracks were damaged.

The earthquake had dumped boulders in the rivers in the hills blocking their courses. The overflow, swelling with torrents of monsoon rain, soon spread all over the flat country at the base of the hills to create the great flood. Travelling across the vast stretches by surface transport was impossible. My Swedish companion, Tore Haakanson and I used our temporary U.N. credentials as reporters to persuade the civilian and Army authorities engaged in relief work to help us in our travel. So from Mohanbari, where the services of Indian Airlines ended, we were flown to NEFA (now Arunachal Pradesh) over the raging waters, in a tiny Beechcraft Bonanza. It was an old privately owned plane borrowed for the emergency. It coughed and spluttered and sometimes veered dangerously close to the waters. In the unending stretch of water, that appeared like a sea, there was no sign of habitation; only some tree tops and floating thatches of huts could be seen. The hills appeared as we approached Pasighat and we landed on a hastily prepared, temporary airstrip in a clearing in the hills.

See page 158:
An Abor family ginning cotton,
Arunachal Pradesh.

See page 159:
A Mijou Mishmi family in their hut,
Arunachal Pradesh.

Facing page:
An Abor village headman.

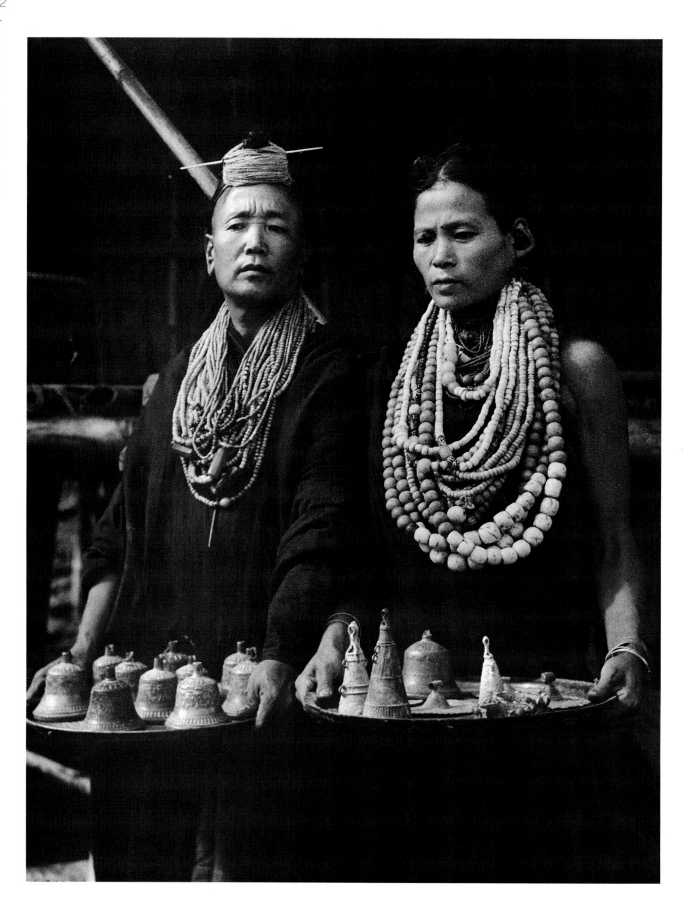

The political officer warned us to be careful in our dealings with the tribals. Sometime back, a group of engineers had gone in to their sacred snow-clad Se-La mountains to investigate the possibility of building a dam in the higher valley. The tribals had concluded that the visit of these outsiders to their forbidden mountains had enraged the Gods and the earthquake and floods were the consequence of their wrath.

We entered the southern regions of the Dafla hills where the Subansiri river came down from the mountains and entered the plains. The northern part of this territory was demarcated even at that time as 'unknown territories, unexplored and inhabited by hostile tribes'. The border land between India and Tibet was then not clearly defined.

The Daflas resembled the Tibetans in their dress and features. In the past, they were known as formidable warriors. The inhabitants of the frontiers were in constant terror of Dafla invasions. After the decline of the Ahom kingdom, the Dafla raids had been quite widespread. British rulers assured the haughty and acrimonious Dafla chiefs of security in return for their allegiance and the preservation of peace and order.

The political officer offered to put us up, but we were eager to walk to the nearest tribal village and live amongst them so as to know them better. We found shelter in a Dafla headman's hut who turned out to be surprisingly hospitable. We could speak to him and his family through our interpreter. Within a short time, I found the curtains of a forbidden country rising.

The Daflas, like the Mishmis, are caught in a mixture of Buddhism and their own tribal rituals of propitiating the gods. Further north in the craggy mountains separating India from Tibet, live totally animistic primitives as well as devoutly Buddhist communities with their lamas and monasteries. Verrier Elwin went far into these territories and I still regret that I was unable to accompany him as I did not have the official pass enabling me to enter the frontier area.

The photographs of the tribes in this chapter are of people I had met during my travels in the North-East Frontier.

The Daflas regard their household rather than the village as a society although that does not mean that they are unfriendly to others. Old couples

Facing page:
The Dafla headman and his wife
showing their treasures.

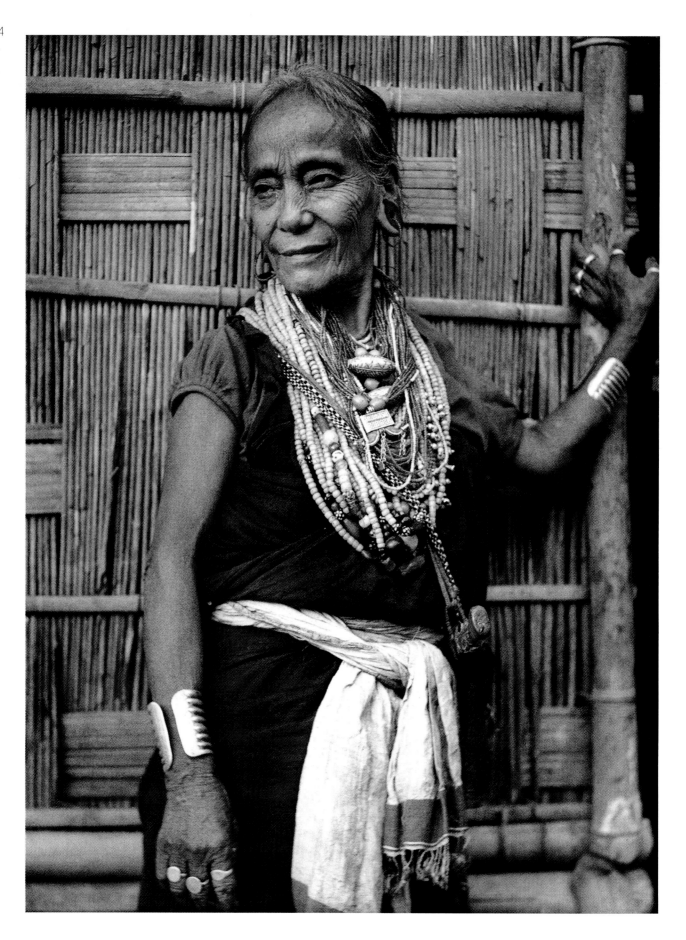

share the house with their adult children and grandchildren. The house is extended as the family grows. They only need wood and leaves from the forest to build these extensions. Each house is so far away from the next in their sparsely populated, densely forested hills, that social communications exist only at a rudimentary level. They have no communal dances, and few pleasures outside their family. But the desire for display, which is a socially motivated phenomenon, exists in their home-bound way of life. The older a woman becomes, the more heavy is her jewellery, although it is scarcely seen by her neighbours. I photographed young girls with a necklace or two, and the older women who could hardly carry the ornaments weighing down their aged necks.

There is very little use for money in Dafla country. Paper currency is not accepted because it is perishable when stored in bamboo funnels, the only container they have for such things. Metal coins are used to some extent; but real wealth consists of ancient Tibetan temple bells and bisons. The value of the bells depends on their antiquity; some of them are so highly valued that a Dafla can buy a whole village with one of them. My host and his wife showed me their store of wealth. They laid out the Tibetan temple bells on ornamented copper plates which they held up stiffly while I photographed them. The bison part is even more strange. There are wild bisons in the forests. If a member of a family goes into the forests, captures one of these and brands it with a family emblem, its ownership rests with the family. Dafla society will accept this claim and although the animal is never tethered it can be bought and sold. During marriages, these animals are offered as dowry to the bride's family. The new owners need not catch the bison immediately, but await a festive occasion to capture the gift and slaughter it for a big feast.

I went into Dafla country during a period of distress caused by the floods and did not, therefore, witness any festivities. But I was present during the funeral rites of one of the victims. The corpse was buried, and along with it the villagers buried the old man's sword, axe, bow and arrow. Before covering the body with earth, a bamboo funnel was inserted into the grave so as to reach the mouth of the deceased. For several days some food and wine would be poured down this funnel to satisfy the dead man's hunger and thirst. The village priest

Facing page:
An old Dafla woman in her jewellery.

chanted prayers to keep away evil spirits so that the soul could rest in peace.

After we finished our work in the area, we found that we had no means of returning to Jorhat. The small plane which had brought us to Pasighat had broken down and could not be put back into service before at least a fortnight. We were told that the only possible way of going back, was to take an elephant ride to the point where the Subansiri river met the Brahmaputra. We could take a steamer from there. The elephant arrived early one morning. We mounted the pachyderm, our rescue ship, with some trepidation. I was afraid it would step into a pond or river and sink us with it. I had underestimated the wisdom and sure-footedness of this great animal. We did not even wet our feet during the twelve-hour trip across the huge stretch of water. It was only when we reached some dry land, between miles of water-logged terrain that we could dismount.

It was an Abor village. We stretched our stiff limbs and walked down to a spot where some of the villagers had gathered. We found that they had skinned a tiger and were stretching the skin on bamboo poles to dry and cure in the sun. Meanwhile, we found some young people barbecuing some meat over a fire. Soon after our arrival, the villagers gave us rice-beer and brought us some meat to eat. We were both hungry and thirsty, having had nothing to eat or drink except lukewarm tea from a thermos flask since we had started. We ate and

Below left:
Dafla burial ground. The cane baskets are supposed to carry food and wine for the departed soul.

Below right:
Abor child attending the barbecuing of tiger meat. The villagers had killed the tiger with poisoned arrows.

drank with great relish. Only later we came to know that the meat we had eaten was that of the killed tiger. That did not bother me at all, but I could not help worrying over the fact that the tiger had been killed by poisoned arrows. Even though I was assured that the poison remained only in the clotted blood, and the tribals were wise enough to wash out all of it before they ate the meat, I was cautious and waited for an hour before re-mounting the elephant. I did not want to die painfully and helplessly on an elephant's back, surrounded by water, where no help would reach me. This was my first brief yet memorable encounter with the Abors. In due course we reached the steamer point where we changed over to a steamboat and left for Dibrugarh.

Our next destination was Mishmi country via Sadia. Sadia was a good base to make trips into the main belt of the Abors.

The tribals inhabiting the Dihang river valley are called Abors by the Assamese, which in some Assamese dialects means 'hostiles'. They are still known by this unfortunate name although in their own language the name simply means 'man'. Like the Daflas, the Abors also have similarities with the

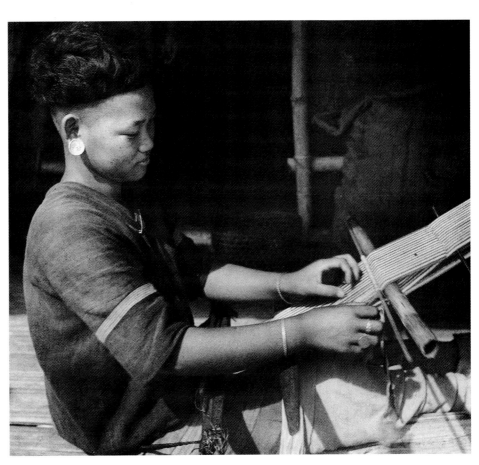

An Abor woman weaving on a loom, Arunachal Pradesh.

Tibetans, and more so with the Tibeto-Burmese. Their features are Mongolian, but their build is small compared to the taller and more virile-looking Daflas. Their country consists of small hills and valleys with sparkling streams running alongside the villages. In an Abor village, the houses are usually adjacent to each other like one long row of terraced houses, and they are built on stilts high above the ground. The walls are made of logs and the roof is thatched with leaves. A long corridor connects the huts, as in railway carriages, so that a village is often like a long dormitory. The wooden floors are covered by split-bamboo mats. The space below is used for keeping their animals: pigs, buffaloes and goats, as well as chickens. The cooking is done in these inflammable rooms in ovens built of stone and sand. In every village there are *mandaps* for the unmarried young men and guests, and separate *rasangs* for the unmarried young women. Until they are married, the young men and women live in these separate hostels which the village provides. They weave their own traditionally designed clothes, and

Abor tribal girls dancing, NEFA, Assam.

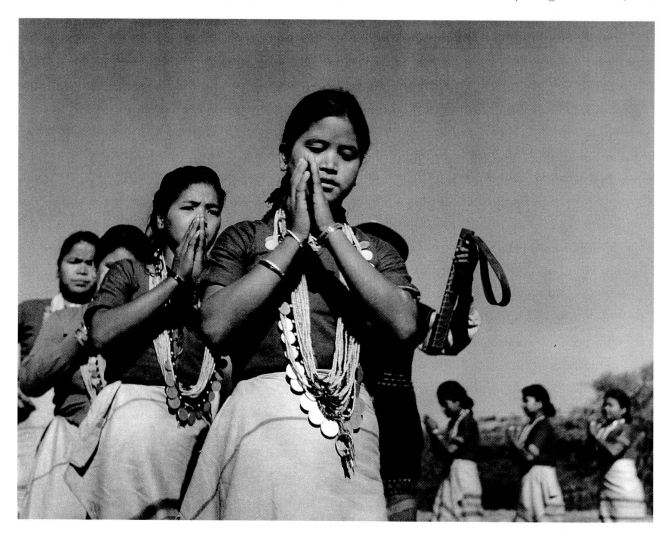

mostly barter forest produce and the food-grain they grow for their small needs and fancies, like mirrors, needles, strings, salt and utensils.

A young man always carries some arms with him, usually a bamboo bow and arrows, and an axe. Besides that, they often have a long Tibetan sword in a bamboo sheath; or else, a much longer, formidable spear. They also wear a defensive headdress woven from strong cane which can stand a blow even from a sharp sword. It is no longer necessary for them either to arm themselves or to wear protective gear, since their inter-tribal feuds have been suppressed by the government, but habits and customs die hard, and they seem to find it gratifying to wear and carry this martial gear.

We went to only a few villages in Abor country as torrential rain made us retreat hastily to Sadia for fear of being marooned again by rising flood waters.

Abors stretching the skin of the tiger they had hunted.

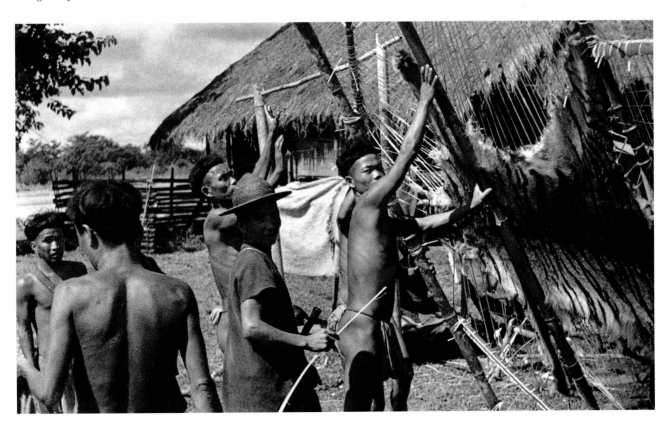

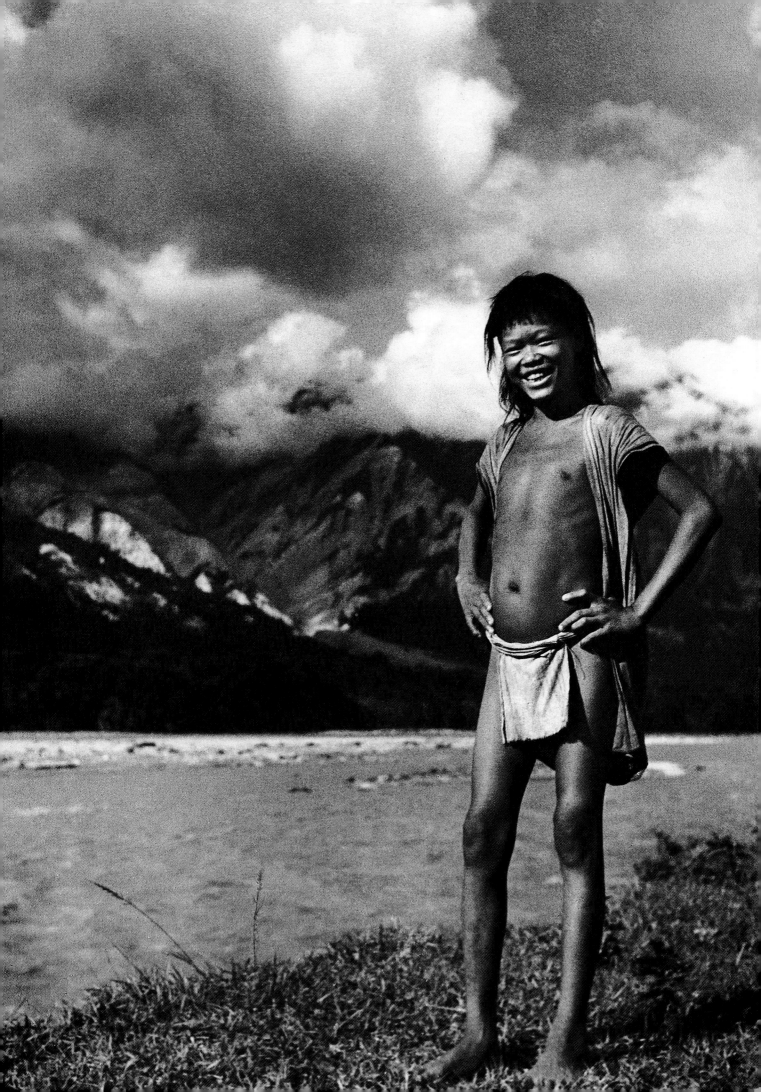

THE MISHMIS

My trip to the Abors and the Mishmis began from Dibrugarh, in Assam, where I was born. I had only spent my infancy there and had no memories of the town. I lazed in the morning, roaming the streets and trying to locate the house where I was born. In the afternoon, a tiny steamboat took us across the raging waters of the flooded Brahmaputra to Sadia. Sadia, the administrative headquarters of all the tribal areas around it, was then totally wrecked by the great Assam earthquake and the consequent flood. The collapsed buildings stood staggering against each other on both sides of the road. The main street was still under knee-deep water.

It was a long way to Mishmi country from there, and I was in despair, not being able to travel any further. Apart from the Abors nearby, the Mishmis were the only tribals who were not entirely inaccessible from the part of Assam I was in. But even under normal conditions it was difficult to reach them and at that time it seemed quite impossible. The District Magistrate of Sadia had difficulties to spare us a suitable transport as most of the jeeps were engaged in relief work in the flooded villages. Eventually, he put us into a jeep carrying supplies to Nizamghat, a far-off but populous Mishmi village, situated deep in the forests. After groaning its way in low gear through the water-logged low plains, the jeep took us to the outskirts of the forests. It was a sunny morning but once we were on the jungle track we soon lost sight of the sun. There were boards nailed to the

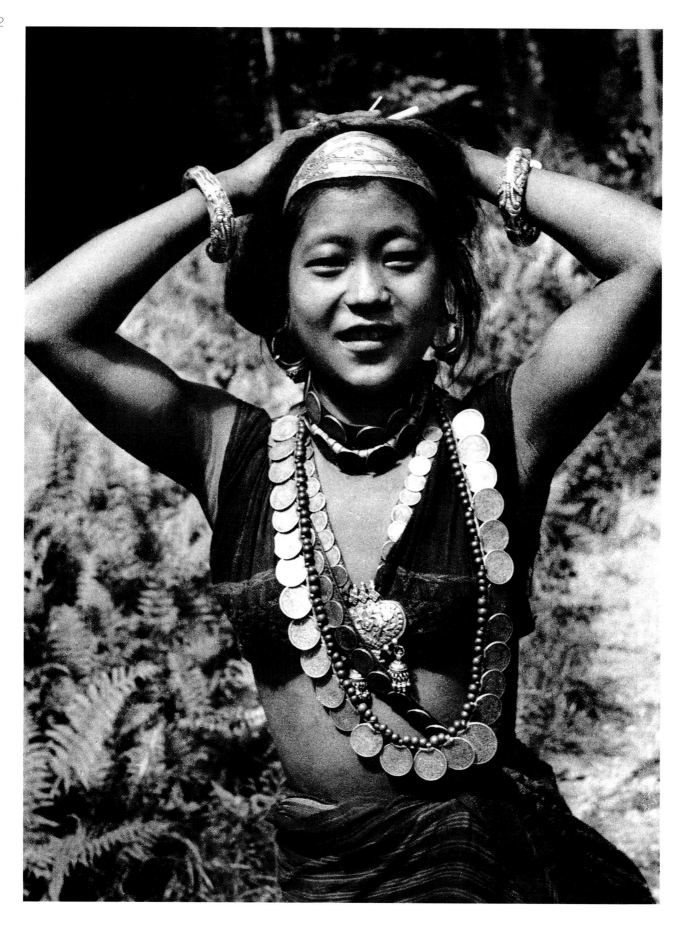

trees saying 'Forbidden Territory. No entry without permission from proper authorities'. These warnings were hardly needed, for nature herself wrote them far more eloquently in these impenetrable tropical forests. The gnarled trunks of tall trees walled in the forest road carpeted with fallen leaves. Wild grass rose man-high on it, bending as the jeep swished past, but springing back again to curtain off the view behind. Creepers and great lianas entwining themselves on the trees all the way up to the topmost branches spanned the narrow patch of sky between them. The road was like a long green tunnel dappled with patches of sunlight filtering through the leafy canopy.

Only the furthest end of the green archway revealed a blue sunlit sky. Small groups of Mishmis armed with axes stopped on their way to let us pass, by stepping back into the gaps in the forest wall swishing their axes behind them to scare away any lurking wild animals or snakes. All of them carried a load on their backs, the way hill people do, in a basket strapped to their foreheads. Judging from the confident way the tribals moved about in the jungle I felt that obviously, an abundance of wildlife left no carnivore starving but they seldom chose men as their prey.

The road ended near Nizamghat, but we had to walk many miles further across the forest to reach some of the other villages. Dressed in shorts, our legs were often covered with leeches which would drop off only with liberal applications of salt. As Nizamabad was situated at a junction, one could see many groups of local tribes, including the Mishmis, resting there on their way back to the villages. In the afternoon, there was great excitement when an army plane dropped bags of food-grain for distribution in the villages marooned by the floods. Surprisingly, there was no scramble to pick up the bags. Instead, they were all brought into an open patch in the village and distributed to the villagers and to people going in different directions. People were honest and there was no doubt that the food would reach the needy. How simple it was for the army to do the relief job among such a people! In times of distress, when people received aid from international organizations and good samaritans all over the world, the food, the medical supplies and clothes donated were often grabbed by corrupt officials and sold in the market, depriving the needy.

Facing page:
A Mijou Mishmi woman proudly displays her extravagant necklace of silver coins, Arunachal Pradesh.

The Mishmis were divided into three major groups, the Digaru, the Mijou and the Chulikata. *Chulikata* meant literally, 'cropped-hair'. During our treks in Mishmi country we came across all three groups. The Chulikatas were the most pronouncedly Mongoloid: they had broader noses, much more evident epithelial eyefolds and higher cheek-bones. Their closely cropped hair emphasized their rather plain features. There was not much of a difference in looks between them and the men of the other groups. But among the Mijou and Digaru, women were often much prettier. Their fine faces were framed by carefully groomed, luxuriant hairstyles.

While in a Mijou village, I found a very pretty young girl keeping herself at a distance from the groups of people I was photographing. I pre-focused my camera at approximately the distance she would be and then walked up to the fence behind which she was sitting all by herself. Her face was lowered, as if nursing a private sorrow. I photographed her, and like an insensitive photographer asked her, 'Why are you hiding away from the others? You are so beautiful, I would like to take many more pictures of you.' She broke down into uncontrollable sobs. The laughing, gesticulating group of people around us, engaged in noisy conversation a moment ago, suddenly became quiet and shuffled about. One of them explained, 'She is a widow, and her husband died soon after an outsider like you took a photograph of him. There is a belief among us that taking anyone's picture may take his soul away. Of course there were many others in the group that man had photographed. None of them except her husband died, but she grieves for him and thinks that since you have photographed her, she too will soon die.' There was little I could do either to console her or to take away her fears: I stood feeling deeply ashamed of myself. It was perhaps a disproportionate reaction, but I did feel very guilty and stupid.

We spent several days photographing people in different villages. The men wore loin cloths and very simply tailored loose slipovers. A length of their homespun woollen fabric wide enough to reach across the shoulders was folded, and the two sides were sewn, leaving unstitched armholes on both sides. Then a slit was cut at the centre of the top for the head to go through. For elegance, the

Facing page:
A Mijou Mishmi woman.
As I focused my camera she was
in tears as she thought she would die.

Digaru Mishmi women carrying water in bamboo funnels. (The cigarette was a bribe from me to stop them from running away.)

edges of these slits and the armholes were embroidered. The women were clad only in very brief but lavishly embroidered *cholis* and striped sarongs around their waists, leaving the midriff bare. The colours they chose were invariably blue or black, embroidered or striped with red and maroon. Like all our tribals, they decked themselves up with necklaces or beads and coins. The Mijou Mishmi woman wore an engraved silver head band and a long ivory hairpin. I had seen such tiaras, made of brass, only among the Bison-horn Marias of Bastar in central India. But they did not have these formidable hairpins.

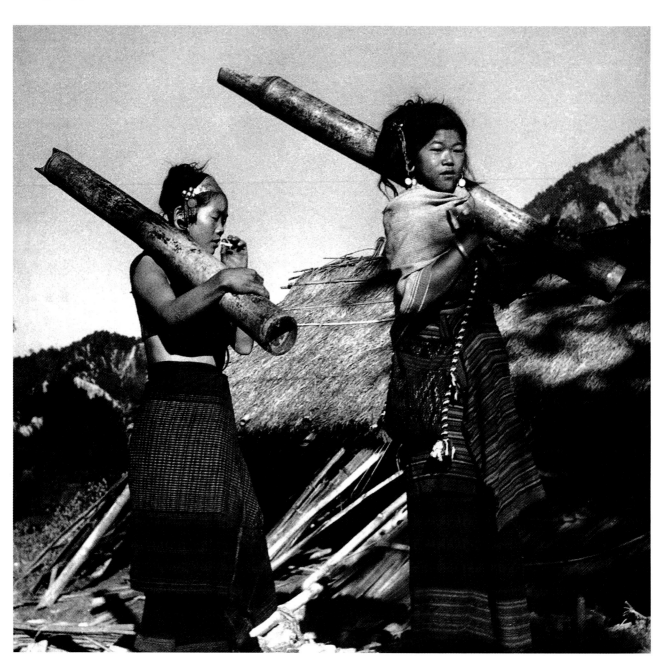

Nights in these forests were quite still. The only sound was the gentle gurgle of the mountain streams. Singing and dancing, which was the routine evening pastime among the tribes of Bihar, Jharkhand, Orissa and central India, seemed to be reserved only for festive and ceremonial occasions. There were no nightly revels in this austere, partly Buddhist country. On our way back, I stopped the jeep and walked off taking some time to photograph some of the tribals carrying firewood, when the driver sounded his horn impatiently. One of the men with us came running towards me: 'Elephant herds pass this way', he said, 'and we must get away from the forest road before nightfall.' I hurried up to the jeep, dropping my Leica camera into my shoulder bag. In my hurry, I forgot to pick up the other jungle-green canvas bag acquired from U.S. Army disposals, which I had kept on the ground. I had in it a Rolleiflex camera, all the rolls of film I had shot during this trip, as well as a purse containing all the money I was carrying. I discovered the loss only after reaching Sadia, and spent a sleepless night distressed by the enormity of the loss. Rolleiflex was an expensive camera, but its loss was nothing compared to the loss of all the photographs taken during the six weeks of my stay in that inaccessible territory. I was penniless. I was so upset that I could hardly eat any breakfast. I pondered gloomily over my loss and the embarrassment of asking the District Magistrate for the money I would need to get back. While I was sitting at the Circuit House at ten o'clock in the morning after having two cups of lukewarm tea, the Magistrate himself dropped in to find out how we had fared on the trip. I poured out my tale of woe. He was quite willing to spare the jeep to take me back all the way to look for my bag but he said, as I myself feared, that it would be almost impossible to find the bag in the forest track. At about eleven o'clock a man informed me that a Mishmi at the District Magistrate's office was enquiring about a man who had taken photographs in his village. I jumped up and ran to meet him. There was the young man I had photographed, with an axe on his shoulder, a stack of firewood still there on his back, and my dear old jungle-green U.S. ammunition bag, slung from his other shoulder. I almost kissed him on the spot. He had come walking all night through the dense forest, infested with dangerous wild animals, to return a small bag to its owner.

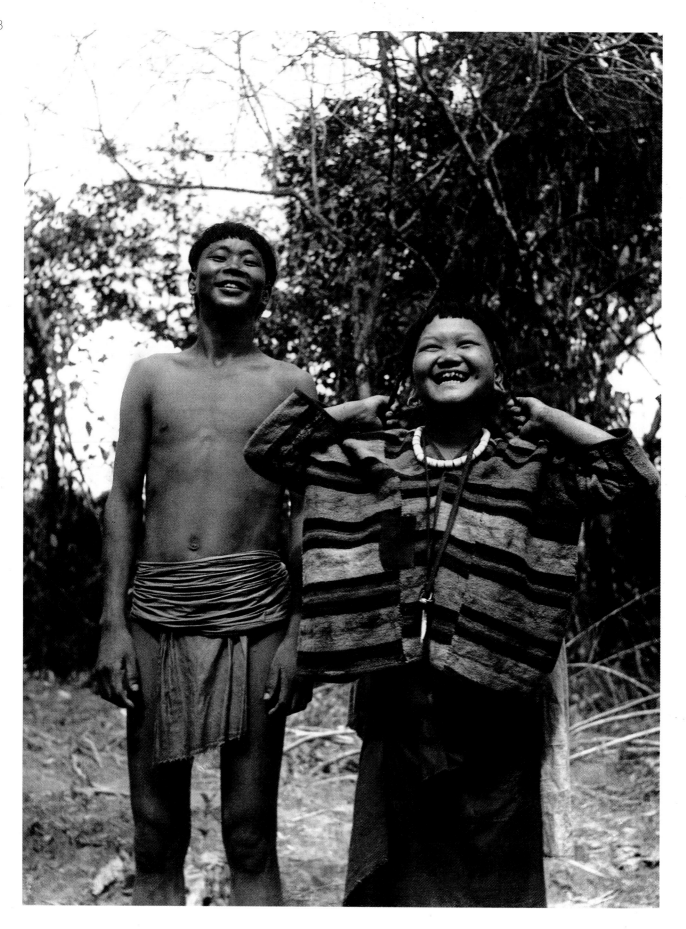

The money, which in those days, could have bought him a score of bisons or perhaps a house, was untouched. One rarely comes across such honesty and compassion. Out of my paltry sum of five hundred rupees left for going back to Kolkata, I could only offer him a hundred in gratitude. He initially refused, but then took it, looking rather bewildered. I am sure that he did what seemed to be right and natural, without the expectation of any reward.

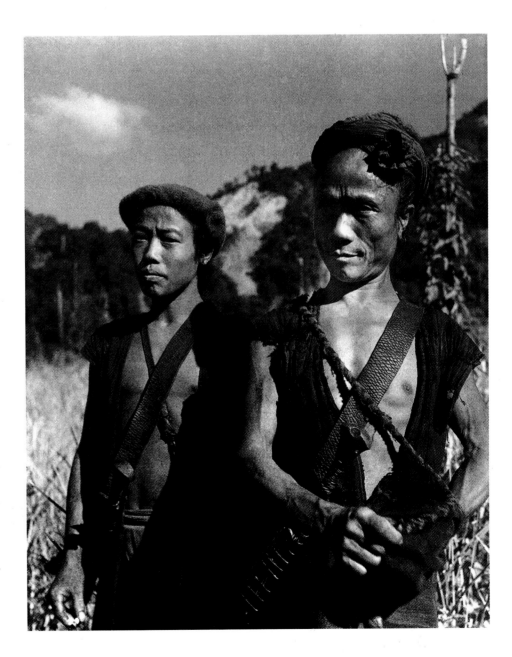

Facing page:
Chulikata Mishmi couple in Nizamghat, Arunachal Pradesh.

Right:
Two Mishmis on the roadside near Sadia.

The Nagas of Nagaland and the
Kukis of Manipur

Nagaland was the first of the tribal territories of India to become a separate state. Entry into this frequently disturbed border area had been strictly controlled during the British days. I never tried to get permission to go there, knowing it would certainly be denied because of my past political affiliations. For years, even after Independence, Nagaland continued to be a 'disturbed area' and the restrictions remained in force.

Long before I could actually visit Nagaland I had photographed some Nagas in Manipur state and their Kuki neighbours. I was in Manipur during their Holi festival in 1962 when a local schoolteacher and a lady MLA offered to take me to Churachandpur on the Myanmar border. On our way back, our friend, who was a Kuki, directed the driver of our vehicle to branch out from the main road to take us to a Kuki village. When we reached it we found that everyone in the village—man, woman and child—was busy engaged in thatching the roof of a newly constructed house. The women were tossing up bundles of straw to the men on the roof to lay out and fix them properly in place. I watched with fascination and photographed the activities until their task was completed and a new house, built with the help of everyone in the village, stood bright and shining in the afternoon sun. In the open ground between it and the neighbouring houses behind which rose the green hills, a big feast was laid on by the grateful family for whom this house was built. Everyone in the village, including the dogs, had his or her share of it, as you can see in the photograph.

Facing page:
Kuki women, Manipur.

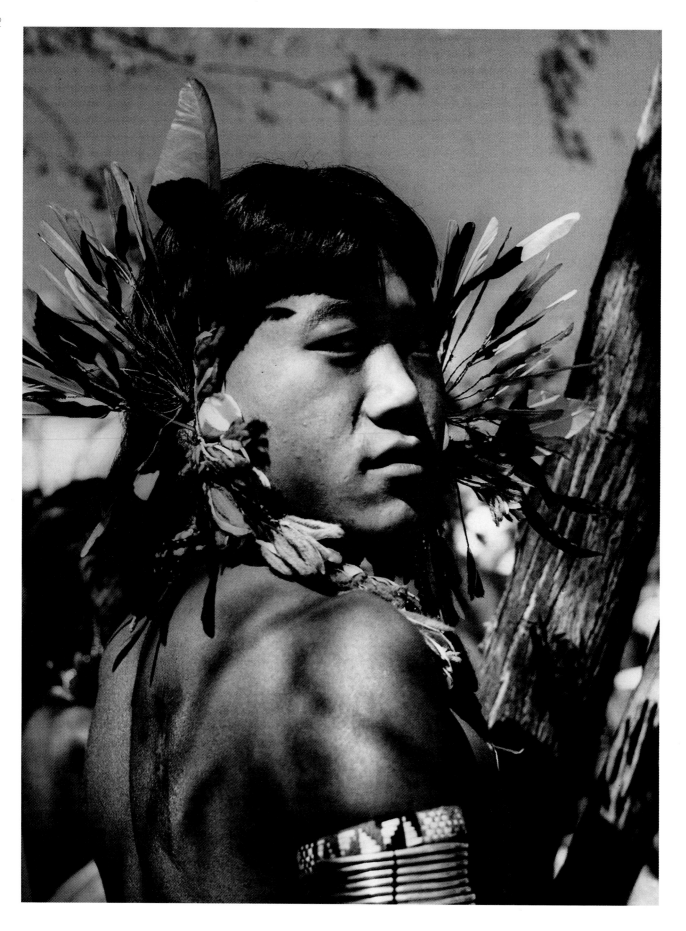

When Verrier Elwin took charge as the Advisor on Tribal Affairs to the Government of India in Shillong at Nehru's request, my long cherished hopes of visiting Nagaland seemed to be assured of fulfilment. Unfortunately, he died before we could make any definite plan for a trip.

I cherished dreams of going to the Konyak Nagas ever since I had read about them in Fürer-Haimendorf's book, *The Naked Nagas.* I visited this adventurous scholar in London in 1959 and was charmed by his warm reception. I was an absolute stranger to him, but he found that I shared his interest in our tribes and had photographs of them to show him. He asked me to go to Tuensang, to the Konyak Nagas, before they were swallowed up by our civilization.

It was only in 1970, ten years after Nagaland had become a state, that I could go there on an assignment for the Indian Tourism Development Corporation. Kohima, the capital and the only town in Nagaland, had no airport or railway connection and could only be approached by road from Imphal in Manipur. It was a long drive on a tortuous road across lovely hills and valleys. The countryside was wild and beautiful with alternating stretches of craggy, precipitous rocks, with ferns sprouting from them and mist-veiled terraces of paddy-fields cascading down the hills to the valley below. Almost all the Naga villages were situated on hilltops. The sites were chosen for their strategic positions, less vulnerable to attacks from other clans. Blood feuds between the different tribes had always been an unhappy feature of Naga lives. At one time, it used to lead to frequent raids on each other's villages and the carrying off of the enemies' severed heads as trophies. The heads used to be shrunk and worn as pendants. The head-hunting was put down and small brass-cast heads came to be worn instead of the gruesome shrunken heads. The Nagas had to live down their disreputable image as blood-thirsty head-hunters. They were never really just that. They were settled cultivators growing their rice on skilfully built terraces on the hills. They had fine handicrafts and they wove exquisite textiles. The villages I saw on my way and during my brief stay consisted of clusters of strongly built log houses with quaint, sloping, thatched roofs, perhaps meant to let the heavy monsoon rain drain off harmlessly. Mist obliterated all but the outlines of these gaunt houses and the salient features of the hills and valleys, leaving only a few

Facing page:
A Naga youth.

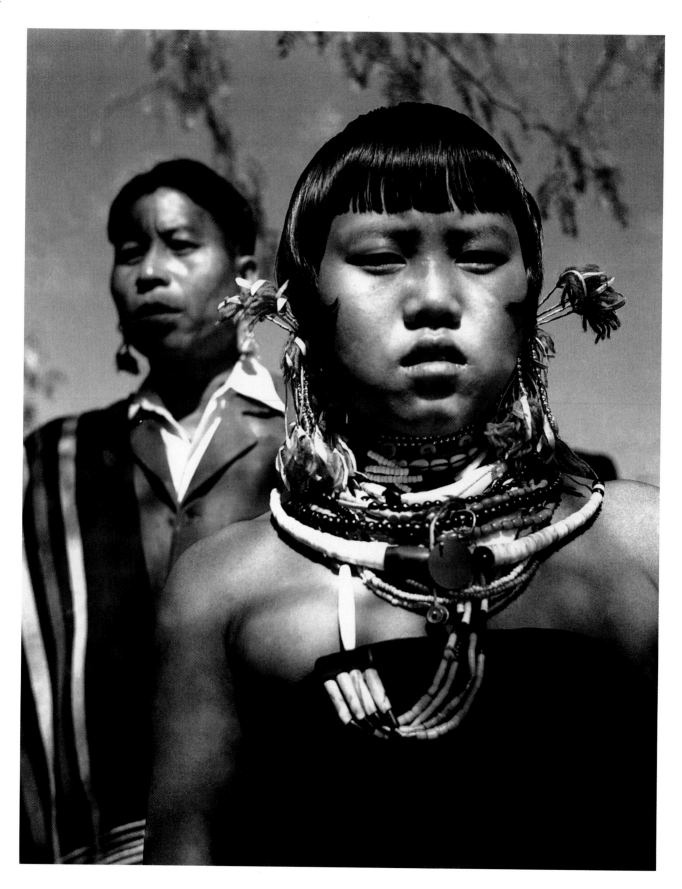

twigs or a tree in the foreground boldly drawn. I was reminded again and again of Chinese landscape paintings.

However, difficulties began at the end of this idyllic journey. I found that the Tourist Officer in Kohima had a massive grievance against his bosses in New Delhi as he had been granted little money to run a tourist service. He had no transport or accommodation to offer, and there was no vehicle that I could hire in Kohima. It seemed it would be hard to do my rather inconsequential assignment—it was obvious that the insurmountable difficulties of going into the interiors that my friends in the government had warned me of, were very true.

During the night, when I found shelter in a log-house kind of hotel, I pondered on who could help. I remembered that the Forest Departments always had vehicles going into the interiors and usually the officials were helpful. The officers often felt lonely in their outposts and welcomed friendly visitors passing by. In the morning I found my way to the Forest Department's office and met the chief officer in the derelict old log cabin which was his office. He immediately

Facing page:
Semi-Naga couple.

Below:
Group of Nagas by the roadside on the road to Kohima.

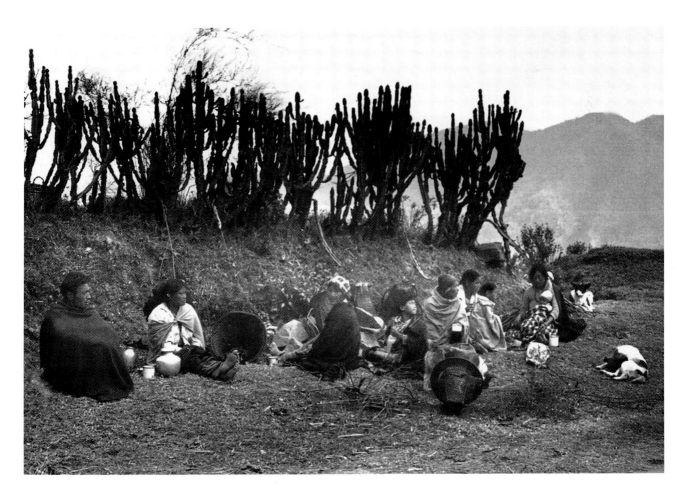

offered me transport but not to Tuensang, which was way out of his jurisdiction. Moreover, I learnt that it would take four or five days to reach the place by the barely jeepable hill roads. And some of these hills were too steep and too high. I had to submit humbly to the geography of the terrain and abandon my long cherished project of visiting the Konyak Nagas.

I gratefully accepted the invitation of a young Bengali officer of the Forest Department to be his guest for the rest of the day and night before being picked up in the morning by one of the Forest Department's jeeps going to some nearby villages. His wife gave me one of the finest Bengali dinners I have ever had. I had never expected *chital* fish to be served anywhere outside Bengal, least of all in Nagaland.

Below:
Tribesmen from different Naga tribes dancing together in preparation for the Folk Dance Festival in New Delhi.

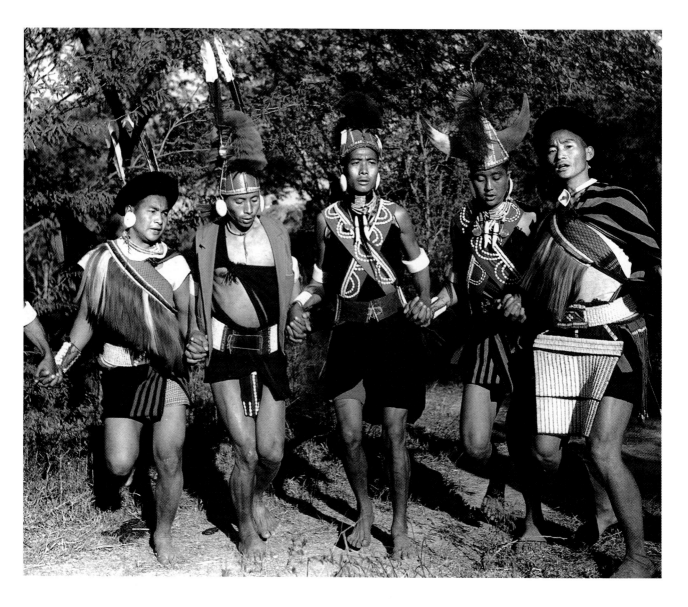

When I stepped out of the jeep the following morning to set my feet for the first time in a Naga village, I could barely conceal my excitement. I had to restrain my childish delight and my curiosity by not looking around immediately. Protocol demanded that we meet and propitiate the headman first. We had not brought any gifts since the Nagas were a proud people disdaining unsolicited gifts and disliking strangers trying to buy their favours. Instead of being led to the headman's house, as was usual in all our tribal villages, we were very surprised at finding ourselves in the great log-house of their matriarch, a very old widow, the richest person in the village. I could not but be impressed by her. The delicate Mongoloid skin—smooth and unblemished as a flower petal in

A Kuki woman taking her child out on a home-made perambulator, Manipur.

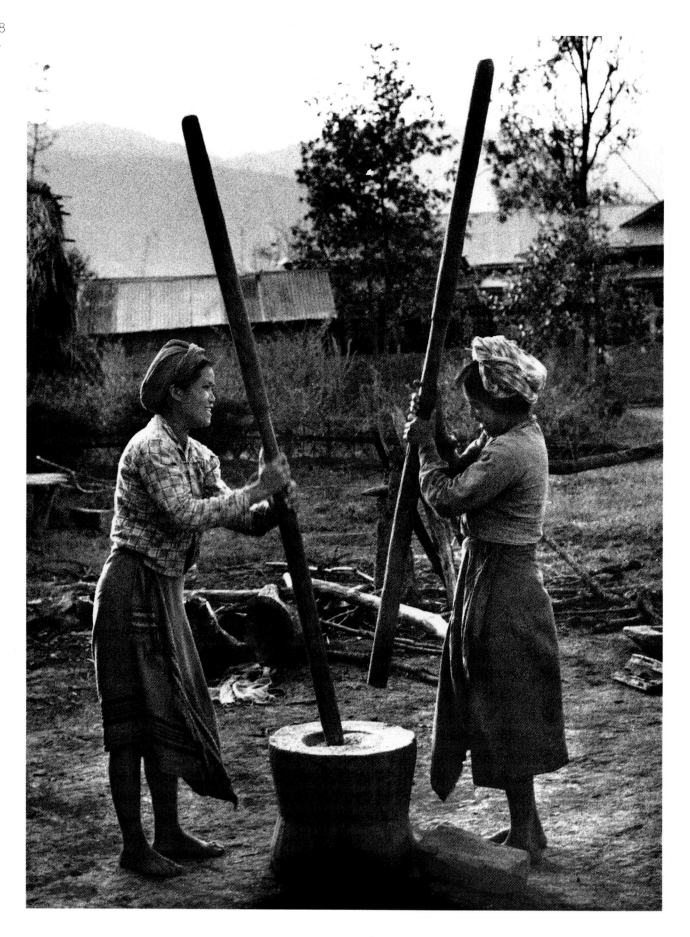

youth—wrinkled early, and her seventy-eight year old face was creased all over with delicate lines running all the way from her nose across her cheeks. When she smiled to welcome us, the lines at the corners of her eyes made deep furrows, and her eyes shone. She looked strangely beautiful, dimly lit by the daylight coming in through the open porch. She was standing alone in her spacious front room against a wall of weathered logs.

Her home was unusually large but nothing about it added to her imperious presence. There were strips of smoked pork hanging from hooks in a line across the end of the room where we were seated and on the walls were old and new calendars with the usual pictures of Hindu gods and of female film stars as well as some framed photographs of her family. On a functional log table with its legs stuck on the mud floor, there were lace doilies and a flower pot with marigolds and hibiscus in it. From one peg on the wall hung various coloured plastic carry-bags. I had rarely found so much evidence of modern commerce in our tribal villages, but then I remembered with some sadness that the Nagas had been 'civilized' by the Christian missionaries. A little boy brought us a pitcher of rice-beer and poured it into the large enamelled mugs on the table. Our hostess reached out for portions of the smoked pork and served them with bowls of boiled vegetables and rice. I was thirsty after the long drive and drank up the rice-beer very quickly. It was replenished the moment I finished it. This happened again and again despite my saying that I had enough. My interpreter nudged me and told me very gently that I should not drain the cup. Their custom of hospitality demanded that the cup should be filled whenever it was emptied, no matter what the guest said. I should leave some undrunk to indicate that I really meant what I said.

When we were walking away from her house towards the centre of the village, I noticed an enormous hollowed-out tree trunk propped up horizontally a few feet above the ground with logs. It had a stoppered bamboo tap fitted to its lower end. Three old tipplers were sprawled on a grass mat and were helping themselves from the tap to the frothy rice-beer stored in that giant communal wine barrel. Anyone in the village could take a drink from it when thirsty, but

Facing page:
Kuki women pounding grain,
Manipur.

the young and the active did not have the time to make an occupation of it while the old were free to indulge without much censure. The idea of imposing prohibition here seemed foolish to me. I found later that a common practice in most Naga villages was that everyone would contribute his share of rice towards the common liquor supply for the community.

I went around the village photographing faces and whatever activities I found interesting—men and boys working in their terraced paddy-fields and playing games, women weaving on their traditional loin-looms. Although their lifestyles had not changed beyond recognition, what I found around me was quite different from what I had read and expected to find. In the afternoon I was an uneasy spectator of a game of football.

My three days in Nagaland were not, however, as disappointing as they could have been. On one of those days, I had climed up precipitous rocks to a village which seemed secluded enough. It was deserted at noon; the men and women had left at dawn for the forests and the fields. But it was an enchanting place ridged

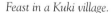

Feast in a Kuki village.

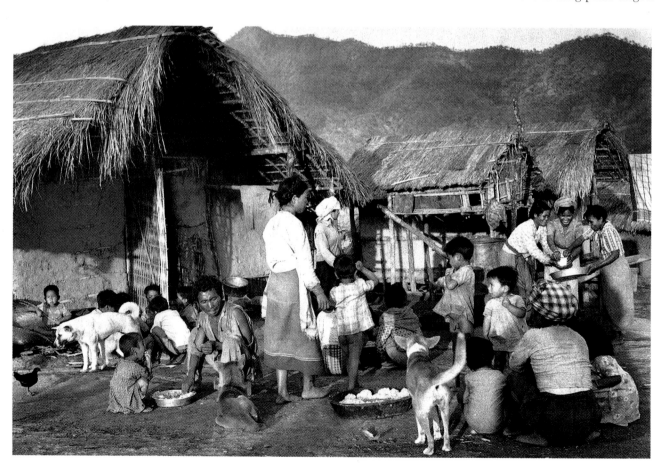

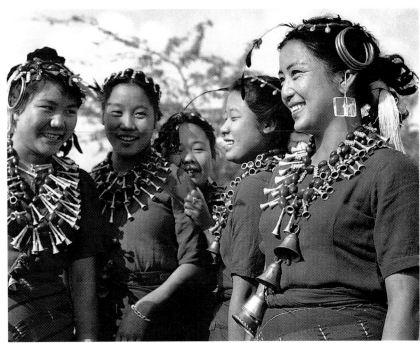

Right:
Naga girls in dancing dress.

Below:
A Naga house in Kohima,
corrugated iron sheets covering
timber walls and roof.

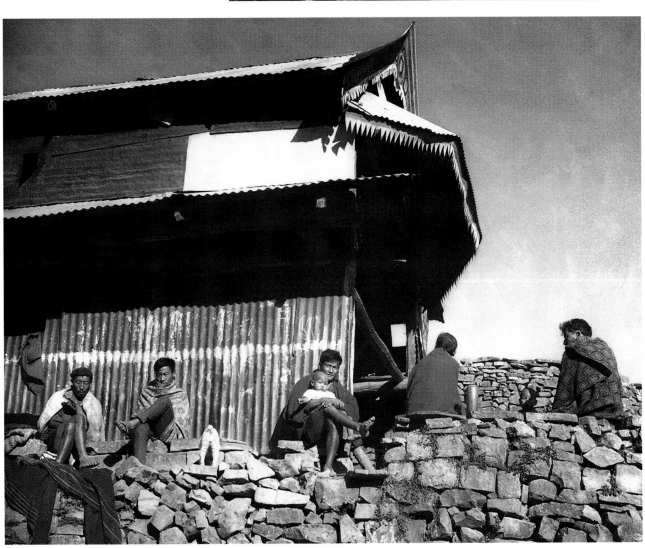

Right:
A Kuki girl carrying straw for
thatching her hut.

Below:
A Naga village on a hill-top.

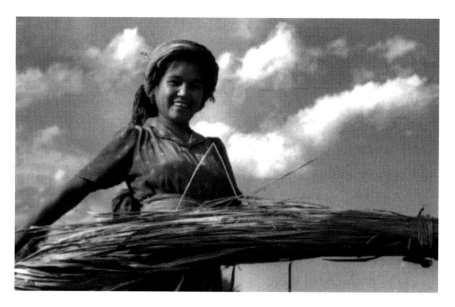

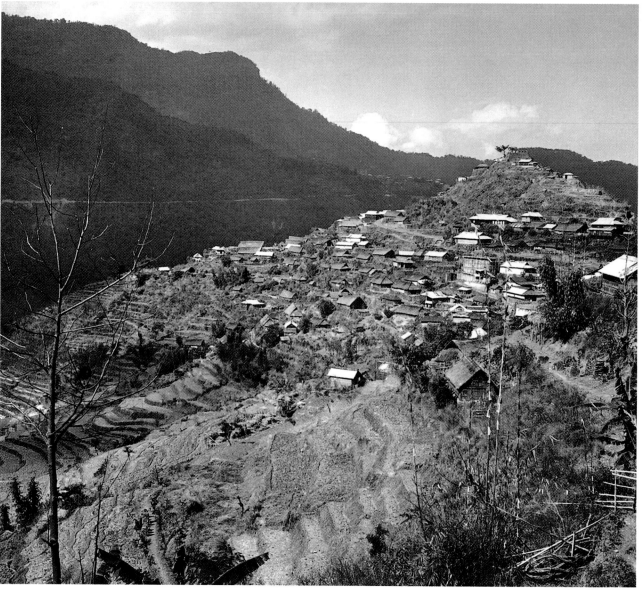

with high mountains. The children and the old people I found there were a joy to photograph. I have fond memories of the strange, rugged beauty of the landscape and the gentleness of the allegedly fierce tribals who inhabit this frontier state of India. It will take months for anyone to photograph the Nagas and their country adequately. I have seen only a small part of it, and for only a very short time.

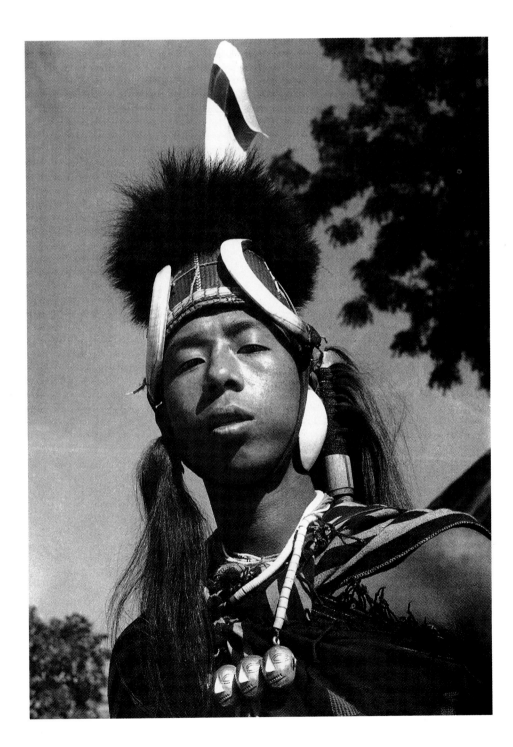

Right:
A Naga youth wearing three brass-cast heads as pendants.

Next page:
A Naga woman drying yarn.

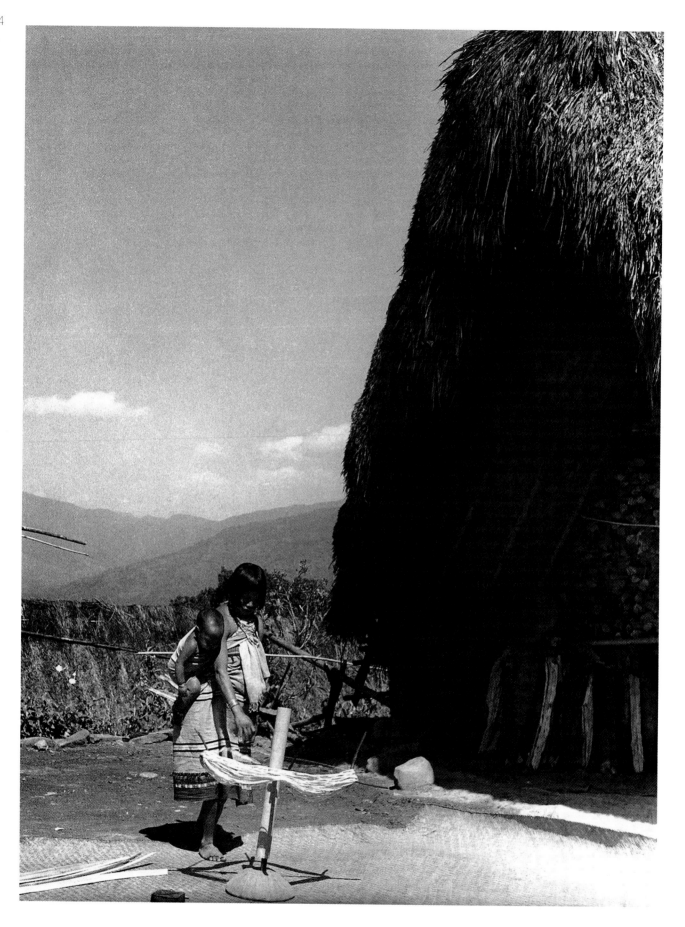

PHOTOGRAPHS